MW01155197

THE ART BOOK FOR CHILDREN

Phaidon Press Inc.
111 Broadway
New York, NY 10006

This combined, revised, and expanded edition of *The Art Book for Children*,
first published in 2024 (the "2024 Edition"), originates from *The Art Book for
Children: White Book*, first published in 2005, and *The Art Book for Children:
Yellow Book*, first published in 2007.
© 2005, 2007, 2024 Phaidon Press Limited.

Text for 2005 edition by Amanda Renshaw and Gilda Williams Ruggi.
Text for 2007 edition by Amanda Renshaw. Text for new entries in the
2024 Edition by Ferren Gipson.

The 2005 and 2007 editions of this book were conceived by
Amanda Renshaw, Alan Fletcher, and Gilda Williams Ruggi.

This 2024 Edition contains changes to the editions originally published
in 2005 and 2007 and has been subjected to treatment to which
Amanda Renshaw has not consented.

Text set in ABC Whyte Regular and Guida Pro Black

ISBN 978 183866 787 0 (US edition)
004-0224

Designed by Meagan Bennett
Production by Rebecca Price

Printed in China

THE ART BOOK

FOR CHILDREN

Written by Ferren Gipson, Amanda Renshaw, and Gilda Williams Ruggi

CONTENTS

- **IS IT A PAINTING OR A PHOTOGRAPH, OR MAYBE A SCULPTURE OR A VIDEO?**

- **IS IT SOMETHING FROM REAL LIFE OR SOMETHING IMAGINED?**

- **DOES IT TELL A STORY?**

- **IS IT BEAUTIFUL OR SHOCKING?**

- **IS THERE A SPECIAL MEANING?**

These are just some of the many questions that can help us think about art. The way you feel about an artwork is personal and unique to you. There are no right or wrong answers!

Take a look at some famous artworks from around the world and throughout history. How do they make you feel? What do you think they mean? Art can be full of mysteries and exciting discoveries. Let's explore it together!

HILMA AF KLINT

Born: October 26, 1862 | Solna, Sweden

KNOWN FOR

Nature, abstract art, scientific discovery

CURIOUS CODES

What do you see in this picture? Here's a hint—it's not a person, a place, or a thing. And there is no right or wrong answer!

Different people may have different answers to what they see here because this painting, by Hilma af Klint, is an example of abstract art. This means that it doesn't look like anything we might see with our eyes in real life. The artist wasn't interested in realistic paintings—she was interested in the meaning behind things, and she represented these ideas using symbols. She created a detailed system of signs and messages—like a secret code! We don't know what all of them mean, but she kept notebooks that can help us decode some of her paintings.

In one notebook, she wrote about a group of paintings called *The Ten Largest*. They are meant to show the different stages of a person's life—from childhood to old age. This painting is one of them, and it represents adulthood. Does it make you think of any adults you know? Take a look at some more paintings from the series on the next page. The childhood pictures are brightly colored, and the older ages get softer in hue over time.

How about the shapes in her paintings? Do they look like anything you've seen in real life? Even though abstract pictures may not look recognizable, an artist's inspiration can still come from real objects. Af Klint lived during a time of exciting discoveries and was very interested in science and nature. Do you see any of these influences in her art?

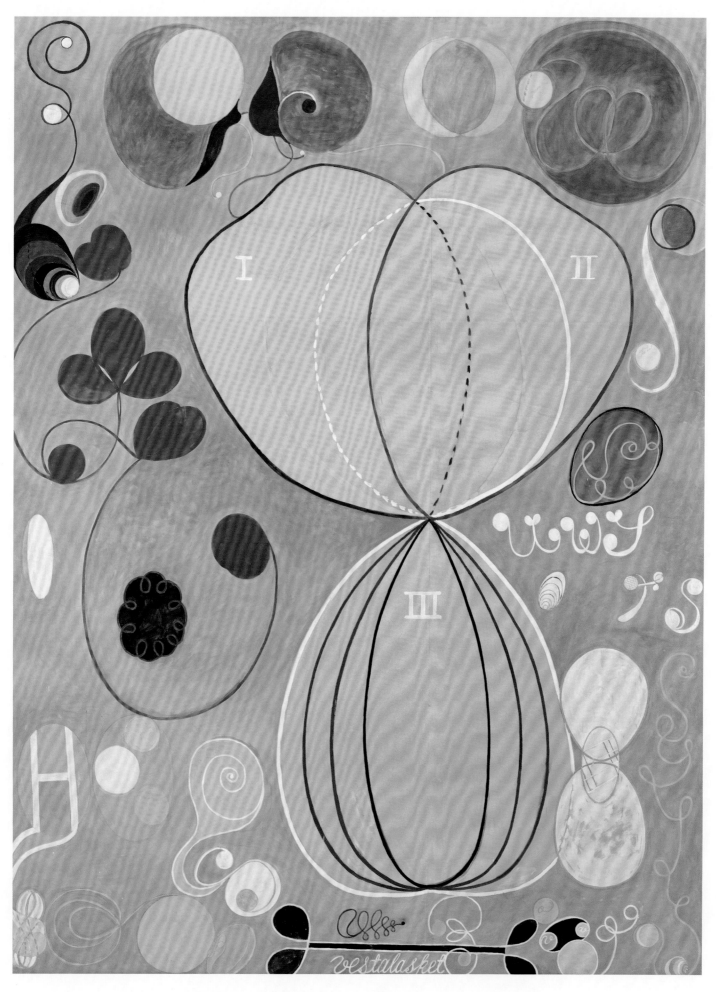

The Ten Largest, No. 7, Adulthood, Group IV

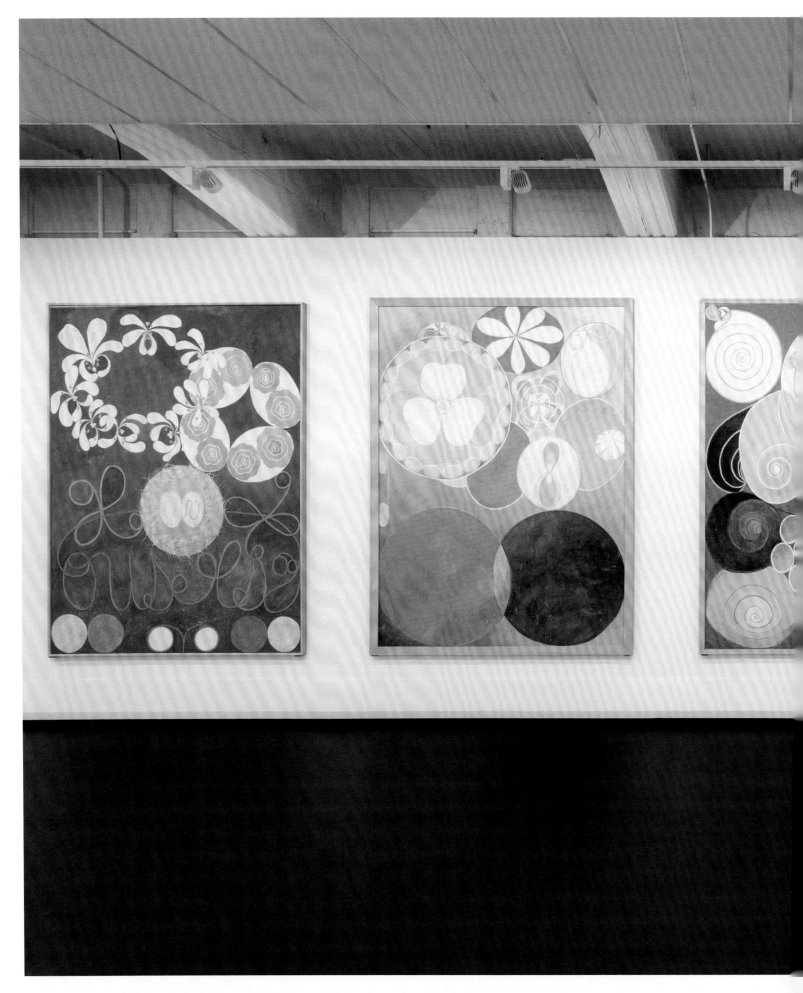

Five pictures from Hilma af Klint's group of paintings—*The Ten Largest*

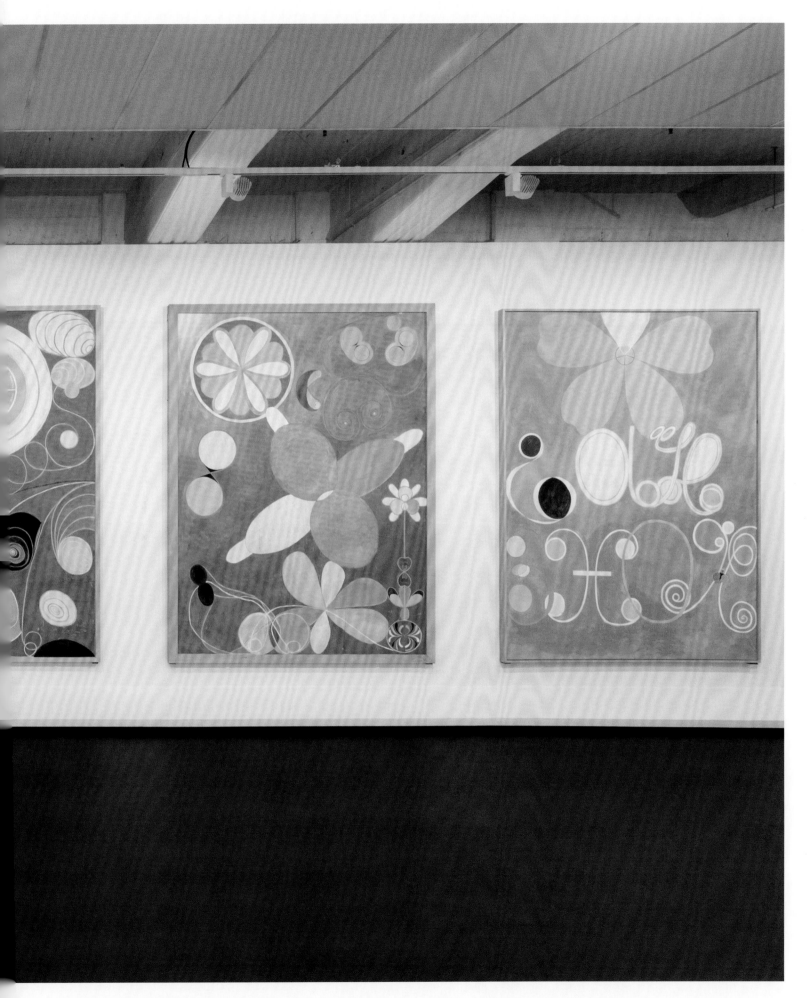

From left: *No.1, Childhood; No.2, Childhood; No.3, Youth; No.4, Youth; No.5, Adulthood*

EL ANATSUI
Born: February 4, 1944 | Anyako, Ghana

KNOWN FOR

Recycled materials, sculpture, abstract art

RECYCLE AND REUSE

Your recycling container might be filled with an artist's favorite art supplies!

It looks like someone has thrown a bucket of blue ink over this sculpture! Do you see how some of the blue looks like it has splashed onto the floor?

This sculpture is meant to look like a painting, but El Anatsui hasn't splashed paint at all! To create *Ink Splash II*, he flattened thousands of metal bottle tops! Then the artist cut and sewed them together using copper wire.

Anatsui loves transforming materials into something completely new. Look how the metal material ripples like fabric. His artworks are similar to quilts, which are made from stitched fabric pieces, but he uses pieces

of metal instead. Some of his favorite materials are bottle caps, newspaper printing plates, and cassava graters. (Cassavas are yummy root vegetables that people eat in many parts of the world, including in Nigeria, where Anatsui lives.) His sculptures often include objects that are connected to different cultures and histories of Africa.

Anatsui once said, "Every one of us has an artist in us." If you unleashed your inner artist to make a sculpture from recycled materials, what would you use?

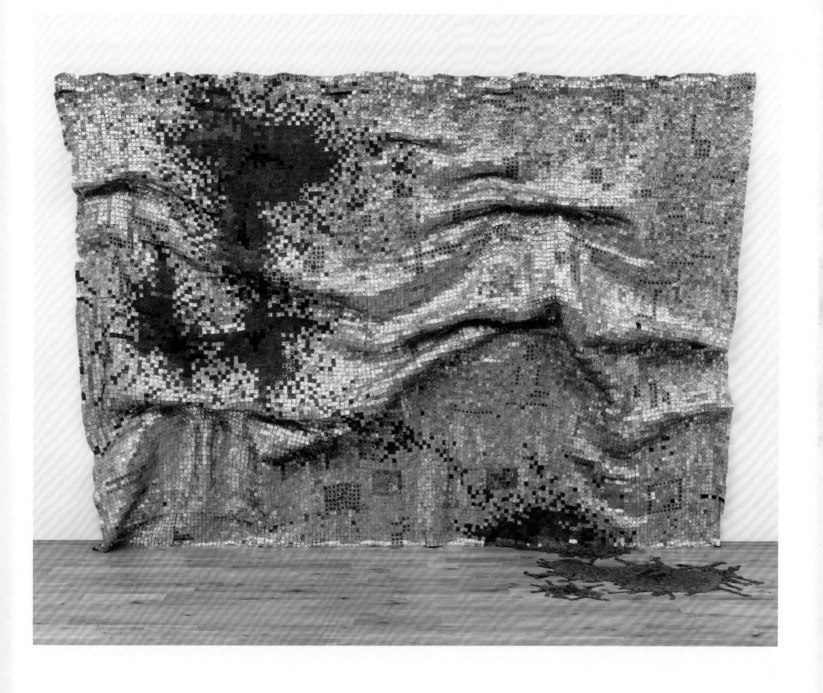

Ink Splash II

GIUSEPPE ARCIMBOLDO

Born: Around 1527 | Milan, Italy

KNOWN FOR

Imaginative portraits, heads, fruits, vegetables, flowers

MAKING FACES

When you look at this painting, what do you see first? A sideways view of a person? Or a colorful pile of fruit, flowers, vegetables, and leaves?

This is one of four playful paintings of people by Giuseppe Arcimboldo. (Look at the next page for the others.) Who are these people? And why did Arcimboldo look for ideas in a grocery store?

These aren't pictures of real people. Each one represents one of the four seasons—spring, summer, fall, and winter—and each person is made up of the fruit, plants, and vegetables that grow at that time of year. Spring is the first season, so spring looks the youngest, then comes summer, who is a little older, then fall, and finally, old winter.

Look at *Summer*. Arcimboldo has painted a picture of the summer season by making a person shaped from all the delicious produce that ripen in the hot months: fruits, such as plums, raspberries, and pears; and vegetables, such as cucumbers, corn on the cob, and an artichoke. The person has cherries for lips, an ear of wheat for eyebrows, and cheeks made up of a big ripe peach! Their teeth are peas, their nose is a cucumber, and their chin is a pear. How many fruits, vegetables, flowers, and plants can you find in these four pictures?

If you were making a face this way, what season and what fruits and vegetables would you pick?

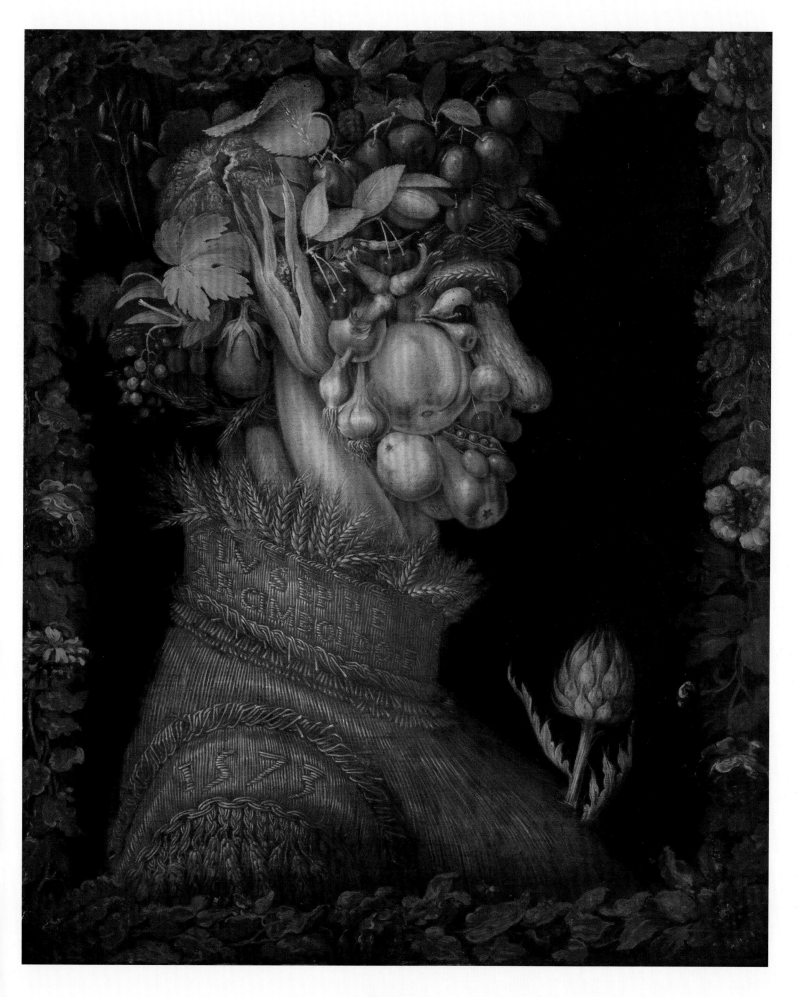

Summer

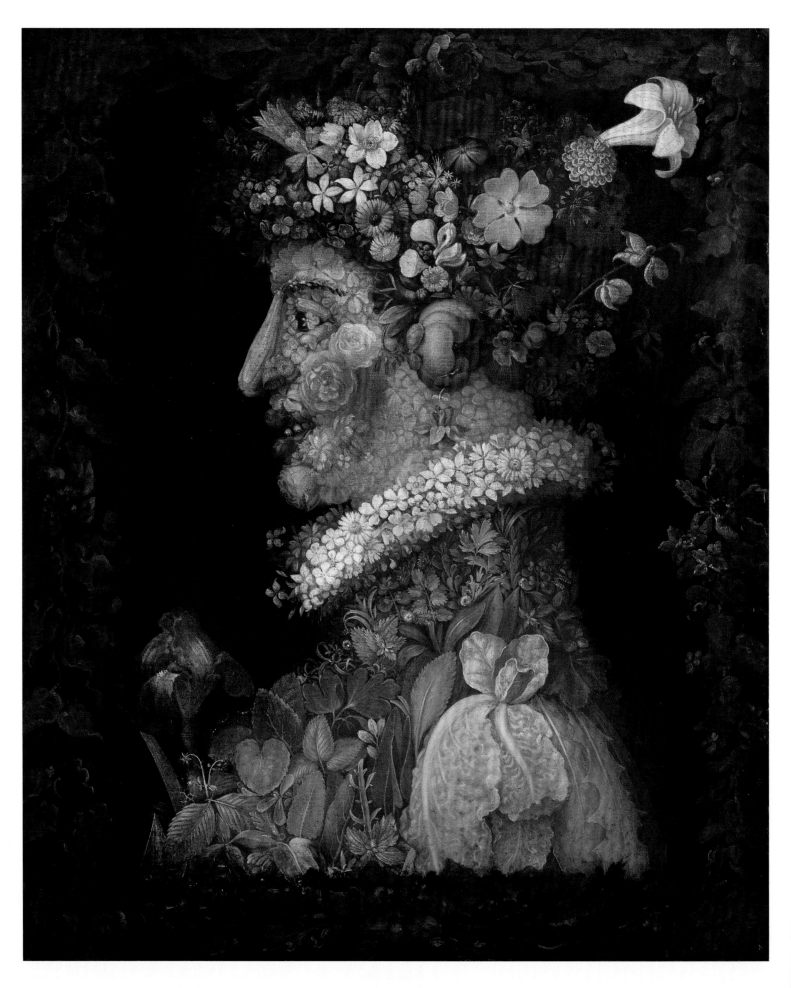

Spring

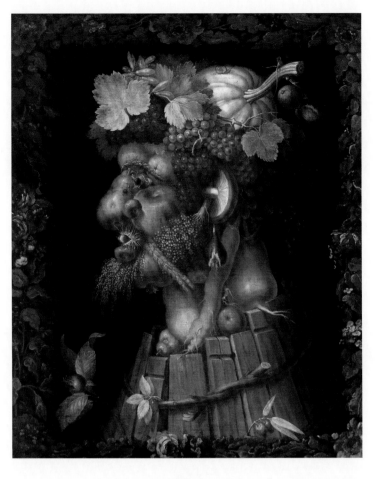

Fall

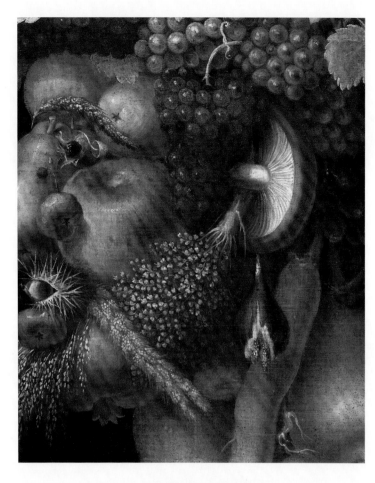

Detail of *Fall*

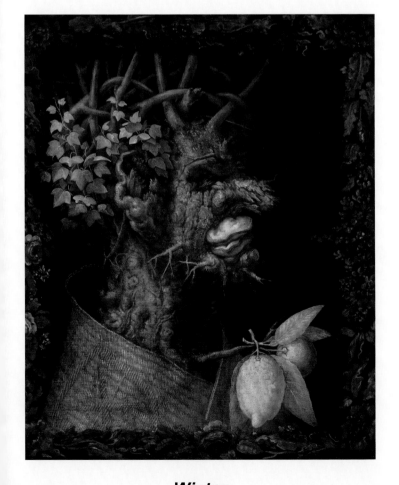

Winter

Detail of *Winter*

BASAWAN

Born: 1500s | India

KNOWN FOR

Court paintings, miniature painting, storytelling, fine details

TELLING A STORY

Some artworks tell colorful, adventure-packed stories, like this Indian miniature painting that is bursting with detail and action!

Watch out for the stampede!

One mighty elephant is chased by another across the river on a bridge made out of boats. The elephants are so wild and heavy that everything is sinking! Most people look terrified and are diving out of the way.

But one man, dressed in white, is in control, fearlessly riding an elephant. That's Emperor Akbar, ruler of the Mughal Empire in South Asia. He sits atop one of his strongest elephants, named Hawa'i. This picture is meant to show that Emperor Akbar was brave and strong enough to tackle difficult challenges.

The painting is by the artist Basawan and is from a book called the *Akbarnama* (*Book of Akbar*), which tells stories of the emperor's reign. The finest artists from Akbar's royal court worked on the book together.

Pictures like this one are called Indian miniature paintings—it's about the size of a sheet of notebook paper and extremely detailed. Look at the head of the person laying on the bridge. You can see individual strands of hair. To create fine lines in a work this size, artists sometimes used mini-paintbrushes made out of squirrel hair!

What scene from your life would you like to have painted? Who would you choose as the artist?

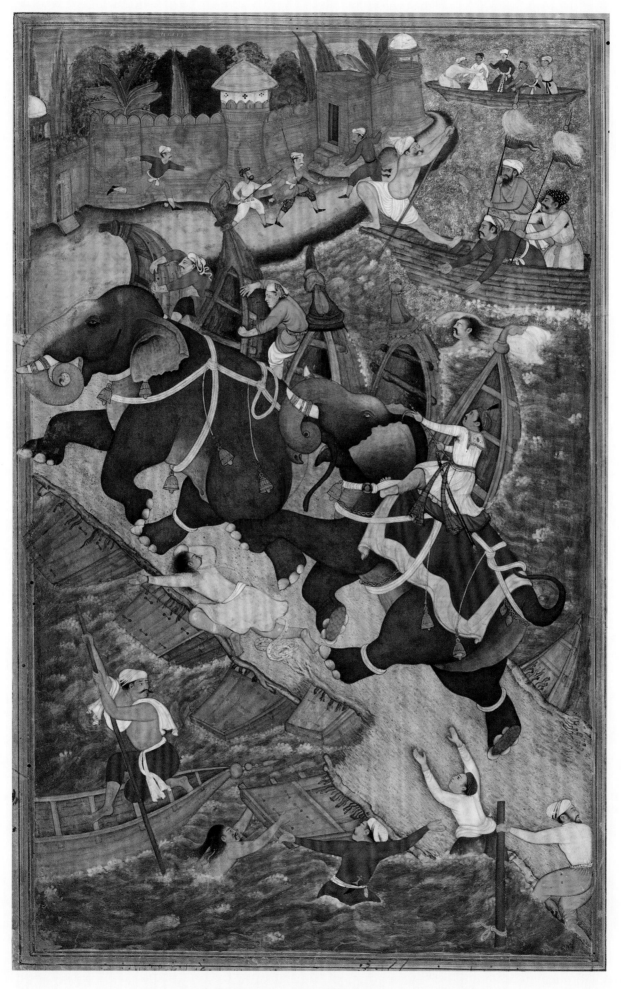

Page from the *Akbarnama* (*Book of Akbar*)

JEAN-MICHEL BASQUIAT

Born: December 22, 1960 | New York City, USA

KNOWN FOR

Graffiti, text with pictures

SHOW AND TELL

What excites you? How would you show it to the world? Jean-Michel Basquiat shared all the things that fascinated him in energetic paintings filled with writing and drawings.

You can almost hear the tunes booming from this painting by Jean-Michel Basquiat. He loved to listen to music while he was painting—especially a style of jazz called bebop. *Horn Players* shows colorful and scratchy drawings of the famous bebop musicians Charlie Parker (on the left) and Dizzy Gillespie (on the right). Basquiat admired many Black male writers, musicians, and athletes, and his pictures sometimes include crowns or halos as a way to celebrate these men as royalty and saints.

Do you like the writing on Basquiat's paintings? When he was a teenager, he and his friend spray-painted poetry graffiti on buildings around New York City. Writing was an important part of his artistic style. He also created handmade postcards and shirts with writing, playful drawings, and newspaper cuttings.

Growing up, Basquiat loved to learn new facts. His mother took him to museums and found him interesting books to read. When he broke his arm, she even gave him a medical textbook about the human body called *Gray's Anatomy*. He became so fascinated by the images that he started drawing cartoonlike pictures of skeletons and the body. Turn the page to see how he drew the figures in *Grillo*. He shows parts of their anatomy, which means the inside of the body.

What else can you spot in the picture?

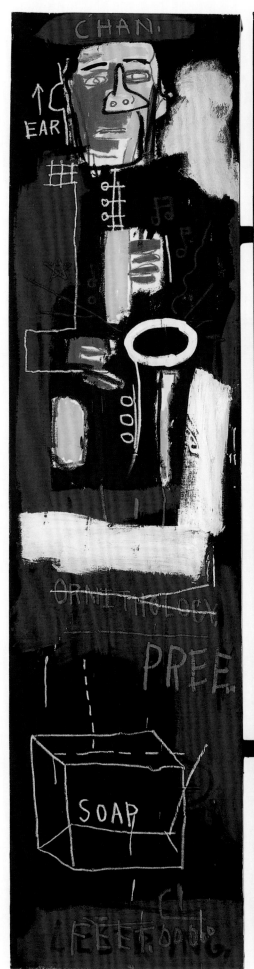
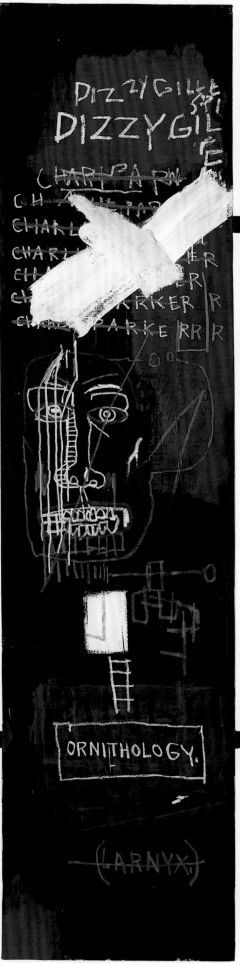
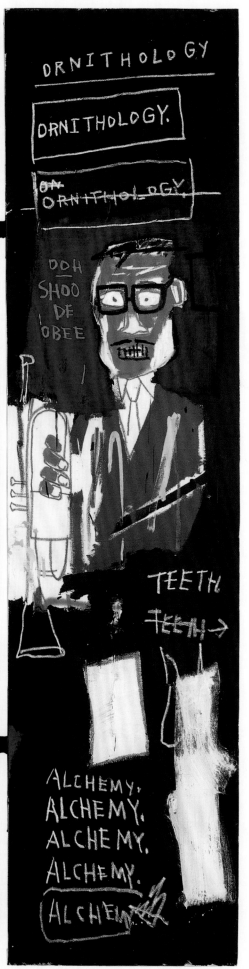

Horn Players

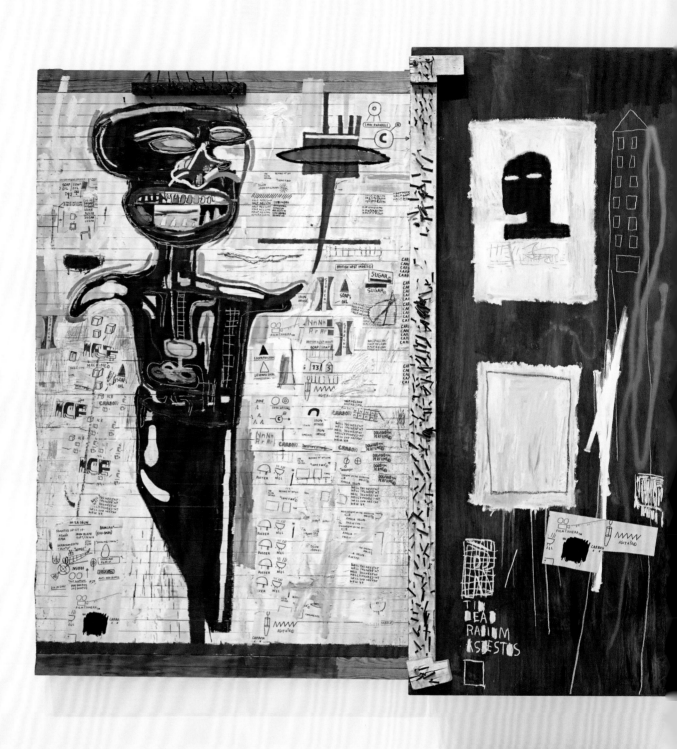

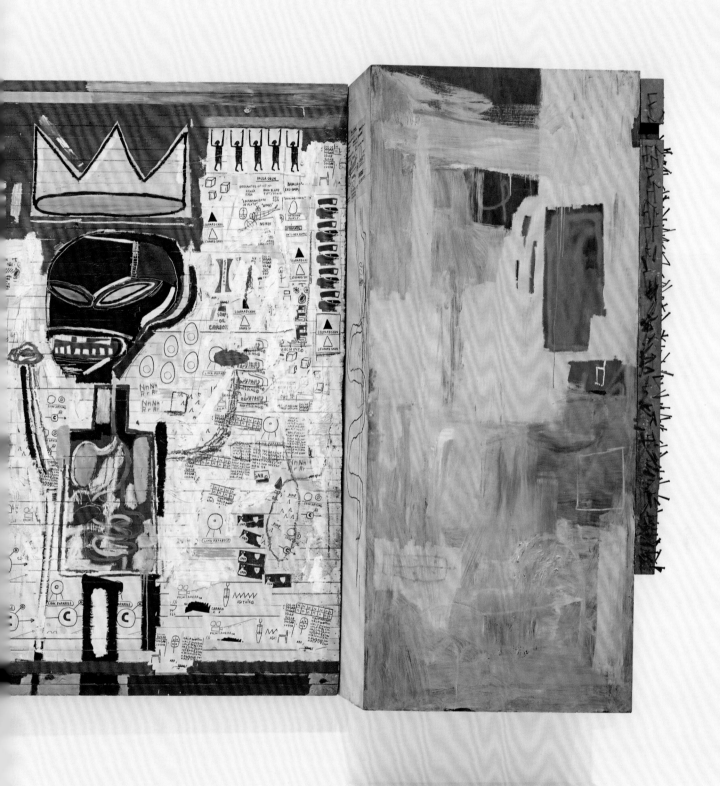

Grillo

ROSA BONHEUR

Born: March 16, 1822 | Bordeaux, France

KNOWN FOR

Animal paintings, lifelike portraits, pioneering female artist

INSPIRING ANIMALS

Can you imagine having a pet lion? Rosa Bonheur had many animals, including stags, boars, and the lion in this picture!

Rosa Bonheur loved to paint animals, and spending time with them gave her the chance to study them closely while she created her art. That's why her paintings look almost as real as photographs—and this was a time before color photography existed! Here, her lion truly looks like the king of the jungle, with his head proudly held up high.

From a young age, Bonheur loved to draw pictures of animals. She made many sketches of animals and even studied their bodies closely at veterinarian schools so that she could make her paintings more lifelike. At this time in France, women were not allowed to wear pants, but she was granted special permission to wear what was then considered men's clothing, making it easier for her to work with animals.

To create her painting *The Horse Fair* (turn the page to take a look), Bonheur spent a year and a half visiting a horse market in Paris to make sketches. If you look at the muscles of the horses and the way their bodies are positioned, you can see that her hard work paid off. People were so impressed that her painting was shown in several cities in Europe and the United States! She soon became one of the most successful women artists of her time.

What animals do you think would be the easiest and most challenging to paint?

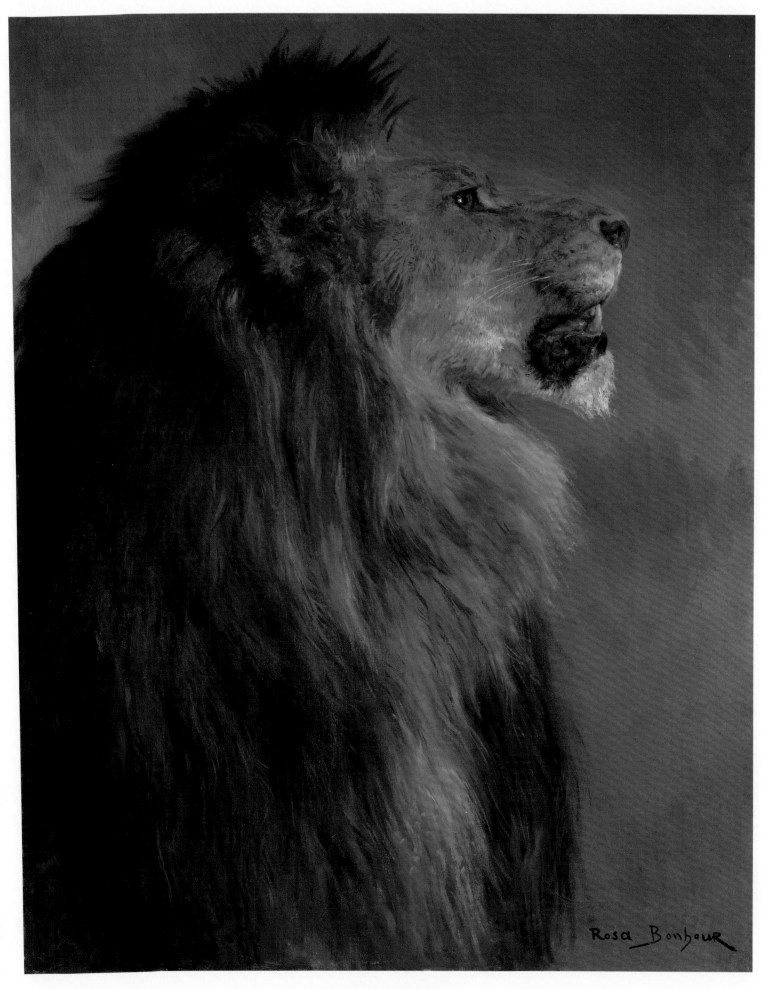

A Lion's Head

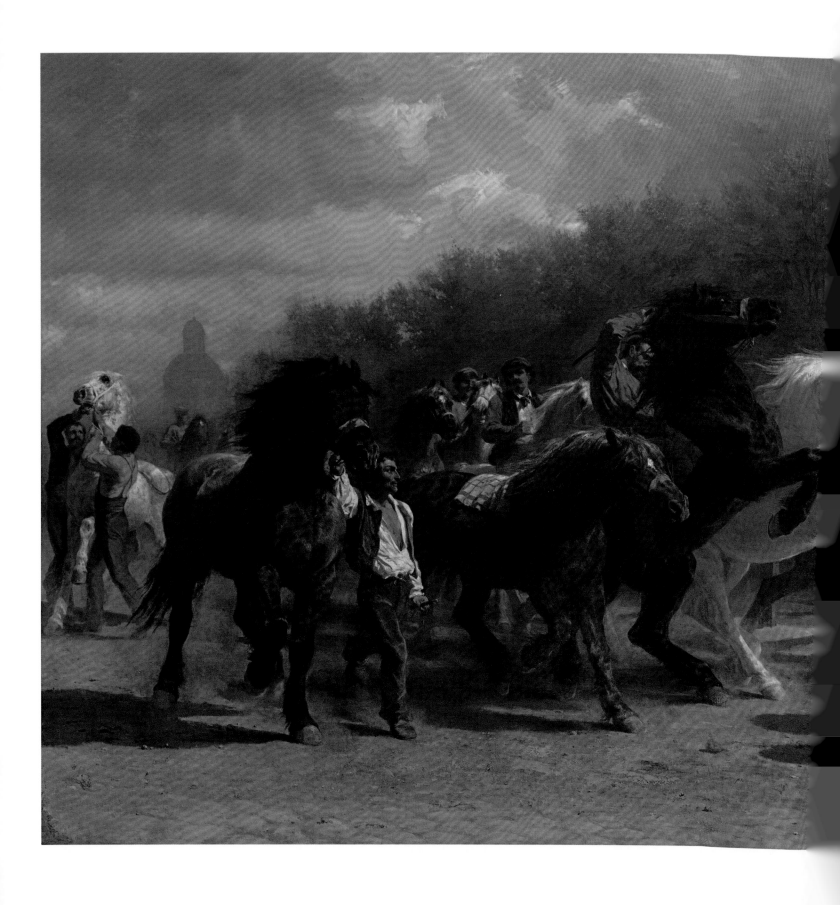

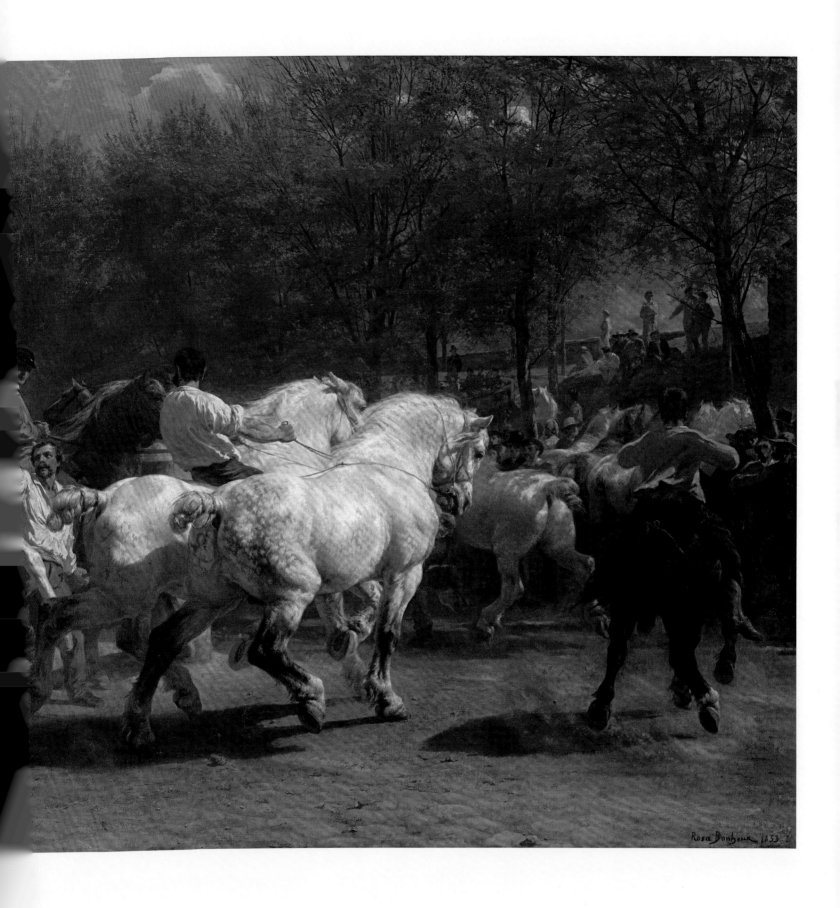

The Horse Fair

SANDRO BOTTICELLI

Born: Around 1445 | Florence, Italy

KNOWN FOR | Mythology, Renaissance painting

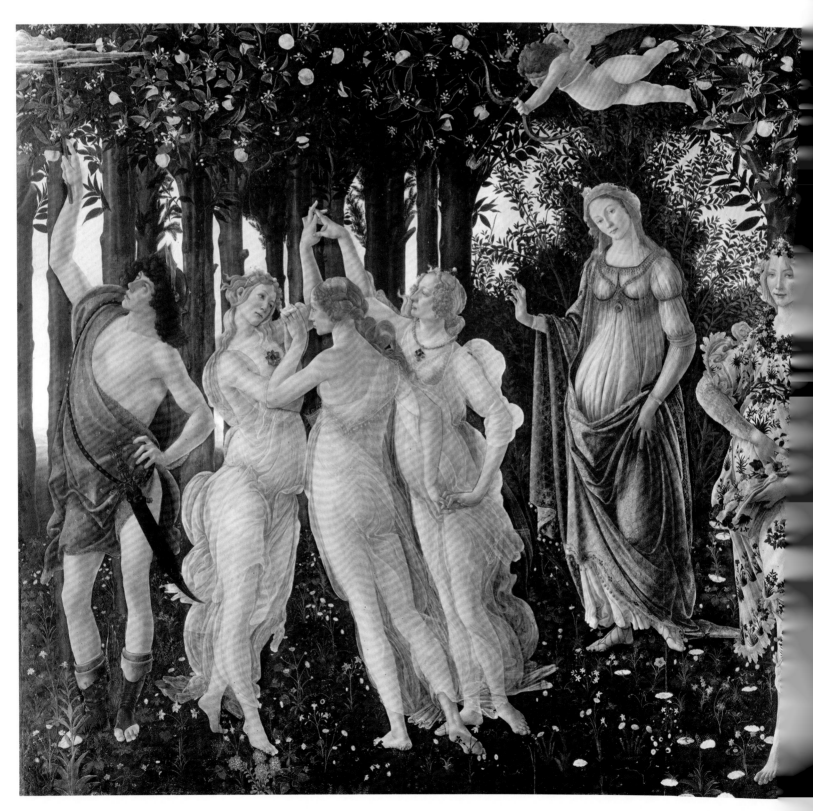

GODS AND GODDESSES

Why do you think this painting is called *Primavera*, which means "spring" in Italian?

These are gods and goddesses from ancient Greek and Roman mythology. Each person shows clues about who they are.

The gray-blue figure on the right is Zephyrus, the Greek god of the west wind. His strong, long wings help him move the wintry clouds away and bring in the warmer spring weather. Zephyrus is chasing a nymph named Chloris. As he captures her, her breath turns into flowers, which you can see falling from her lips. Once caught, Chloris transforms into Flora, the goddess of flowers and spring, wearing her flowery dress. The flowers spill from Chloris's mouth onto Flora's dress, and Flora scatters them onto the grass beneath their feet.

The woman in the middle of the painting is thought to be Venus, the goddess of love and beauty. Flying above her is her son, Cupid, aiming his bow and arrow at the Three Graces, Venus's helpers. And on the far left stands Mercury, the messenger of the gods. Some think he is pushing away the clouds with his caduceus (similar to a wand) to announce the arrival of spring.

How do you think Botticelli shows us that it is springtime?

Spring

LOUISE BOURGEOIS

Born: December 25, 1911 | Paris, France

KNOWN FOR

Giant sculptures, spiders, installation art, textiles, motherhood

ARTISTIC ARACHNIDS

This giant spider sculpture actually represents a person whom Louise Bourgeois loved very much. Who do you think it could be?

If you've ever admired a spiderweb, it's easy to see that spiders are talented weavers and artists. Similar to the way some artists make beautiful art by sewing or weaving, spiders are able to spin webs made of delicate and complicated designs.

Louise Bourgeois loved spiders. She drew, painted, and sculpted them throughout her life, but it wasn't until she turned 87 years old that she made her most famous one. This gigantic steel and marble spider is more than 30 feet tall and weighs about 8,000 pounds. That's as tall as two giraffes and as heavy as a hippopotamus!

The sculpture is called *Maman*, which means "mom" in French. On the bottom side of the spider's belly, there's a wire sac full of 17 white and gray marble eggs. These are her babies.

When Bourgeois was growing up in France, her family owned a shop that sold and repaired very old and rare antique tapestries. Tapestries are a kind of woven picture that can be hung on a wall. As a kid, she would sometimes help her mother by dyeing fabric or redrawing some of the sections that were damaged and needed repair. Bourgeois thought that her mother was clever, helpful, patient, and a talented weaver—just like a spider. She made this sculpture to celebrate her mother, who she said was her best friend.

What animal do you think you are most like?

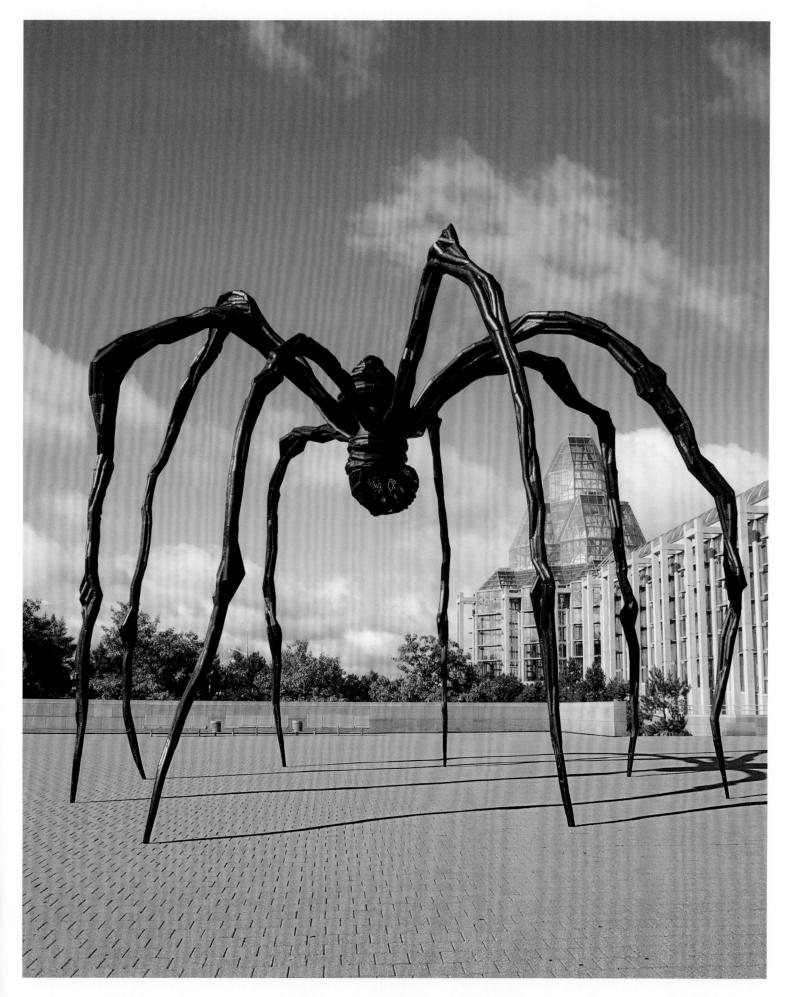

Maman

PIETER BRUEGEL THE ELDER

Born: Around 1525 | in or near Breda, Netherlands

KNOWN FOR | Busy scenes, stories, landscapes

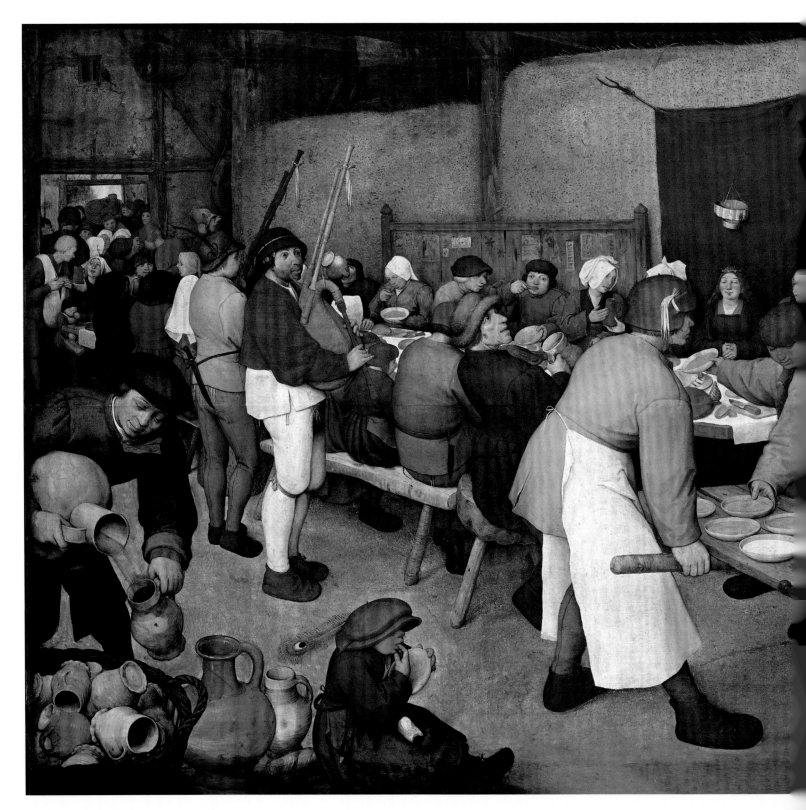

PARTY TIME!

This painting tells the story of a party. Can you guess what kind of celebration it is?

This isn't just any party—it's a wedding feast! Do you see how the yellow walls are stacks of hay bales? That's because this party is taking place in a barn. If you're looking for the bride, don't look for a woman dressed in white. She is sitting in front of the blue-green cloth and is wearing a black dress and a simple tiara. In those days the bride didn't sit next to her groom, so we don't know who her new husband is.

There are so many details in this lively picture: a bagpiper playing music, and people munching, gulping, and chattering—you can almost hear the noise! The musician in the red jacket has stopped playing to stare at the food being brought in, and a man grabs a full plate from the tray to pass to other guests at the long table. The food must be delicious. The child wearing a red, floppy cap with a peacock feather is eating every last bit on his plate with his fingers. Can you find a wooden spoon stuck in someone's hat? Look at the large tray that is being used to bring in the plates—it's actually an old door! You can see one of the hinges on the left-hand side.

Pieter Bruegel was a great storyteller, and, thanks to him, we have a sense of what life was like over 400 years ago.

Peasant Wedding Feast

ELIZABETH CATLETT

Born: 15 April, 1915 | Washington, D.C., USA

KNOWN FOR

Printmaking, sculpture, art focusing on Black American life

PRINTED PICTURES

Have you ever used a rubber stamp or carved your own potato stamp? Stamping a picture onto paper is similar to the way Elizabeth Catlett created this picture.

Elizabeth Catlett used printing to create pictures with amazing designs. She carved her own stamps by using a sharp tool to cut a design into the surface of a soft, rubbery material called linoleum. She then rolled ink onto the linoleum surface and pressed it down like a big stamp onto paper. She would print many copies on cheap paper so that her work could be shared with lots of people. Catlett believed that art should be inexpensive and available to many.

She often made prints that show the lives of women and Black Americans. This print is called *Sharecropper*. That's a word for a farmer who doesn't own land and must pay rent by giving landowners a share of the crops. After slavery ended in the United States, many Black families became sharecroppers to earn money. This way of working was often unjust to the farmers, who worked the land and had to give up more than they could afford. Catlett's picture shows a woman who worked as a sharecropper. She wears a big hat to block out the sun and a safety pin to keep her jacket fastened. The artist shows her respect by the angle of the portrait—we are looking up at the sharecropper—and her proud, tall pose.

If you designed your own stamp to share a story with lots of people, what would it look like? What would it be about?

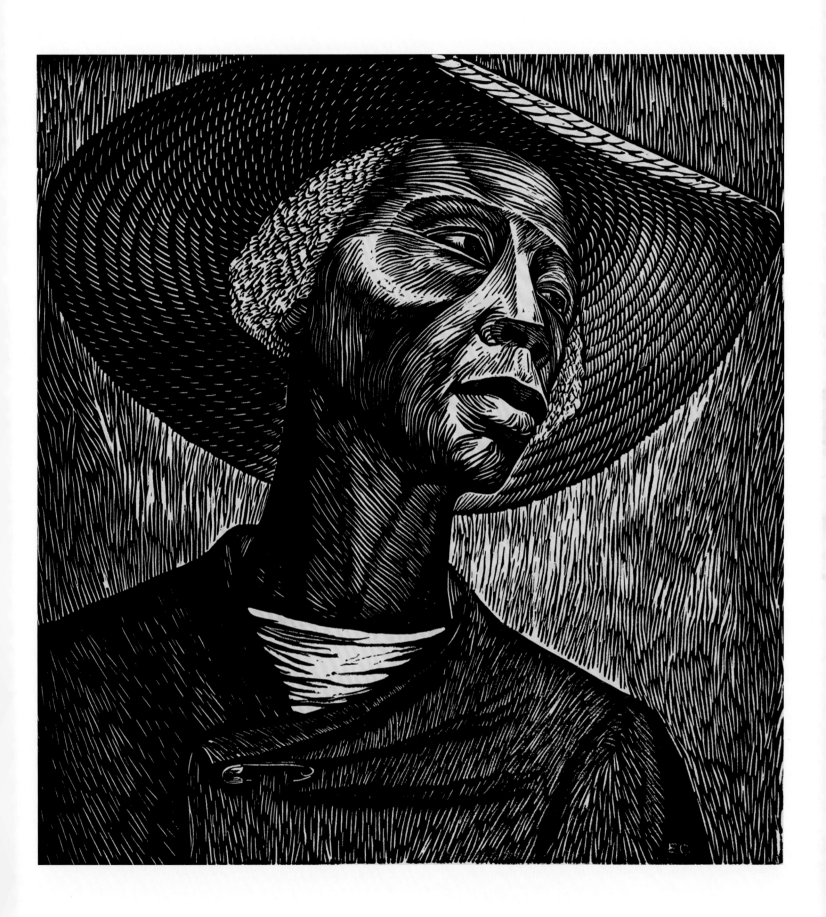

Sharecropper

JUDY CHICAGO

Born: July 20, 1939 | Chicago, USA

KNOWN FOR

Women in history, ceramics, textiles

FANTASY DINNER PARTY

If you could throw a party and invite anyone in the world—even people who were famous a long time ago—who would you choose? It would be a tough choice!

Judy Chicago thought hard about this question and turned her fantasy dinner party into a large work of art that celebrates extraordinary women from history, famous myths, and stories.

She made her table into the shape of a triangle with room for 13 women on each side—large enough for 39 guests. There are place settings for powerful rulers, like Egyptian Pharaoh Hatshepsut and England's Queen Elizabeth I, as well as 17th-century Italian painter Artemisia Gentileschi (see page 66) and modern American artist Georgia O'Keeffe (see page 118). The table is set on a tiled surface called the Heritage Floor with 999 more women's names inscribed on the tiles! On that list, there are many more fantastic

artists to explore, including Rosa Bonheur (see page 24) and Frida Kahlo (see page 88).

For each dinner guest, the artist set out a gold cup and utensils, a porcelain plate, a napkin edged in embroidery, and a specially designed table runner with their name hand embroidered in gold. The plates are unique to each woman, and many are sculpted to look like butterflies or flowers.

Creating this dream party was a massive project that took Chicago over five years and more than 400 helpers to complete. With the help of these needleworkers, researchers, and ceramicists, Chicago was able to make a celebration that would go down in history!

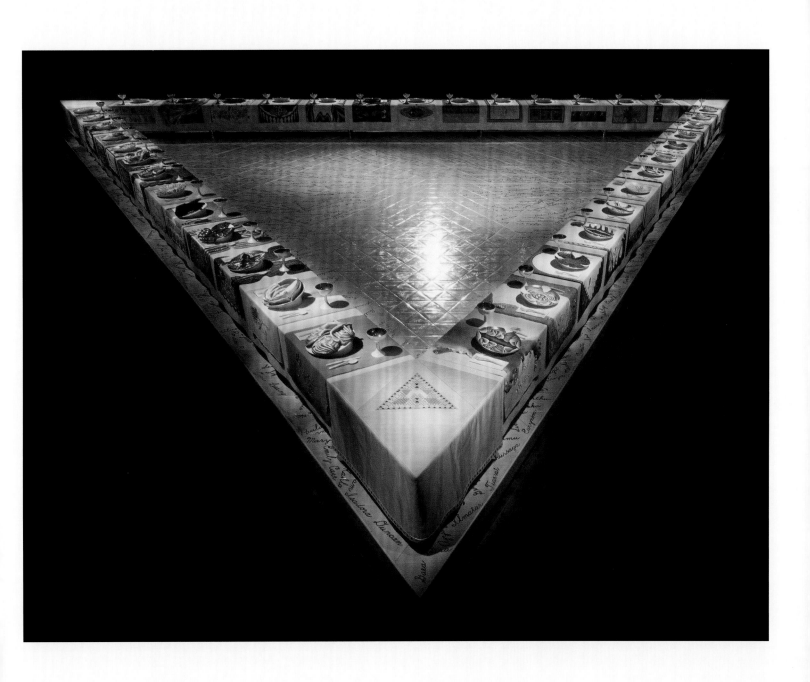

The Dinner Party

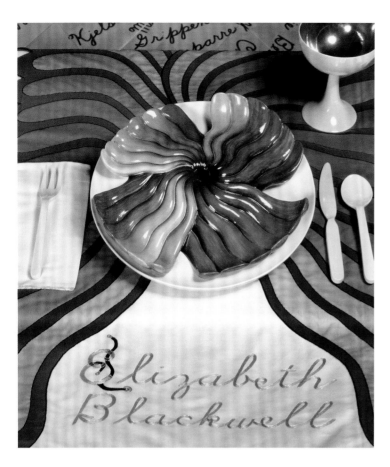

Elizabeth Blackwell was the first woman in the United States to receive a medical degree.

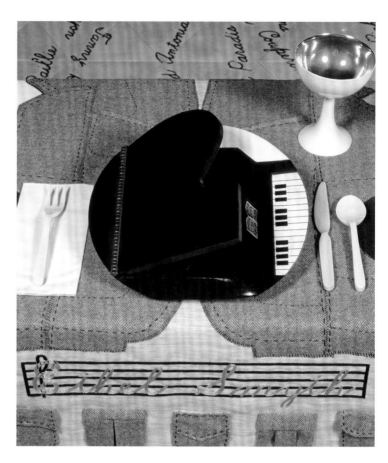

Ethel Smyth was a British composer and a champion of women's rights.

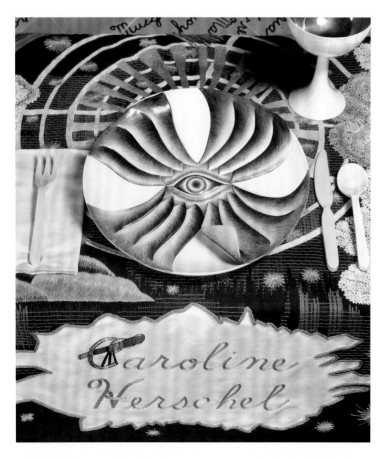

Caroline Herschel was an astronomer and the first woman to discover a comet.

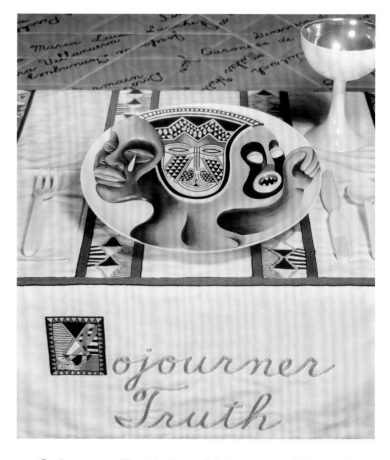

Sojourner Truth fought for equality and justice for African Americans and women.

GUESTS of HONOR

SIDE 1

PRIMORDIAL GODDESS
Goddess of the
earth and nature

FERTILE GODDESS
Goddess of the
creation of life

ISHTAR
Ancient Mesopotamian
goddess of love and war

KALI
Powerful Hindu goddess
of time, change and death

SNAKE GODDESS
Mysterious goddess
worshipped in ancient Crete

SOPHIA
Goddess who
represents wisdom

AMAZON
A group of powerful
female warriors

HATSHEPSUT
Longest-reigning female
pharaoh in Egyptian history

JUDITH
Biblical hero, who saved
her city from an attack

SAPPHO
Ancient Greek poet, who
wrote many love poems

ASPASIA
Ancient Greek scholar, who
started a school for girls

BOADACEIA
British warrior queen, who
fought the Romans

HYPATIA
Early Egyptian teacher of mathematics,
philosophy, and astronomy

SIDE 2

MARCELLA
Roman Christian who
was considered a saint

SAINT BRIDGET
Female patron saint of Ireland
who set up convents for nuns

THEODORA
Byzantine empress who
supported women's rights

HROSVITHA
Medieval German nun who is the
earliest known female poet in Germany

TROTULA
Medieval Italian doctor who specialized
in women's health and childbirth

ELEANOR OF AQUITAINE
Rich and influential queen of France
and England during medieval times

HILDEGARD OF BINGEN
Medieval German nun who wrote books
about the study of God and medicine

PETRONILLA DE MEATH
First Irish woman to be accused of
witchcraft and burned at the stake

CHRISTINE DE PISAN
Writer and poet at the
French royal court

ISABELLA D'ESTE
Italian ruler and
patron of the arts

ELIZABETH R.
Long-reigning queen of England
during the Tudor age

ARTEMISIA GENTILESCHI
Italian artist who painted dramatic scenes
using light and shadow (see page 66)

ANNA MARIA VAN SCHURMAN
First female university
student in the Netherlands

SIDE 3

ANNE HUTCHINSON
Puritan who was banished
for questioning male authority

SACAJAWEA
Enslaved Native American who
guided an expedition of North America

CAROLINE HERSCHEL
German-born British astronomer and
the first woman to discover a comet

MARY WOLLSTONECRAFT
Wrote one of the earliest publications
championing women's rights

SOJOURNER TRUTH
Formerly enslaved woman who fought
for Black Americans' freedom

SUSAN B. ANTHONY
American who fought
for women's right to vote

ELIZABETH BLACKWELL
First female doctor
in the United States

EMILY DICKINSON
Fiercely independent American
poet who wrote by her own rules

ETHEL SMYTH
British composer and
champion of women's rights

MARGARET SANGER
American activist who taught
women about their bodies

NATALIE BARNEY
American writer who lived in
Paris and brought writers together

VIRGINIA WOOLF
Experimental British writer who
believed in equal rights for women

GEORGIA O'KEEFFE
Artist who painted bold and vibrant
landscapes (see page 118)

CHRISTO & JEANNE-CLAUDE

Born: June 13, 1935 | Gabrovo, Bulgaria
Born: June 13, 1935 | Casablanca, Morocco

KNOWN FOR

Wrapping things in fabric, large-scale installations, environmental art

ALL WRAPPED UP!

We normally wrap things to hide or protect them. When Christo and Jeanne-Claude wrapped things, they drew our attention to them!

Christo and Jeanne-Claude have wrapped many surprising things in fabric. In 1980–83, they wrapped the coastlines of 11 islands in Biscayne Bay, Miami, Florida, in shiny pink fabric! For 14 days, these islands, which had been ignored and very badly looked after, became beautiful shapes, like flowers floating on a lily pond. But what you see is only one part of the whole project. Most of their time was spent on planning! They had to secure permissions from eight different people and institutions, including the governor of Florida, the City of North Miami, the US Army Corps of Engineers, and local environmental organizations. Their crews removed 40 tons of garbage

from the islands in the bay and eventually constructed nine enormous pink "belts," which fit snugly around the islands and floated on the water's surface. (Seven of the islands each had its own belt, and two pairs of islands each shared a single belt).

We know what Christo and Jeanne-Claude's artworks look like from photographs, but a large part of their work is invisible. It might take them many years to make a work of art, and the research and preparation are a critical part of their creative process. Christo creates drawings, collages, and scale models. They negotiate and seek necessary permissions. The organizing is just as much a part of the art as the work itself.

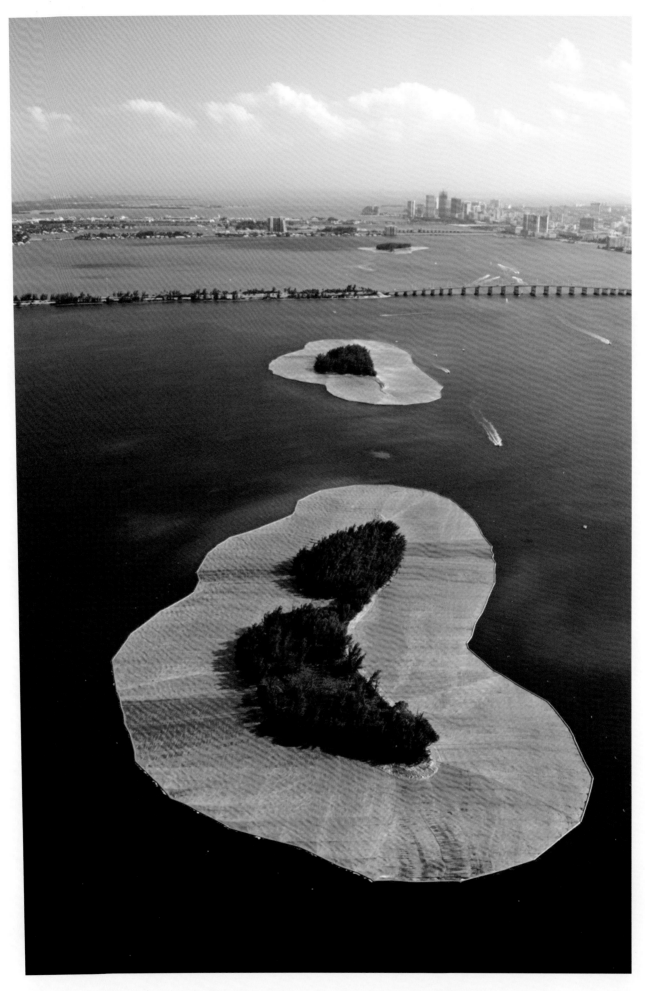

Surrounded Islands, Biscayne Bay, Greater Miami, Florida

Who allowed Christo and Jeanne-Claude to wrap this famous Parisian bridge in fabric?

Did they sneak up one night while no one was looking? Absolutely not! It took 10 years of preparation, 300 skilled workers, 439,989 square feet of fabric secured by eight miles

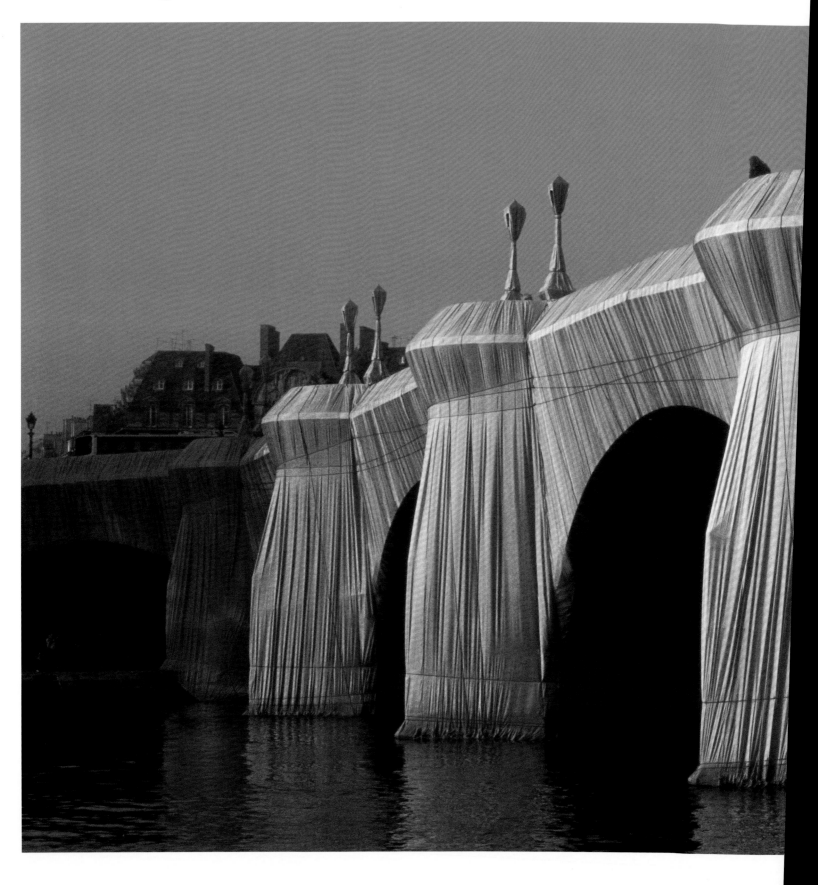

of rope, and eight permits from the Mayor of Paris, Ministry of Culture, Police Department, Fire Department, River Traffic Department, and National Historic Monuments Department!

The monumental sculpture lasted for only 14 days, during which time the bridge looked totally different, but boats still sailed under it and people and cars still walked and drove across it.

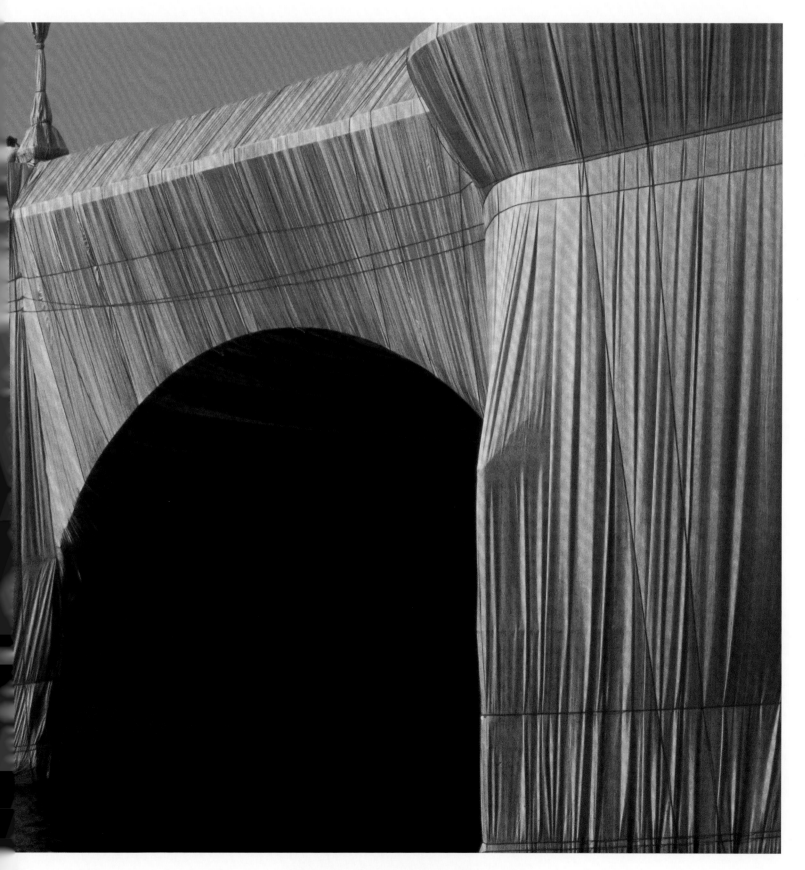

The Pont Neuf Wrapped, Paris

SALVADOR DALÍ

Born: May 11, 1904 | Figueres, Spain

KNOWN FOR

Surrealism, dreams

CAMEMBERT CLOCKS

Melting clocks and strange faces. Nothing that Salvador Dalí painted seems to behave like it should. Instead, Dalí made art that was inspired by dreams.

Like René Magritte (see page 102), Salvador Dalí was a Surrealist artist. This means many of his paintings seem to be dreamlike. He got the idea to paint these drooping clocks from thinking about melting Camembert cheese. Each clock is almost like a little wheel of cheese softening in the hot sun.

We usually think of clocks as hard objects, just like we think of time as having a fixed set of rules. In this fantasy world, time seems to work differently. These clocks are ripe, and bugs are eating them—maybe time doesn't even exist in this place!

Look at the full painting on the next page. Do you notice that odd shape in the middle of the painting? It's a strange creature that appears to be sleeping. Its eye is closed, showing off long lashes. It's difficult to know for sure, but it looks like the creature has a nose, eyebrow, and a tongue sticking out. Some people think this is a sort of self-portrait of Dalí. A self-portrait is when an artist makes a picture of themself. Do you think this creature is the one who is having the dream we're seeing?

Dalí's paintings are unlike anybody else's. It is sometimes said that once you've seen this image, you'll never forget it. Do you think you'll ever forget it, now that you've seen it?

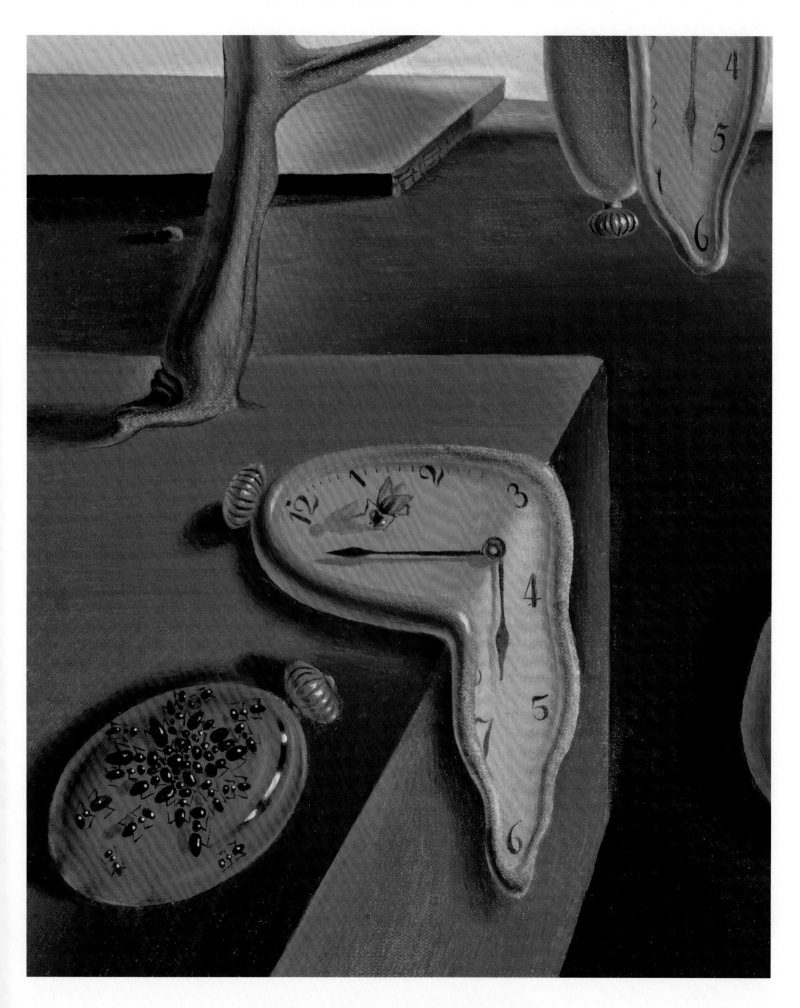

Detail of *The Persistence of Memory*

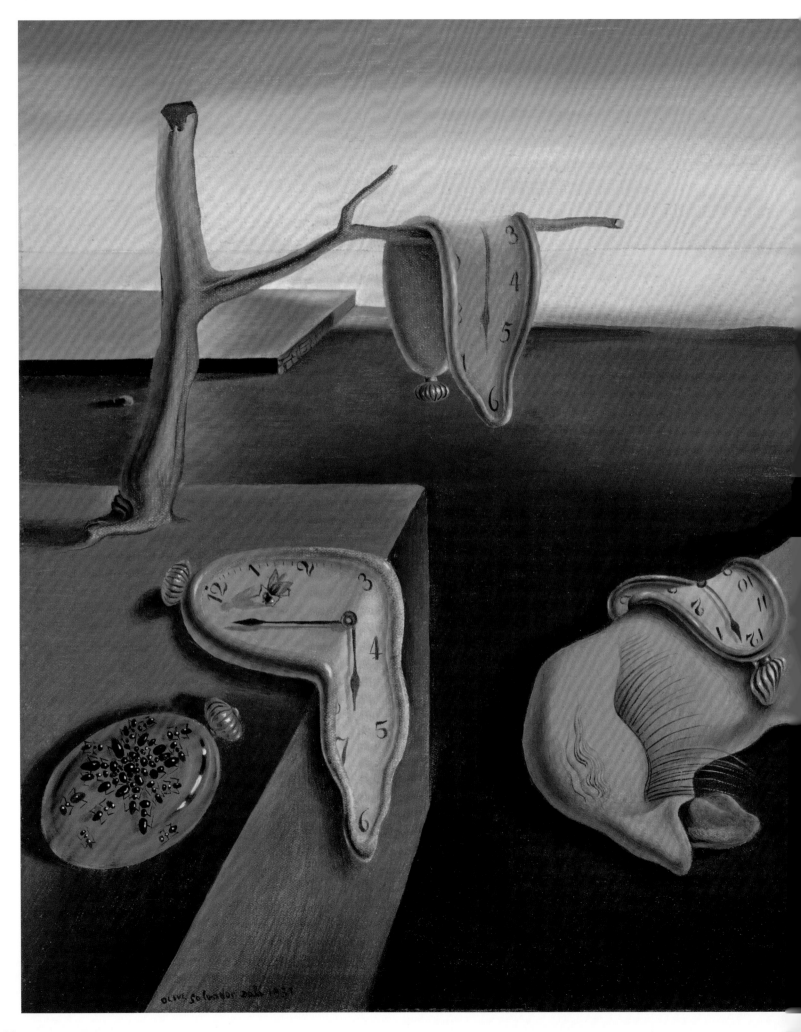

The Persistence of Memory

EDGAR DEGAS

Born: July 19, 1834 | Paris, France

KNOWN FOR | Ballet dancers, pictures from odd angles, Impressionism

In most paintings, the main subject is in the center of the picture—but at the middle of this picture are floorboards!

This painting of ballet dancers rehearsing is not posed or perfectly centered. In fact, all the action is taking place toward the edges of the painting, and perhaps even outside it.

The girl sitting with her feet apart on the right seems to be more interested in something that is happening outside the picture frame. She might be looking at her friend on the far right, who is only half in the picture. We can't even see the friend's face and hands properly, so we don't know what she is doing. Another ballerina is hidden by the spiral staircase— only her legs and the corner of her skirt are visible—and there's another dancer, a few steps up, who is just about to walk down the staircase into the picture.

None of these figures, half in and half out of the picture, is positioned this way by chance: Edgar Degas has composed this painting very carefully to make it seem as if he has quickly and quietly taken a photograph of them on the go. The artist spent a lot of time observing real life, making sketches, and carefully working out how he would arrange the figures.

The Rehearsal

WHERE'S THE SUBJECT?

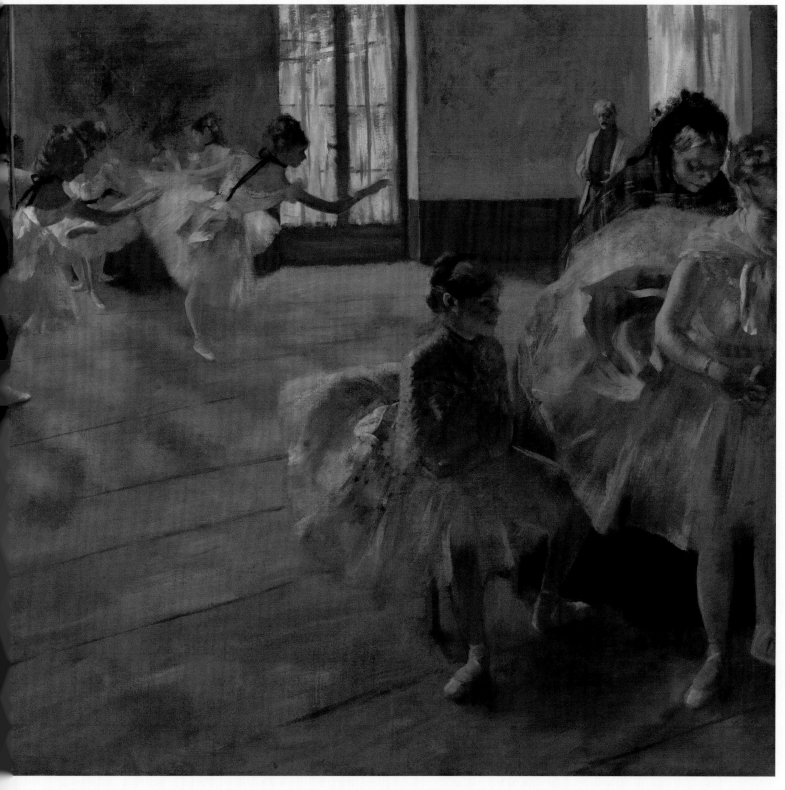

KNOWN FOR

Landscape art

A HOPEFUL LANDSCAPE

If you were asked to find or create a picture that represents hope, what would you show?

This painting by Robert S. Duncanson shows two people walking in a beautiful pasture with a bright sky, rolling hills, grazing cows, and a lovely river. The man is pointing, as if to tell us where they are going. Turn the page and you'll see where! A rainbow gleams across the sky, shining directly onto a little house hidden in the trees. Perhaps the couple lives there. Do you see how the clouds are slightly pink and the sun shines low in the background? That's because it's sunset and everyone—including the cattle— is heading back home for the day.

Duncanson wanted to show us the beauty of where he lived, near the Ohio River. Artists creating grand American landscapes around this time were inspired by the growing popularity of large, dramatic pictures of nature, many by artists in Europe, such as J. M. W. Turner (see page 170). Duncanson visited Europe many times throughout his life to travel and study.

Duncanson was one of few free Black men who developed a successful career as an artist during the time of slavery in the United States. He made this painting shortly before the Civil War, a period when the northern American states fought against the southern states to end slavery. He included the rainbow because rainbows often appear after storms. Storms can be a symbol of difficult times but in many cultures and countries, rainbows are a symbol of hope.

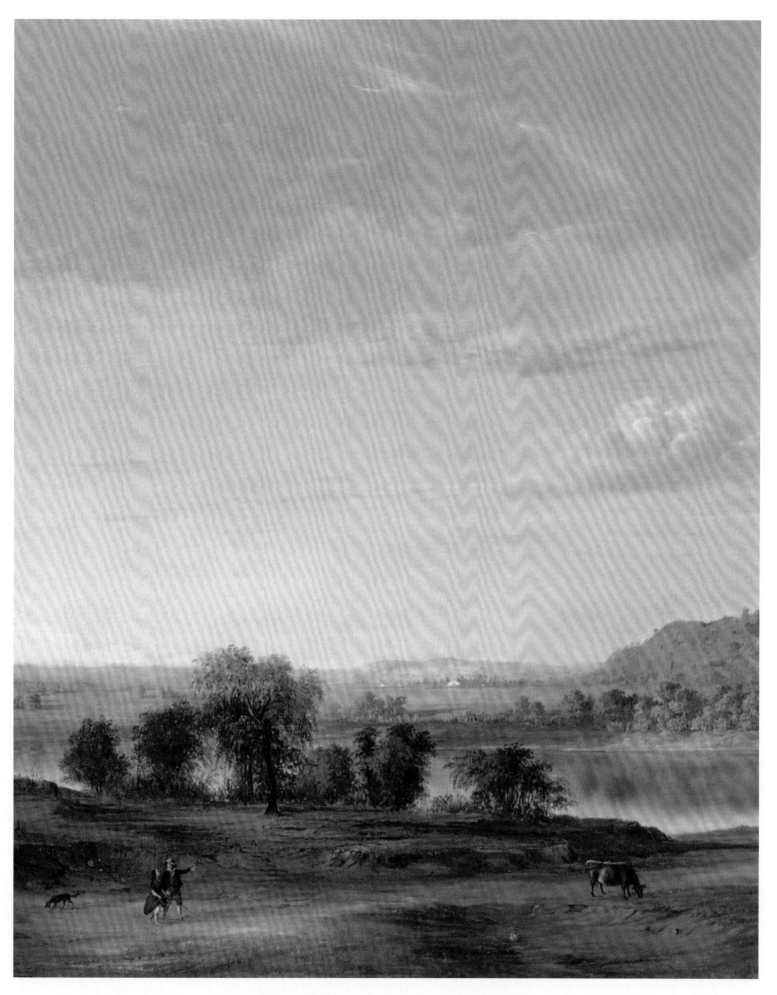

Detail of *Landscape with Rainbow*

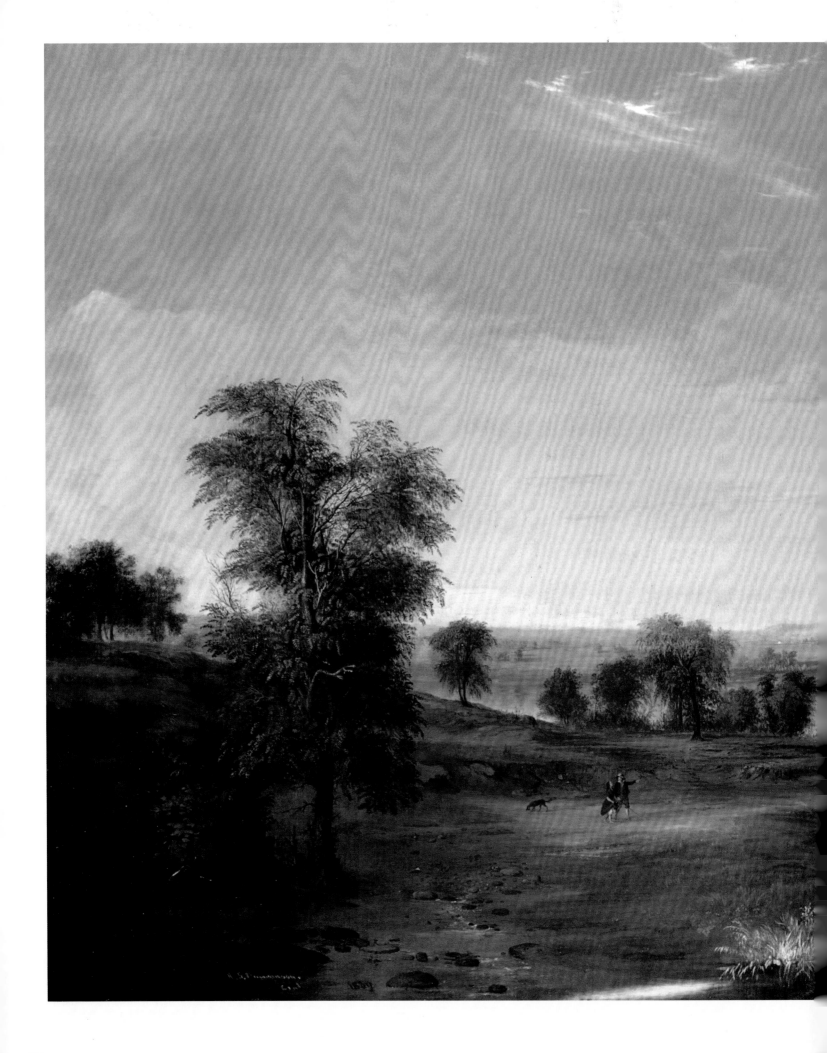

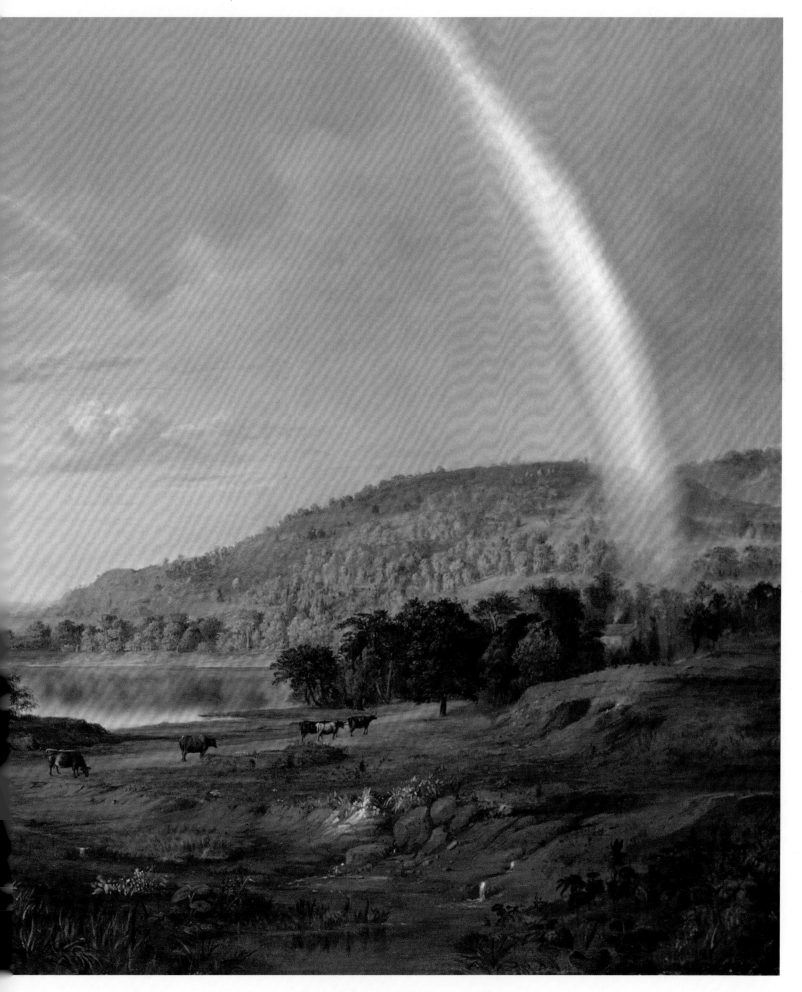

Landscape with Rainbow

ALBRECHT DÜRER

Born: May 21, 1471 | Nuremberg, Germany

KNOWN FOR

Self-portraits, Renaissance painting

GUESS THE AGE

Did you know the first selfies were painted and drawn? Here are four self-portraits by the same artist, made at different times of his life. Can you guess the order from youngest to oldest?

Here are some clues: Albrecht Dürer made these self-portraits (pictures he made of himself) when he was 13, 22, 26, and 28. In the drawing from when he was 13, he has no facial hair and appears young. In the portrait from when he was 22, he looks a little nervous, is clean-shaven, and holds a plant. When he was 26, he painted a self-portrait after he had been on a journey that took him across snow-capped mountains. In the picture with him at his oldest, he is facing directly towards us instead of sitting at an angle. What other similarities and differences can you spot across the four self-portraits?

The way an artist paints themselves can tell us about their life and how they saw themself at that time. For example, when Dürer was 26, he is dressed nicely in clothes that a rich gentleman might wear. This self-portrait shows that he felt confident and that he believed artists should be treated with respect. In the picture he made when he was 28, the background is black, so we focus our attention on the artist. Portraits at this time usually showed subjects turned slightly to the side, like he is positioned in the first three pictures, but in this later one, Dürer faces forward. In which portrait do you think the artist looks the most confident?

Look back at selfies you've taken over the years. How have you changed?

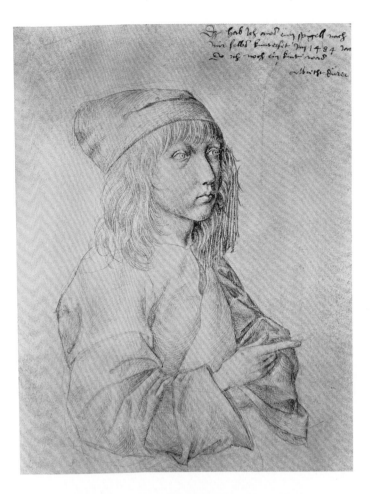

Self-portrait at ?? years old

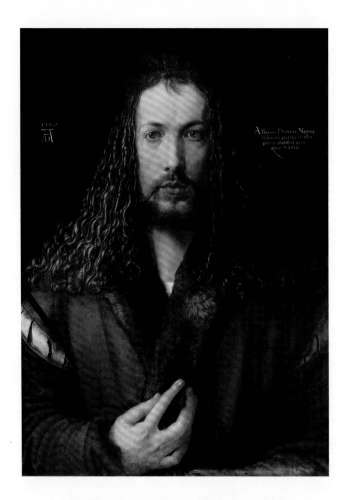

Self-portrait at ?? years old

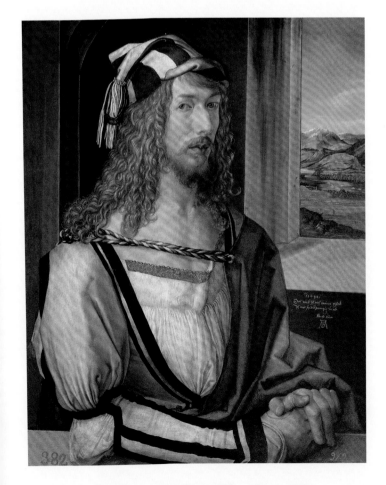

Self-portrait at ?? years old

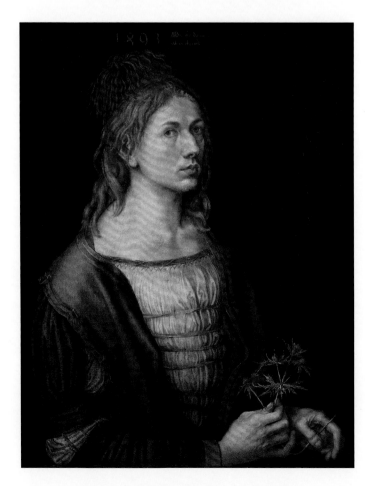

Self-portrait at ?? years old

JAN VAN EYCK

Born: Around 1390 | Maaseik (now Belgium)

KNOWN FOR

Realistic paintings, details, portraits

SHOWING OFF?

This picture shows just how good Jan van Eyck's painting abilities were. He was so proud that he signed his name on the back wall to make sure everyone knew who had painted it!

Jan van Eyck painted this wealthy couple so that he can tell us more about them. The man in this painting is thought to be Giovanni di Nicolao Arnolfini, an Italian merchant who traded beautifully made cloth. To show us Arnolfini's interest in fabric, van Eyck included many different types of cloth and painted them in great detail.

Arnolfini's robe is trimmed with soft fur and his wife wears a white headdress trimmed with lace. Her heavy green gown, with its pleated bodice, has fancy sleeves—and is also edged with fur. Beneath her green flowing robe, Arnolfini's wife is wearing a beautiful blue dress that looks as if it is made of satin. She is standing in front of a woven carpet, and the bed behind her is covered in a rich red bedspread. Everything is painted in great detail—even the hairs on the little dog at their feet.

The artist may have been showing off a little in this picture. He and his brother, who was also an artist, invented a way of mixing paints and linseed oil that enabled them to paint the tiniest details. This picture shows us just how good his technique was! He was so proud that he wrote "Jan van Eyck was here" in Latin at the center of the back wall to tell everyone that he painted it.

Next time you make a piece of art, don't forget to sign it like van Eyck did!

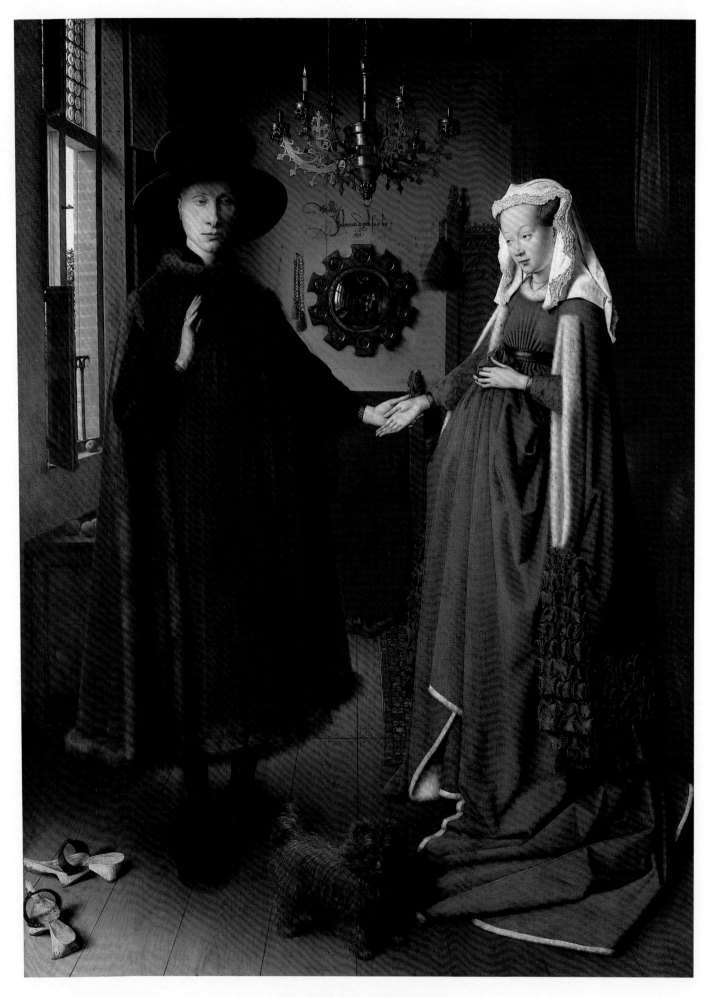

The Arnolfini Portrait

MONIR SHAHROUDY FARMANFARMAIAN

Born: January 13, 1923 | Qazvin, Iran

KNOWN FOR

Geometric patterns, mirrors, mosaics, traditional Iranian art

SHINING SYMMETRY

Sometimes we can revisit old traditions using modern ideas to create something entirely new. Prepare to be dazzled by geometric designs twinkling like a diamond!

Have you ever looked through a kaleidoscope? The bright geometric patterns are similar to Monir Shahroudy Farmanfarmaian's mosaics, which are made with lots of small pieces of mirror glass. She was inspired to create them after visiting the Shah Cheragh mosque (a Muslim place of worship) in her home country of Iran. The inside of this shimmering mosque is covered in countless pieces of mirror and glass to reflect light around the room.

If you were to fold her sculpture *Third Family Hexagon* in half, it would look the same on both sides—that's called symmetry. Many of Monir's artworks are symmetrical and have repeating patterns. She worked with skilled craftspeople from Iran to cut the triangles, squares, and hexagons for her mosaic designs. The shapes, patterns, and techniques used in her artworks all have a connection to designs found in many traditional mosques.

For another artwork called *Lightning for Neda* (on the next page), the artist used more than 4,000 pieces of mirror arranged in hexagonal patterns. She created this piece to honor a young woman named Neda Soltani, who died during protests in Iran. The six sides of the hexagon and the six sections that make up the work represent the six positive qualities of generosity, self-discipline, patience, determination, insight, and compassion.

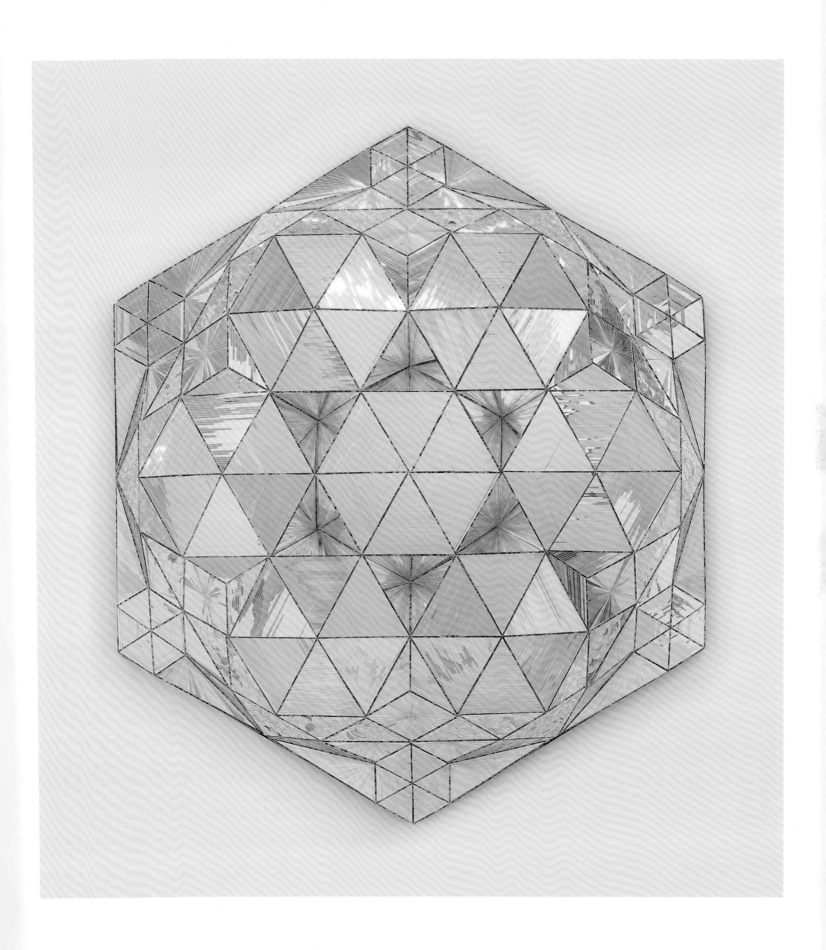

Third Family Hexagon

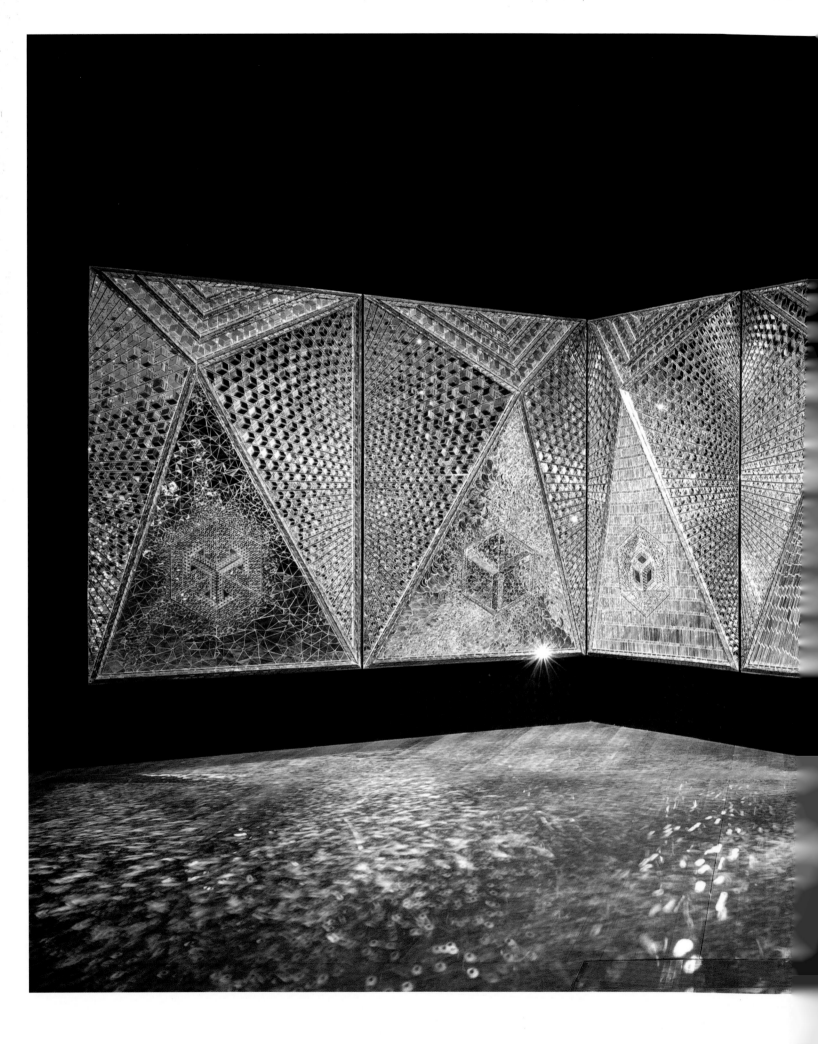

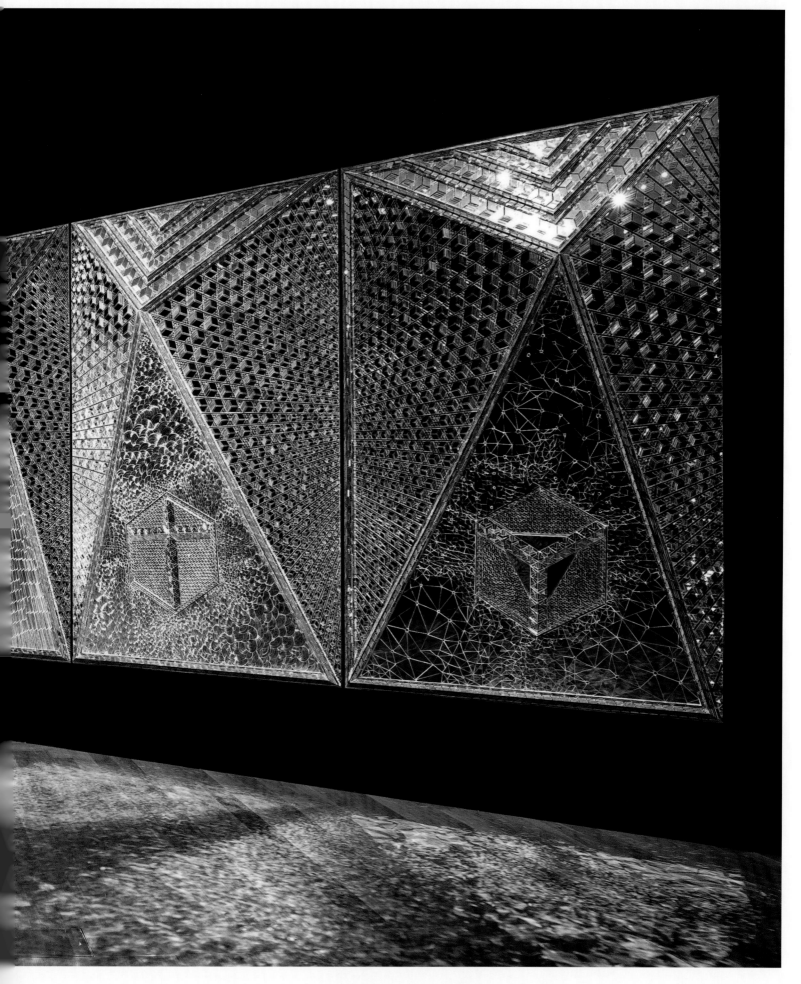

Lightning for Neda

HELEN FRANKENTHALER

Born: December 12, 1928 | New York, USA

KNOWN FOR

Abstract Expressionism, soak stains, bold colors

SOAK IT IN

Stains on your favorite clothes can be a pain, but Helen Frankenthaler created her own art technique that welcomes spills and stains!

Have you ever knocked over a glass of juice and made a big stain? Once a drink lands in your lap or on the carpet, it can soak into the fabric more quickly than you can wipe it up. But is that a disaster? Not always!

Helen Frankenthaler stained things *on purpose*. She would pour watery liquid paint onto giant canvases on the floor, then let the pools of color sink into the material. This technique is called "soak-stain." To make sure the paint was nice and runny, she mixed it with a special liquid called turpentine. Sometimes she poured the paint and let the colors soak into pools on the canvas. Other times she would push them around with a brush or various tools to spread

the paint, or she tilted the canvas to move the paint around. Turn the page to see her at work!

Frankenthaler painted in an abstract (not lifelike) style, but she was inspired by nature and the outdoors. What can you see in this painting?

It's called *Flood* and is meant to look a little like a landscape. Can you see how the blue looks like water and the green could be hills or mountains? There's even a tiny strip of brown at the bottom that could be a sandy stretch of beach.

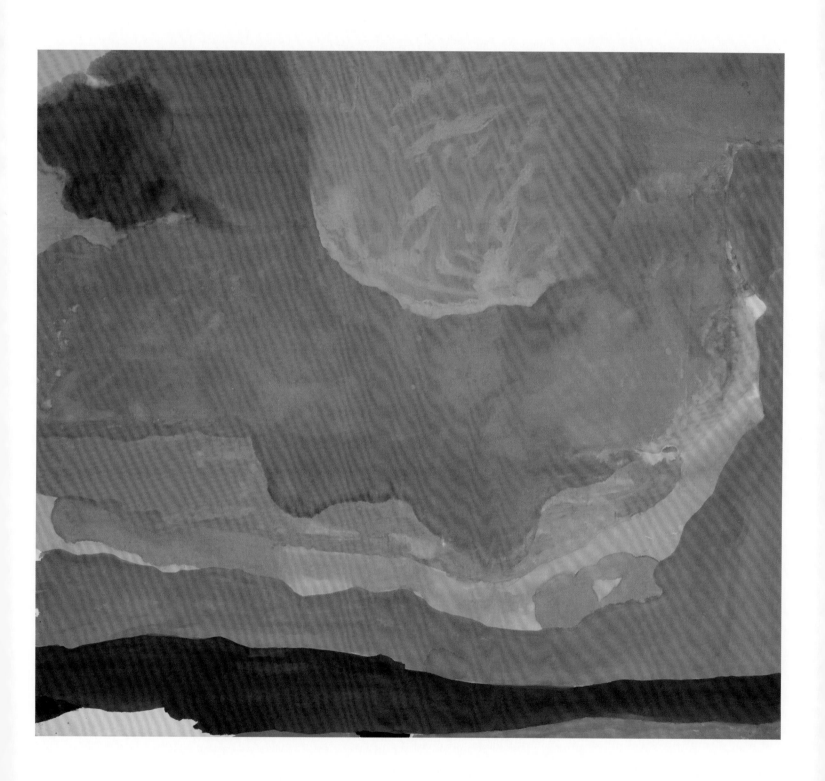

Flood

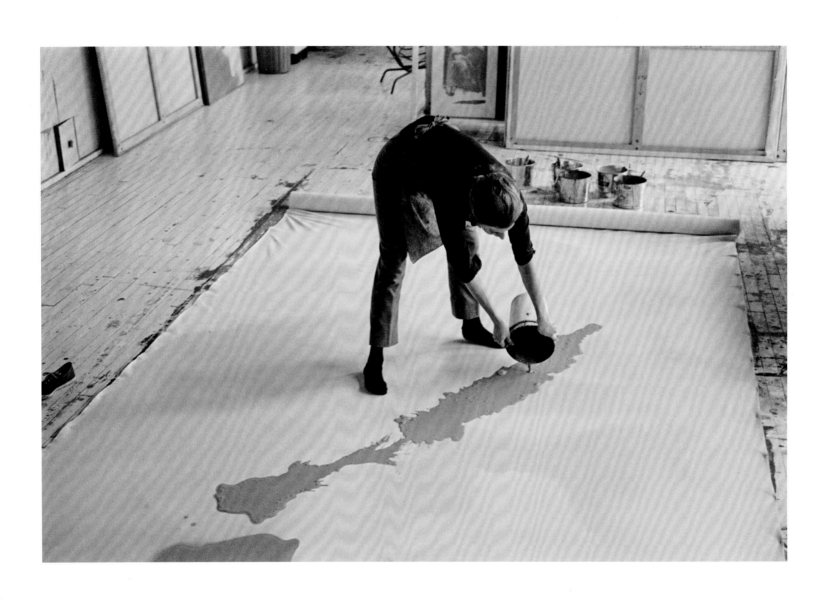

Helen Frankenthaler at work in her studio

ARTEMISIA GENTILESCHI

Born: July 8, 1593 | Rome, Italy

KNOWN FOR

Dramatic paintings, powerful women, biblical and mythological stories

DRAMA

Lights, paintbrushes, action! Artemisia Gentileschi combined powerful storytelling with dramatic lighting to create emotional, action-packed pictures.

What is happening to the woman wearing the gold dress in this painting? She has fainted, and her maids caught her just in time! This painting by Artemisia Gentileschi captures a moment from the biblical story of Esther. When Esther—a Jewish woman married to the Persian King Ahasuerus—heard that her husband's chief minister was plotting to attack her own people, she ran to him for help. At the time, no one could see the king without an invitation. She was so nervous that she fainted! Despite this, Esther's husband was inspired by her bravery and called off the attack.

Do you notice how Esther and the king look like there's a spotlight shining on them in this painting? Gentileschi is known for using this dramatic painting technique—it's called tenebrism. That's when an artist makes some areas of a painting look like they are lit by a very bright light while keeping other areas of the picture in dark shadow. This makes the painting look especially moody and emotional.

Like the women in her paintings, Gentileschi was also very courageous. Few women in the 17th century were allowed to train to be an artist but that didn't stop her! She first learned how to paint from her father when she was a teenager and moved to Florence to become the first woman to study at the Academy of Design. She went on to have a long and successful career as a painter.

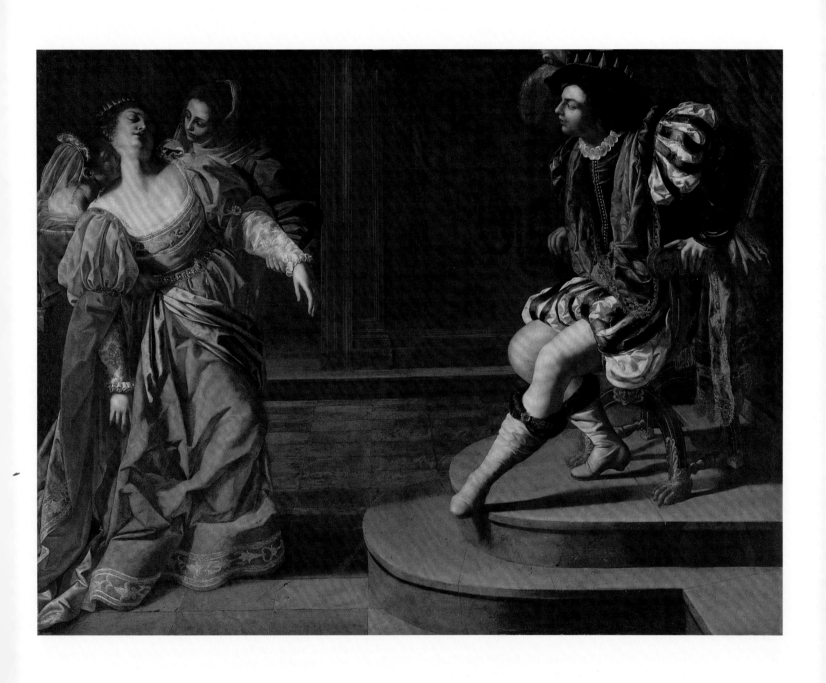

Esther before Ahasuerus

ALBERTO GIACOMETTI

Born: October 10, 1901 | Borgonovo, Switzerland

KNOWN FOR

Skinny sticklike sculptures

FROZEN IN TIME

This man looks like someone pressed pause while he was walking. If someone were to make a sculpture of you frozen in time, what would you want it to look like?

Giacometti made skinny sticklike figures that are like no other sculptures—you can recognize them instantly.

This man looks like he may have been buried under the ground for years and discovered during an archaeological dig. It even looks like he has started to fall apart, with bits of the bronze worn off over time. In fact, he has never been buried; Alberto Giacometti chose to make him look like this.

Instead of carving away at huge pieces of stone or wood to create his figures, which was the traditional way to make a sculpture, Giacometti did the opposite: he used thin rods of metal

to make a frame in the same shape as the sculpture he wanted to create. Then, bit by bit, he slowly added small chunks of clay to the metal frame, to "grow" his figure. This is what gives his works their lumpy texture.

This man has long, thin arms and legs that make him appear very fragile. There's very little we can tell about him. We don't know if he's old or young, smiling or thoughtful, happy or sad.

How does this sculpture make you feel? Why do you think Alberto Giacometti froze him in this position?

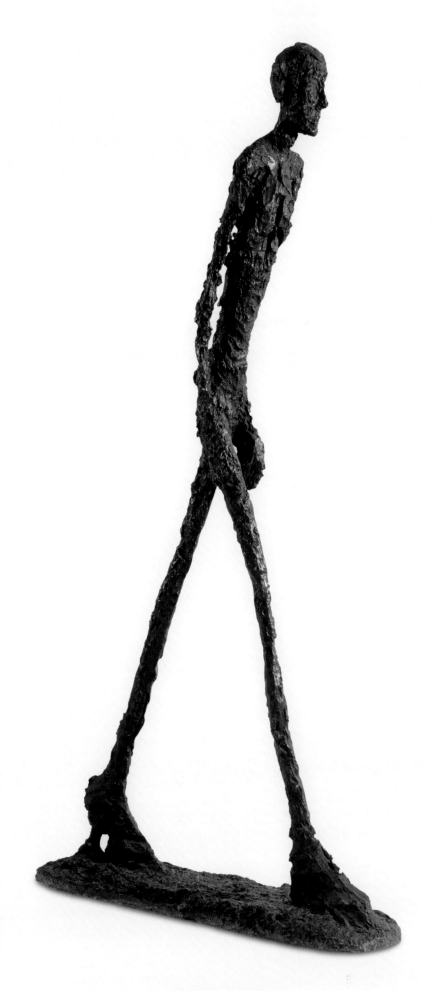

Walking Man

VINCENT VAN GOGH

Born: March 30, 1853 | Zundert, the Netherlands

KNOWN FOR

Bold colors, expressive brushstrokes, painting emotion, self-portraits

YELLOW

How many tubes of yellow and orange paint do you think Vincent van Gogh used to make this picture?

The flowers, the vase, the table, and the wall are all yellow or orange. Vincent Van Gogh must have liked the color a lot. In fact, he painted lots of artworks with yellow as the main color during his stay in the sunny south of France. He must have used a lot of paint for this sunflower picture. Can you see how thick it is? If you ran your fingers over the surface of the picture in real life, you'd be able to feel its bumps, ridges, and dips. The artist squirted paint straight from the tube onto the canvas and made patterns in it with the hard end of his brush.

Have you ever set out flowers to make a room look more beautiful? These flowers were painted for a similar reason. When his friend, the artist

Paul Gauguin, made plans to stay with him, Van Gogh decorated the guest room with two sunflower paintings. To him, sunflowers were happy and made him think of gratitude.

If you were going to paint a vase of flowers for a friend, what kind of flowers would they be? Would you paint the whole picture by using different shades of the same color?

Van Gogh painted four pictures of sunflowers but only added his signature to some of them. Can you find his signature here? He has signed it with only his first name, Vincent. How do you sign your paintings?

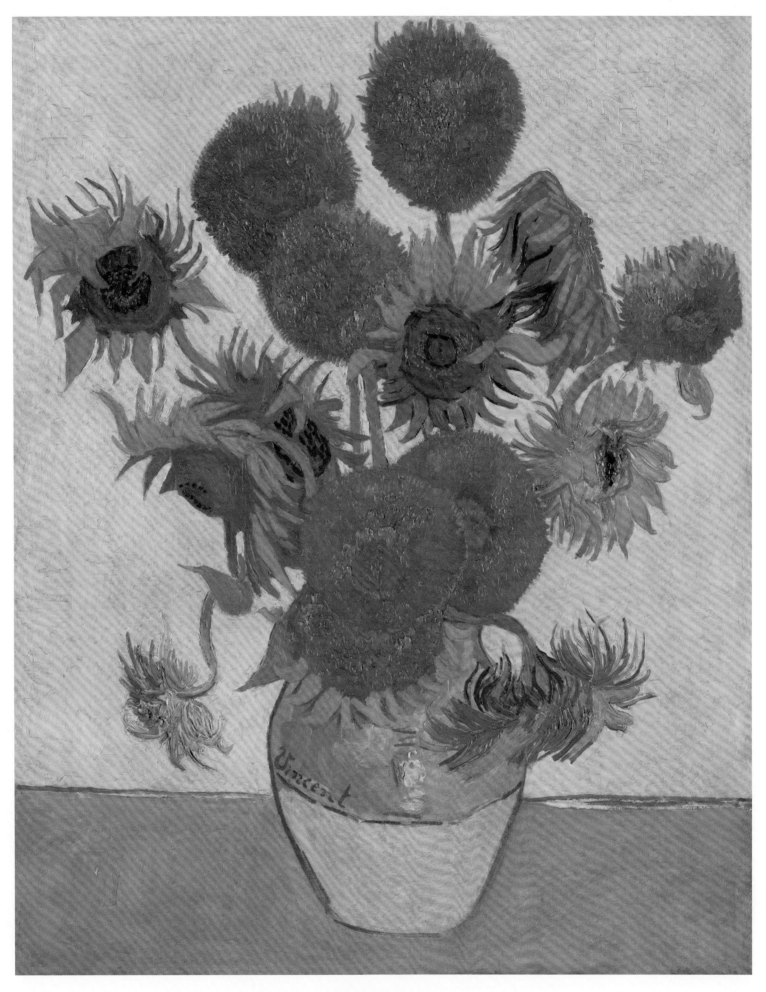

Sunflowers

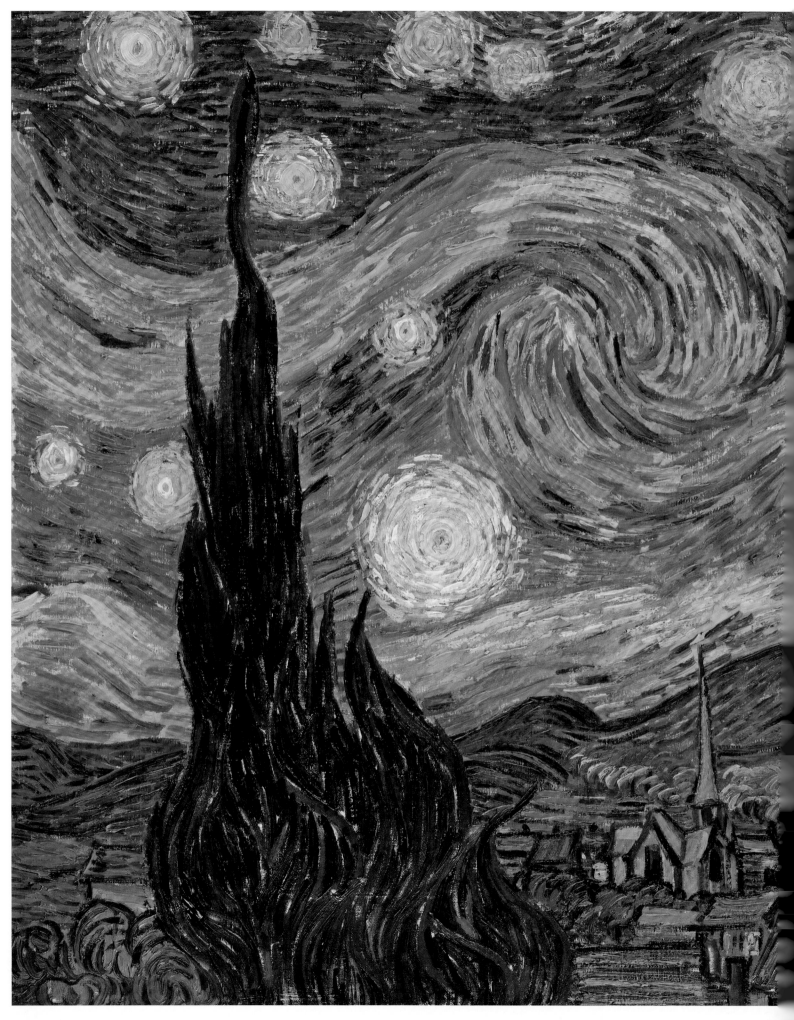

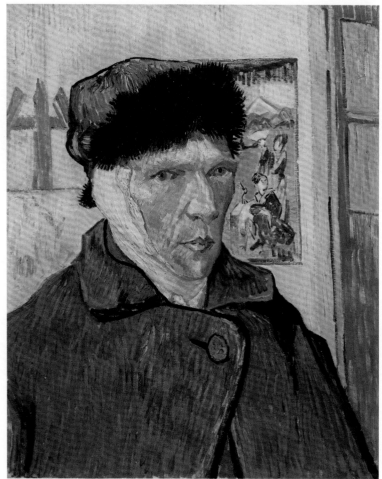

Van Gogh painted more than 35 self-portraits (pictures of himself) in his lifetime. He didn't have much money to pay for models, so he painted himself to practice. Many think he also painted himself when he wanted to spend time exploring his own thoughts and feelings.

Sometimes Van Gogh experienced very strong emotions and would feel sad or upset for long periods of time. He painted this self-portrait and picture of the village where he lived after a particularly difficult time. You can see his signature thick yellow paint, and big brushstrokes.

This swirling, blue landscape is called *The Starry Night*. Some people think this is a painting of hope—that even in a dark night, there are shining stars lighting the sky. What do you think he was feeling when he painted this?

The Starry Night (left), *Self-Portrait* (above)

FÉLIX GONZÁLEZ-TORRES

Born: November 26, 1957 | Guáimaro, Cuba

KNOWN FOR

Conceptual art, wrapped candies, sculptures

PLEASE TOUCH THE ART

When you are in an art gallery, you usually have to be very careful not to touch the art that is on display. Félix González-Torres not only wants you to touch the art but also to take a piece home with you.

This pile of brightly colored candies represents a person. His name was Ross Laycock and he was the artist Félix González-Torres's boyfriend. Sadly, Ross died from an AIDS-related illness.

The pile of candies is a unique portrait of Ross. It weighs 175 pounds, which is meant to represent what Ross was supposed to weigh. Even though the candies don't tell us about Ross's character or what he looked like, it makes us think about Ross.

González-Torres wanted people to feel free to touch the pile and to take one of the colorful treats for themselves. As people took the candies away, Ross's portrait slowly disappeared. This could make people think about how it feels to lose a loved one. But taking a candy is also like taking a piece of Ross away with you. It's a memento, which can be a nice way to remember him. González-Torres must have loved Ross very much. It's as if he wanted other people to share Ross with him.

There's no need to worry that this portrait will eventually disappear. After some candies are taken away, more candy is added, and the pile grows back. These changes are similar to the emotions we may experience when people we know die. We can feel very sad from missing that person, but we can also keep the happy memories of them in our minds to cherish forever.

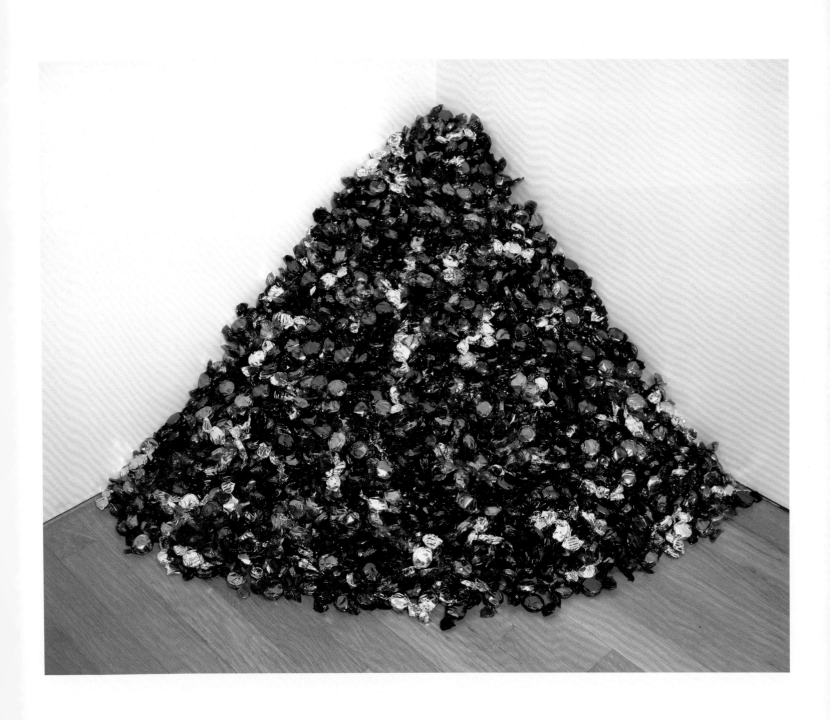

"Untitled" (Portrait of Ross in L.A.)

DAVID HOCKNEY

Born: July 9, 1937 | Bradford, United Kingdom

KNOWN FOR

Painting, photography, drawing, printmaking, stage design

SPLASH

Who made the splash? Are they still in the water? Was it a beautiful, streamlined dive or a big belly flop? What noise did the splash make?

Can you see anything else in the painting that might make a noise? The diving board might have squeaked when the diver jumped off, but what makes everything else look so still and silent?

It looks like a very hot day in this painting by David Hockney. There are no clouds, no breeze, and very little shade from the sun. No wonder the person chose to jump into the cool, refreshing water in the pool!

Looking at the weather and palm trees, we can guess that this is a picture of a sunny place. Hockney is from England, but he painted this when he lived in California. He painted many pictures of pools while he lived there and liked

to show how the water can change: sometimes it can be very still, or it can have ripples, or it can go flying into the air after someone jumps in!

Although we recognize things in this painting—the house, the palm trees, the chair, the swimming pool—not everything looks lifelike. The sky, the water, the building, and the pool deck look flat. It's almost as if this is not a painting of real things, but a painting of shapes: we can see rectangles (look at the windows, the wall, and the deck), bands (look at the shadow of the roof, the blue edge of the swimming pool, and the window frames), and lines (look at the trunks of the palm trees, the white line along the edge of the pool, and the lines of the window frames).

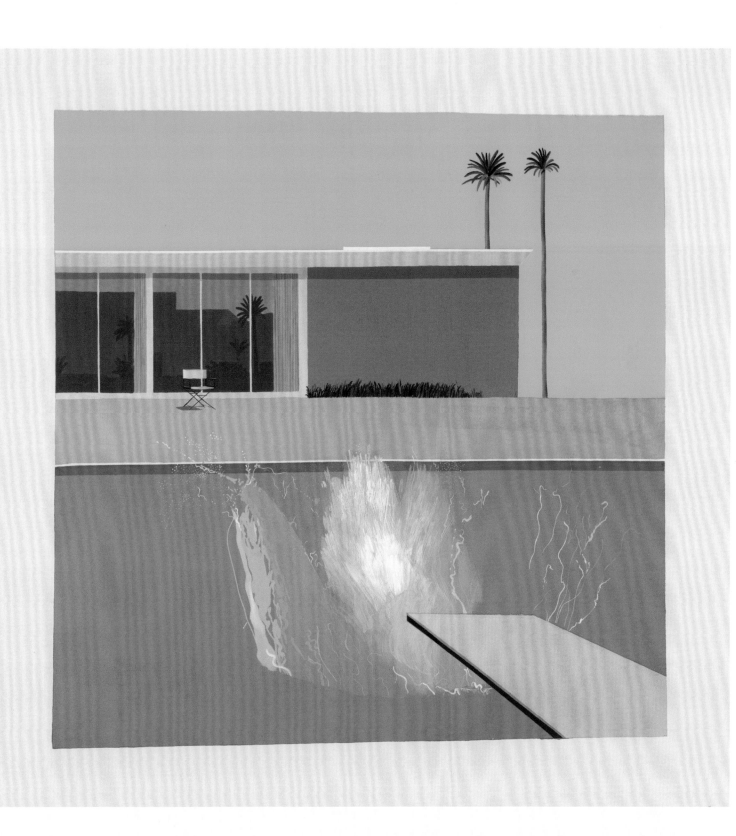

A Bigger Splash

KATSUSHIKA HOKUSAI

Born: Around 1760 | Edo (now Tokyo), Japan

KNOWN FOR | Woodblock prints

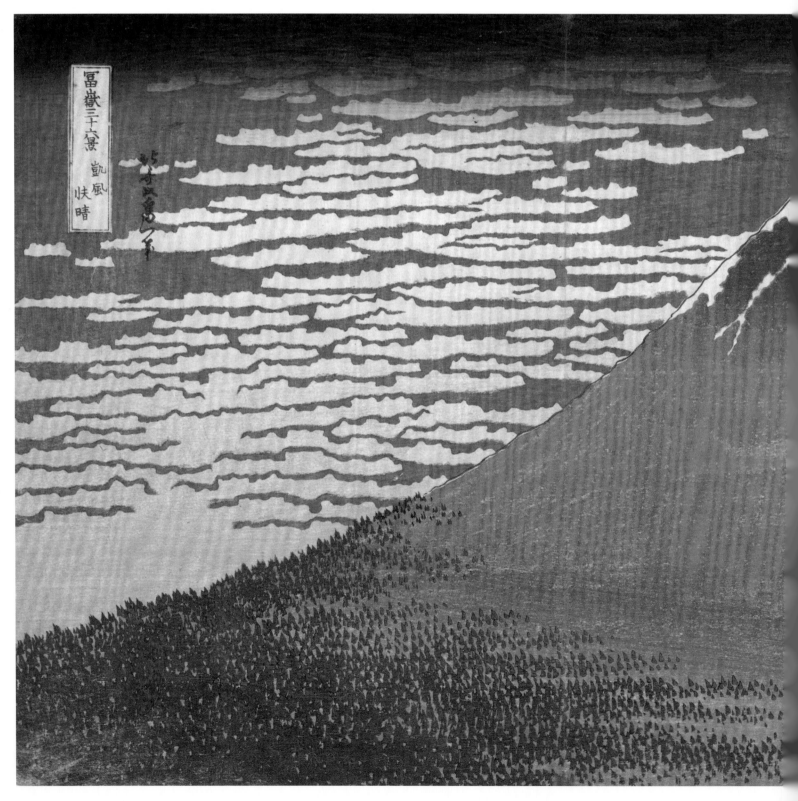

INSPIRED

Do you ever draw things that are special to you many, many times?

Katsushika Hokusai was so inspired by Mount Fuji, the tallest and most famous mountain in Japan, that he made a series of pictures showing the mountain from 36 different angles. They became so popular that he created 10 more!

Of all the pictures he made of the mountain, *Red Fuji* is one of the most famous. Hokusai wanted to show the mountain in the early morning, so he made it a glowing red color as if lit by the rays of the rising sun. There is very little else in the picture apart from trees, sky, and clouds. Hokusai wanted to keep everything as simple as possible so that nothing distracted from the majestic mountain and its snow-covered peak.

There may be hundreds of copies of these pictures—that's because they are woodblock prints. Hokusai made drawings, which the printer would carve into a block of wood. Ink would be placed onto the block and pressed against a piece of paper to make a print, or "copy," of the image. Different blocks would be created for each color he wanted to use. There are only three colors in *Red Fuji*: red, blue, and green.

Lots of these prints were sent all over the world and went on to influence many artists. Vincent van Gogh (see page 70) loved them!

Red Fuji

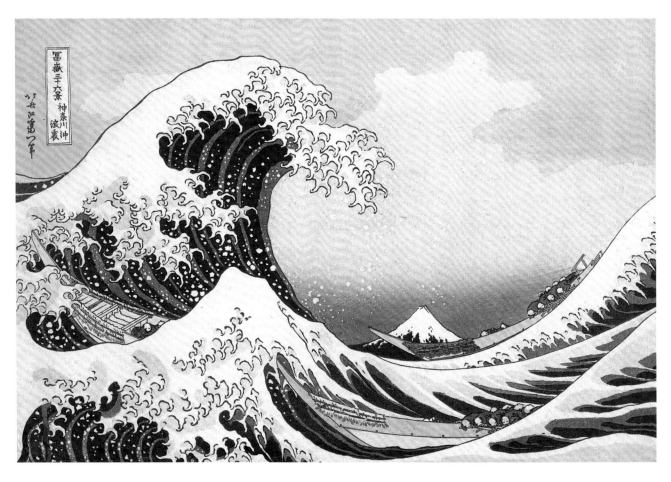

The Great Wave

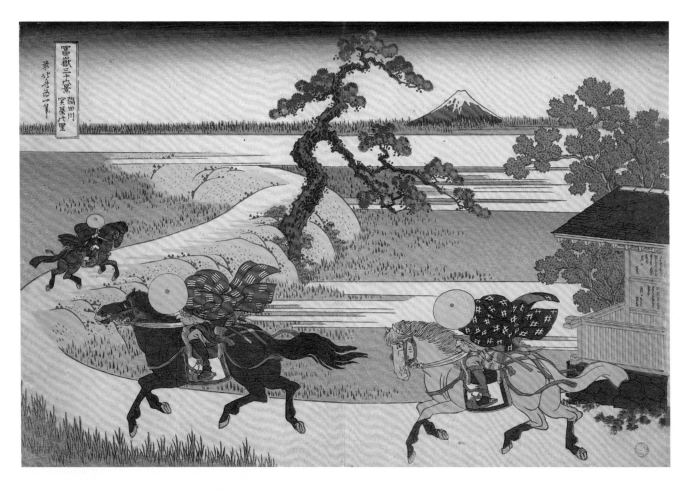

Sekiya Village on the Sumida River

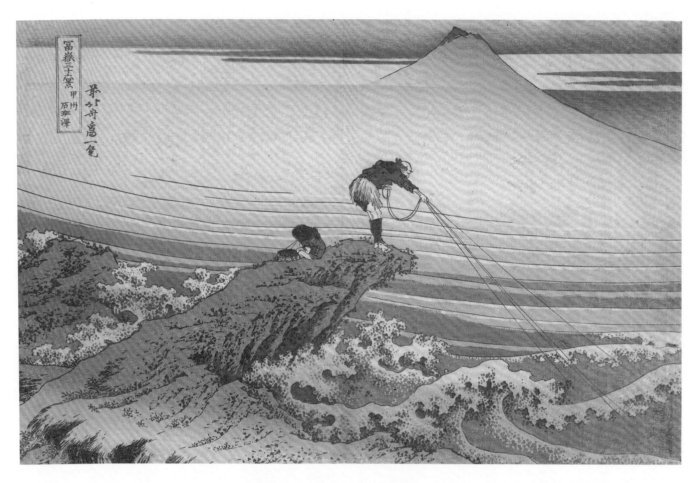

Kajikazawa in Kai Provence

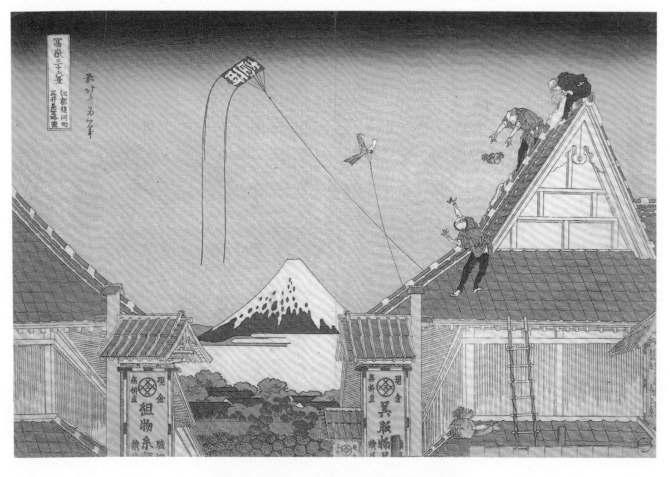

Mitsui Shop at Surugachō in Edo

HANS HOLBEIN THE YOUNGER

Born: Around 1497-98 | Augsburg, Germany

KNOWN FOR

Painting the Tudors (one of the most famous families ever to rule England)

DETECTIVE WORK

You sometimes have to be a detective when you look at art. Paintings are often full of clues. Everything is probably there for a reason.

It's not a coincidence that these two men are standing by a table stacked with gadgets. What can that tell you about the men? There are two globes: the one on the bottom shelf shows the Earth (a terrestrial globe), and the one on the top shelf shows the planets (a celestial globe). There are two books: one wide open, the other almost closed. The big wooden object that looks like half a melon is a musical instrument called a lute. Next to the lute, there are some flutes.

Hans Holbein has included these objects to tell us that the men are well traveled (the terrestrial globe), interested in astronomy (the celestial globe), musical (the lute and the flutes), and well educated (the books). The man on the left is the French ambassador to England, and the man on the right is a French bishop.

What is that strange shape on the floor between the men? If you move your face close to the page and look at the picture from the right-hand side, this strange blob changes into a skull! Holbein wants to tell us that however knowledgeable, powerful, or rich they might be, they are only human and will die one day, like everyone else.

If a detective came into your bedroom, would they be able to guess what kind of person you are by looking at the objects on your walls and shelves?

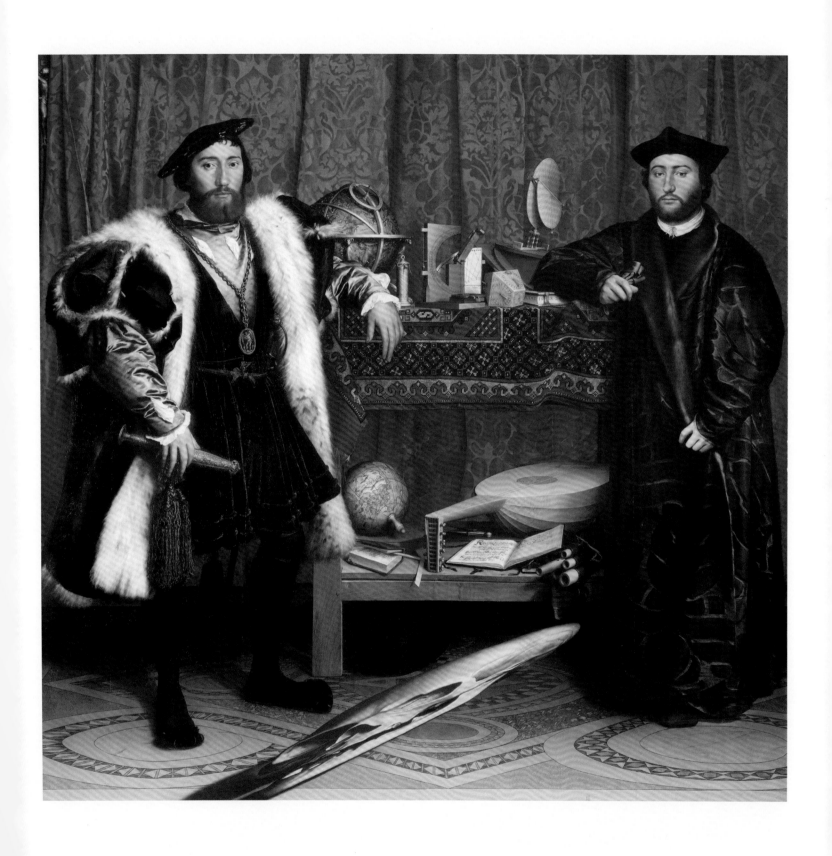

The Ambassadors

WINSLOW HOMER

Born: February 24, 1836 | Boston, USA

KNOWN FOR | American art, landscape paintings

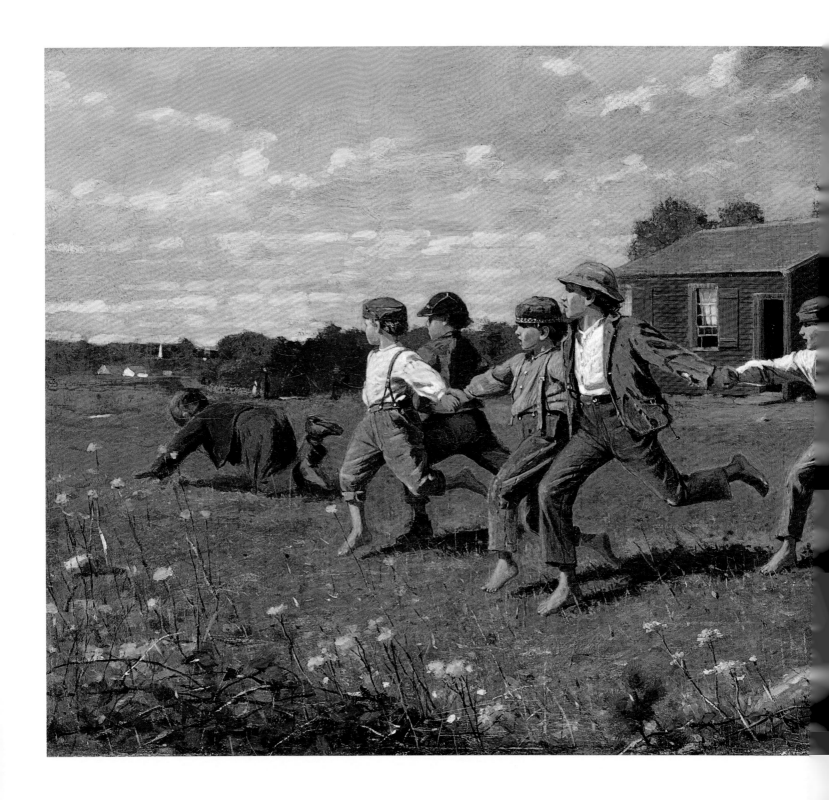

FAST OR STILL?

How fast are these boys running?

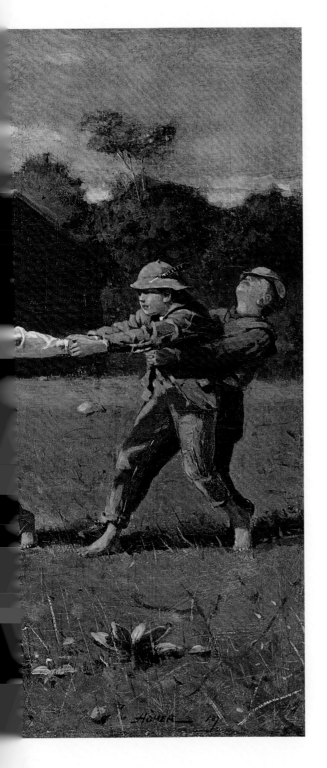

They look as if they are racing across the field as fast as their legs will carry them. You can almost hear their bare feet thumping on the grass. The boy with his blue jacket open is pulling the others as he charges across the meadow.

The children are playing a game called "snap the whip," in which a group of people hold hands in a long line and run as fast as they can. Then, suddenly, without warning, those at one end of the line stop in their tracks. The others keep running and the rest of the line is yanked sideways. It's as if the line is a whip that's been cracked or "snapped." You can see that the boys on the right have stopped and the boys at the other end of the line have been thrown off-balance; one has fallen over because the jolt was so abrupt.

How did Winslow Homer make the running action so lively? He did this by including two opposites: speed and stillness. You can feel that the boys in the middle are running hard—they have their chests out and their feet racing ahead. But you can also feel that the two boys on the right have really stopped. One boy is grabbing the other around his waist, leaning backward with all of his weight to ensure that he doesn't budge from his spot.

Which place in the line do you think would be the most fun?

Snap the Whip

ITŌ JAKUCHŪ

Born: March 2, 1716 | Kyoto, Japan

KNOWN FOR

Animal paintings

UNDER THE SEA

Hold your breath and dive into these fish-filled paintings by Itō Jakuchū. How many colorful fish do you count?

Life in the ocean looks busy in these paintings by Itō Jakuchū. Do you see the long red fish that looks like a pencil? This is a cornetfish. It can grow as long as 6.5 feet, and its long snout is used for sucking up food. Do you see the white squid and the hammerhead shark on the right? What other fish do you recognize? Don't miss the tiny octopus riding its parent's tentacle!

These are two of 30 paintings the artist made in a series called *The Colorful Realm of Living Beings*. These pictures show collections of fish, birds, and plants in all kinds of settings and seasons. It took Jakuchū around 10 years to paint them all, and in such great detail. Once

the pictures were complete, they were fixed onto scrolls—long, vertical paintings that are hung on walls. Scrolls are a great way to display art, but they are also perfect for storage and for transporting! Scrolled artworks can be rolled up and tied shut or stored in a tube for safekeeping.

Jakuchū loved painting when he was a kid. There weren't any aquariums or scuba-diving equipment in those days, so he practiced drawing the fish he saw at the fishmongers near his family's grocery shop. When he grew up, he was put in charge of his family store, but he eventually quit his job and became a celebrated artist in the busy city of Kyoto.

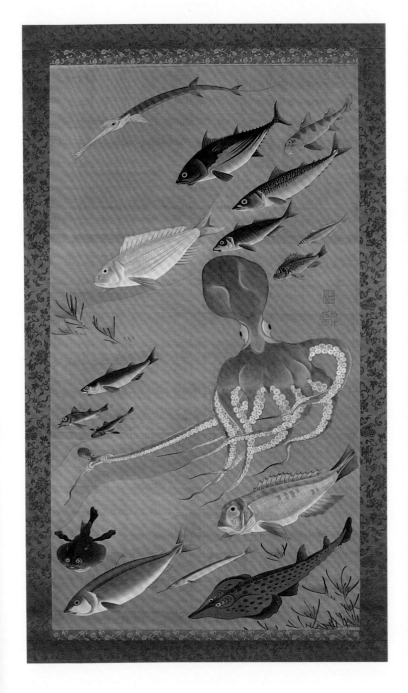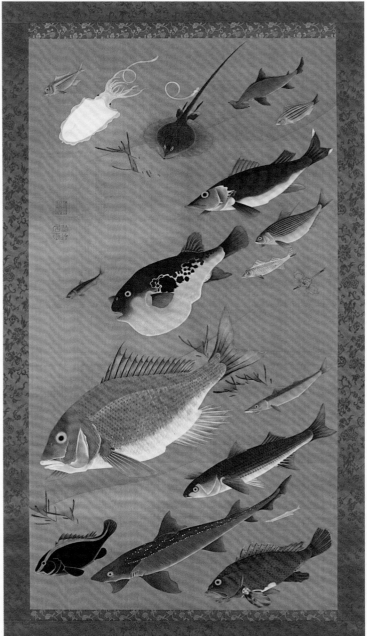

Fish and Octopus (left), and *Fish* (right), from *The Colorful Realm of Living Beings*

FRIDA KAHLO

Born: July 6, 1907 | Mexico City, Mexico

KNOWN FOR

Self-portraits, pets, Mexican heritage

PORTRAITS WITH PETS

Frida Kahlo's imaginative self-portraits reveal meaningful connections to her animals and her Mexican heritage.

Is there an animal you think is so great that you like to draw them or take pictures of them? Maybe it's an animal you've seen at a zoo or a pet you adore. You may have even included them in selfies you've taken or pictures you've drawn of yourself. In this painting, Frida Kahlo has painted herself with her spider monkey, Fulang-Chang, and her dog, Señor Xolotl. Do you see the colored ribbons that appear around the artist and the animals? They are there to show the loving connection tying them together. Kahlo kept many pets in her home in Mexico, including monkeys, dogs, a parrot, and a fawn. They often appear in her paintings.

But what made her pets so special? Kahlo was in a bus accident when she was younger, and the injuries left the artist unable to have children. Throughout her life, she became close to her many pets, and she loved them as family.

Some of the animals also had meaningful connections to her Mexican heritage, which was very important to Kahlo. Do you notice how Señor Xolotl seems to not have much fur? That's because he was a breed of hairless dog called a Xoloitzcuintli. They are the national dog of Mexico and were special to the native Maya and Aztec people of Mexico for thousands of years. Spider monkeys were also meaningful in Aztec and Maya cultures. They were seen as playful creatures and connected to the god of music, poetry, and dance.

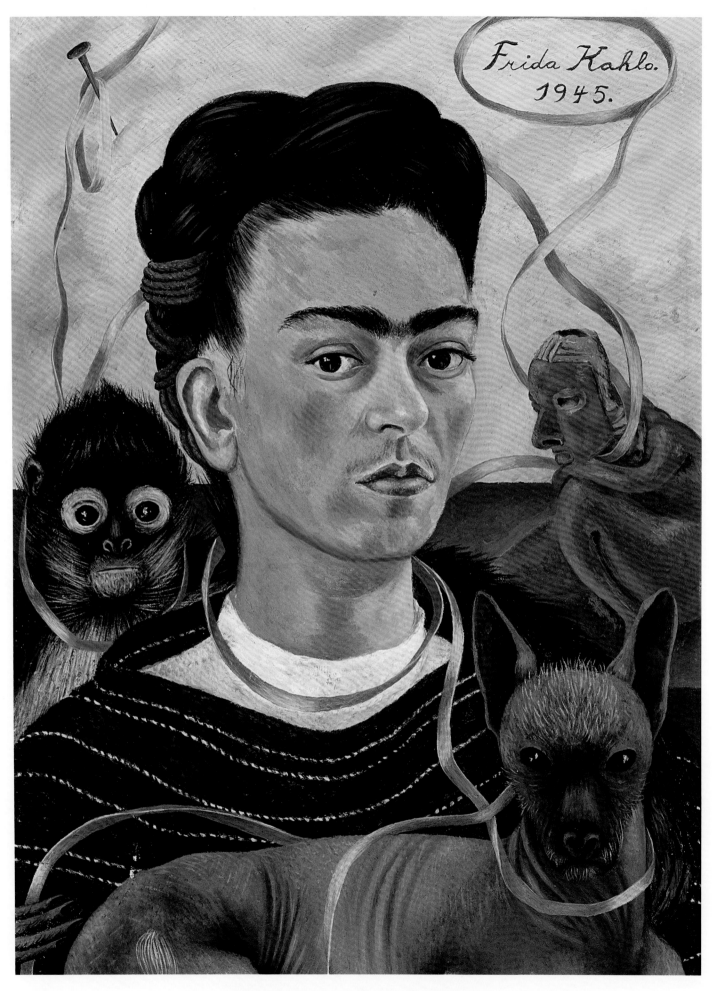

Self-Portrait with Small Monkey

Frida Kahlo.
1945.

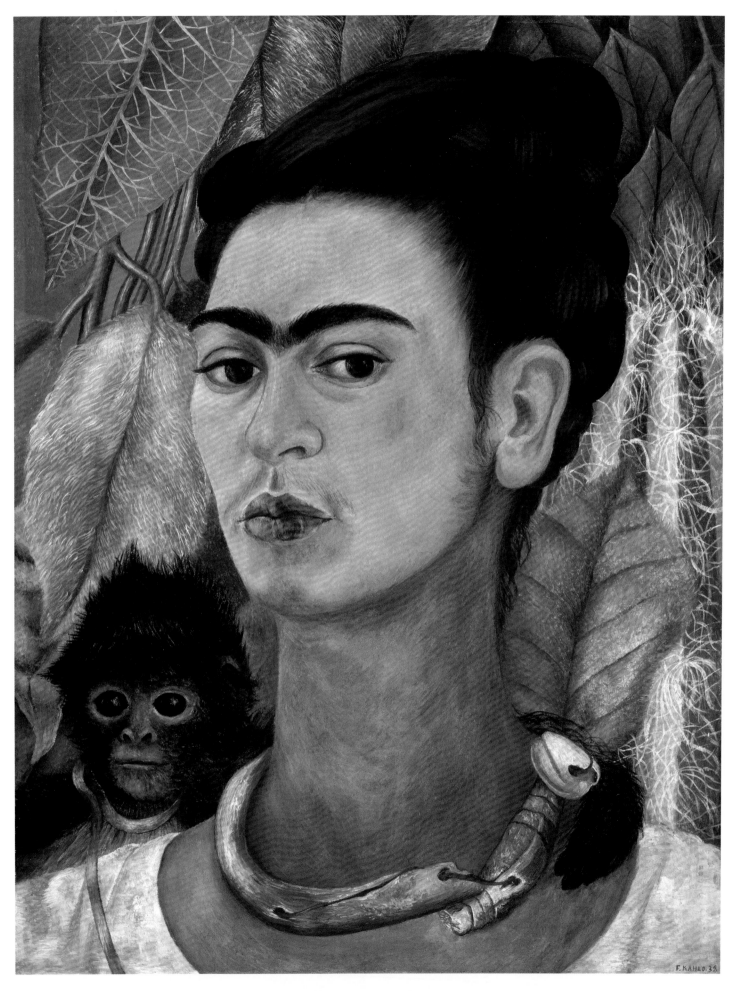

Self-Portrait with Monkey

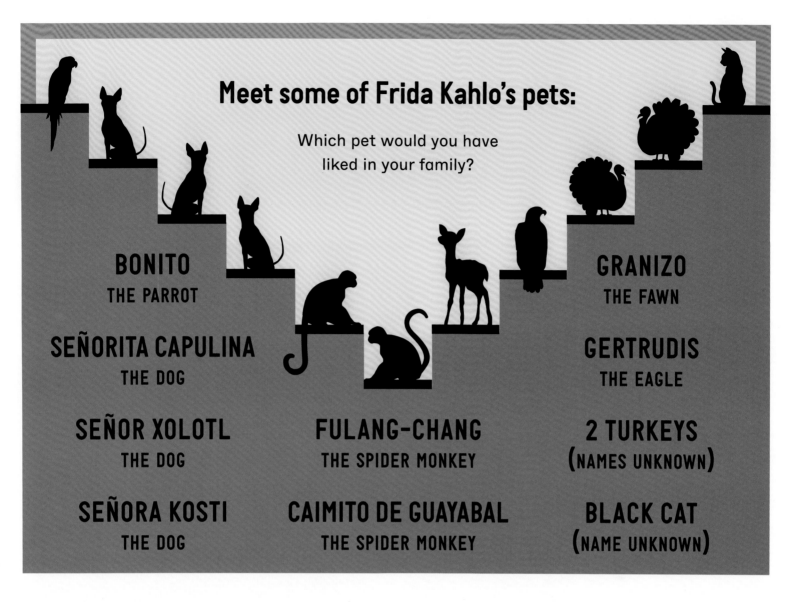

Meet some of Frida Kahlo's pets:

Which pet would you have
liked in your family?

BONITO
THE PARROT

SEÑORITA CAPULINA
THE DOG

SEÑOR XOLOTL
THE DOG

SEÑORA KOSTI
THE DOG

FULANG-CHANG
THE SPIDER MONKEY

CAIMITO DE GUAYABAL
THE SPIDER MONKEY

GRANIZO
THE FAWN

GERTRUDIS
THE EAGLE

2 TURKEYS
(NAMES UNKNOWN)

BLACK CAT
(NAME UNKNOWN)

Frida Kahlo loved her pets so much, that a special pyramid was built in her courtyard for them to play on. The design was inspired by the ancient pyramids made during the time of the Aztec Empire in Mexico.

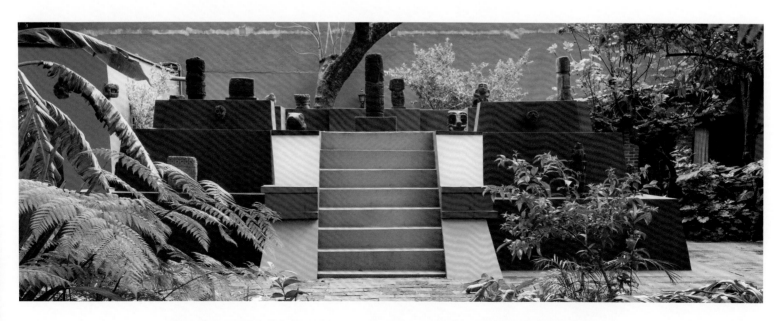

The Pyramid inside the courtyard of the Frida Kahlo House

WASSILY KANDINSKY

Born: December 16, 1866 | Moscow, Russia

KNOWN FOR | Abstract art, painting sound

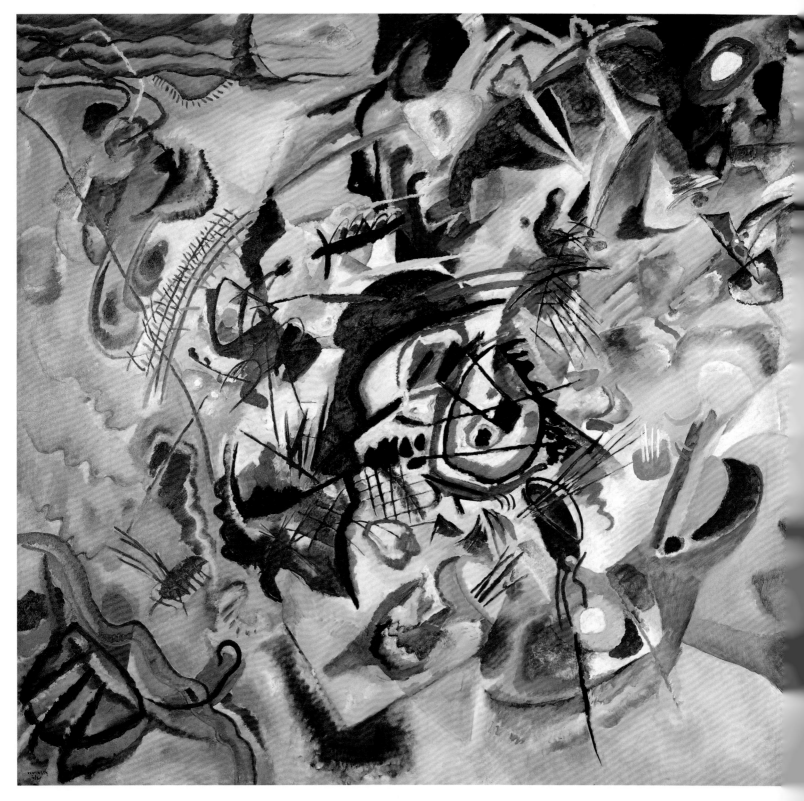

MUSIC TO OUR EYES

Imagine what it would be like if you could *see* music.

This is a painting of music. It isn't a painting of people playing music. But if you could *see* music, it might look like this. Can you imagine what this music might sound like? Would it be gentle and soothing, or dramatic and loud, with drums rolling, cymbals clashing, and horns blowing? Perhaps you can see the long thin sound of a flute or a clear bright oboe, whooshing violins or warm swirling cello notes, or the circular blasts of the trumpets.

Wassily Kandinsky liked to create pictures in a similar way to how a musician might compose a song—that's why he called his paintings "compositions," which is a musical term.

Kandinsky was one of the first artists to become known for painting abstract pictures (images that aren't of anything we can see or touch.) He believed that an abstract composition of colors and shapes could be just as powerful and emotional as a painting of an amazing landscape, a battle scene, or even a piece of music.

What's your favorite piece of music? What would it look like if you painted it?

Composition VII

EMILY KAME KNGWARREYE

Born: Around 1910 | Utopia, Australia

KNOWN FOR

Aboriginal painting

CONNECTING WITH NATURE

How would you draw the plants and animals around your home? Emily Kame Kngwarreye used dots and lines inspired by her Aboriginal traditions to show the beauty of nature.

Emily Kame Kngwarreye only started making art when she was over 60 years old, and became famous when she started painting, when she was around 80 years old! In the eight years that she was a painter, she created more than 3,000 works.

What does this abstract (not realistic) painting by Kngwarreye look like to you? *Emu Woman* is her earliest canvas painting. The way she painted the colorful lines and dots in this picture was inspired by designs that the women in her community made in sand or on the body during religious ceremonies. They represent plants and seeds and are part of the traditions her people used to connect to nature and pass on

stories. Kngwarreye lived most of her life in an Aboriginal community called Utopia, which is in the Australian desert. The Aboriginal Australians include many different groups who were the first people to live on the continent. Kngwarreye was an elder member of the Anmatyerre people. Being an elder meant that it was her responsibility to help look after special places near her home that had important religious meanings. The beliefs and traditions of her people were a very important part of her artworks.

Emu Woman

YAYOI KUSAMA

Born: March 22, 1929 | Matsumoto, Japan

KNOWN FOR

Polka dots, pumpkins, mirror rooms, installations

POLKA-DOT PUMPKIN PATCH

Have you ever seen entire rooms covered in polka dots or pumpkins?! Yayoi Kusama covers canvases, sculptures, and even rooms with *both*!

Yayoi Kusama grew up surrounded by plants and flowers. Her family owned a plant nursery and seed farm. When she saw pumpkins for the first time, she thought their fun, friendly shapes were so interesting that they became one of her favorite things to draw. She's been making paintings and giant sculptures of them ever since!

Did you notice that these pumpkins are covered in dots? That's because she loves polka dots too! One day, when Kusama was in a field of flowers on her family's farm, she imagined the flowers talking to her. The flower heads looked like thousands of dots—an infinite field of them. This frightened her. She hurried back home to draw what she had seen, to help ease her fear.

Kusama now covers everything in dots—from canvases and sculptures to entire rooms! Today she sees dots as something that bring her peace.

All the Eternal Love I Have for the Pumpkins is an installation, which means it's an artwork that has been specially made to transform a place. The walls, floor, and ceiling are all made of mirrors, and the mirrors reflect off each other. This makes the room repeat itself so that it looks like it carries on forever! Kusama fills these rooms with things she wants repeated over and over again. These rooms are called "Infinity Mirror Rooms."

If you could surround yourself in a mirror room full of your favorite thing, what would you choose?

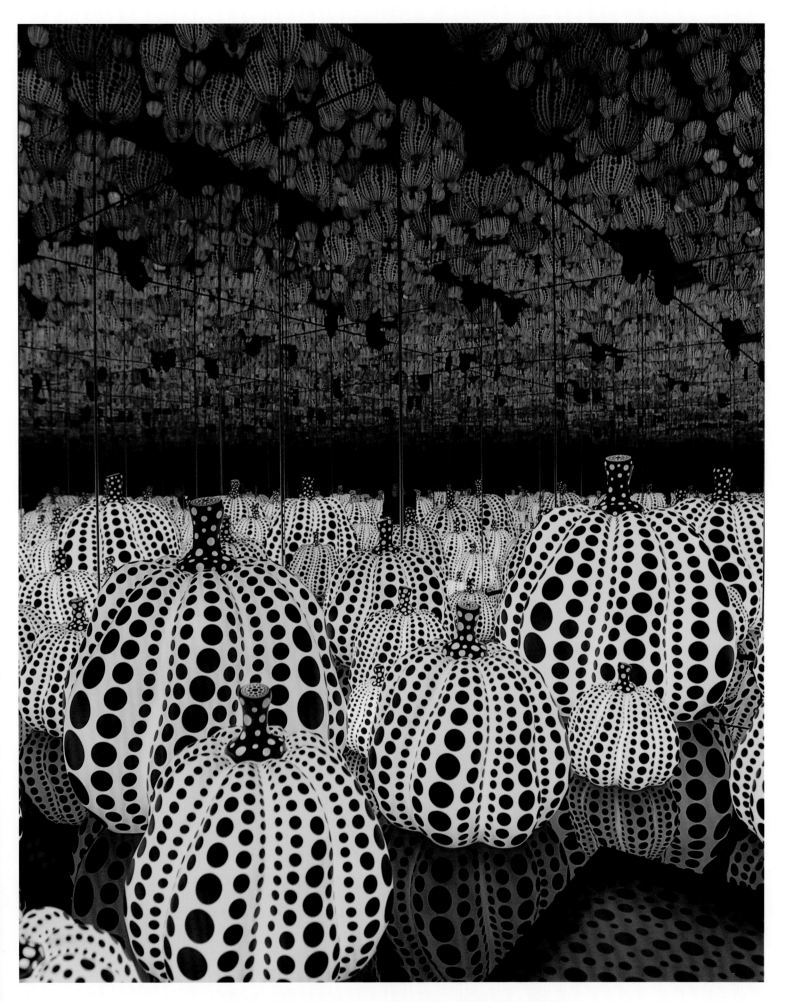

All the Eternal Love I Have for the Pumpkins

Infinity Mirrored Room—Brilliance of the Souls

LEONARDO DA VINCI

Born: April 15, 1452 | Anchiano, Italy

KNOWN FOR

Painting, drawings, scientific ideas and theories

A MYSTERY

The *Mona Lisa* is one of the most famous portraits in the world, but it's full of mysteries!

Who was Lisa? And why did Leonardo da Vinci keep this painting of her until the day he died? We are not completely sure, but Lisa is believed to be Lisa Gherardini, who was married to a man named Francesco del Giocondo. *Mona* is short for the Italian word *ma donna*, which means "my lady." So the title means "my lady Lisa," but it's also sometimes called *La Gioconda*.

Where is Lisa? Look at the scenery behind her. Is she in front of a window? Are the lake, roads, and mountains behind her real, or are they part of a picture hanging on the wall in the background? Perhaps they are just from Leonardo's imagination.

What is she thinking? Look into her eyes and at her mysterious smile. Is she happy? Is she sad? Maybe she's just bored!

The more you look at Mona Lisa, the more you feel that she might suddenly move her gently folded hands and come to life. She might even explain her mysterious secrets!

Why do you think this picture was so important to Leonardo? No one knows.

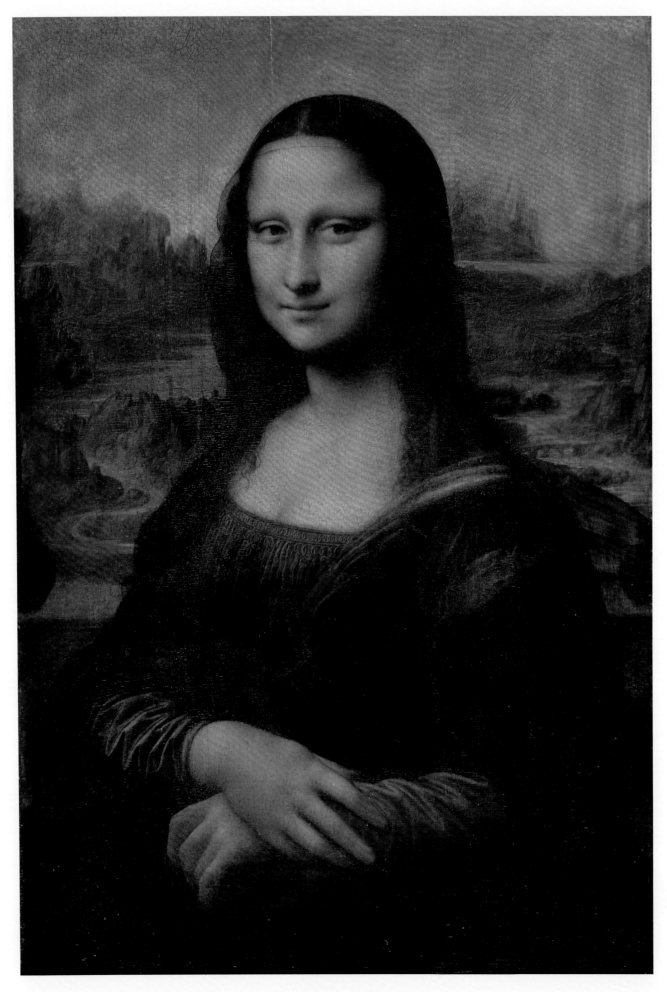

Mona Lisa

RENÉ MAGRITTE

Born: November 21, 1898 | Lessines, Belgium

KNOWN FOR

Surrealism, dreams

NEVER TRUST A PAINTING!

What do you see in this painting? If you said a pipe, then Magritte would disagree!

Ceci ... n'est ... pas ... une ... pipe.

This ... is ... not ... a ... pipe.

Is this a French lesson gone wrong? If it's not a pipe, what is it? René Magritte is telling us not to trust what we see. Another painter might try to trick you into thinking that this is a pipe, but in fact it's not. It's a *painting* of a pipe.

Magritte loved creating pictures that made people stop and think. He was a Surrealist, a member of a group of artists and writers who were very interested in showing the unexpected, wild, and wonderful things our minds might imagine, especially when we dream.

Take a look at the man on the next page. There's something strange going on. Can't put your finger on it? Here's a clue: When you look into a mirror, what do you see? If he were really standing in front of a mirror, would we see the reflection of the back of his head or his face?

Now take a look at the painting next to it. Is the landscape inside the room or outside the window? If you look closely, you'll spot the legs of an easel holding up a painting that looks exactly like the landscape outside!

Not everything is as it seems at first glance with Magritte's paintings.

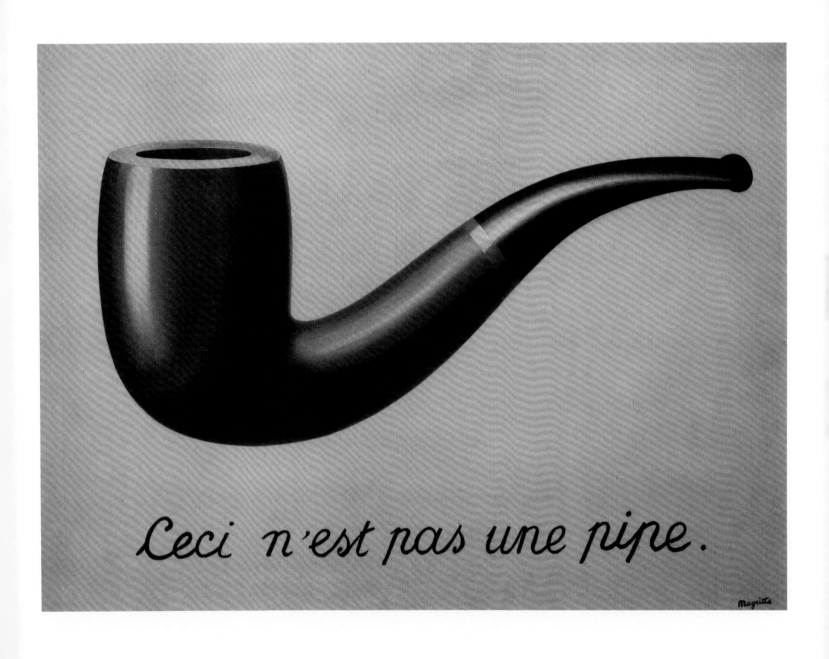

The Treachery of Images (This is Not a Pipe)

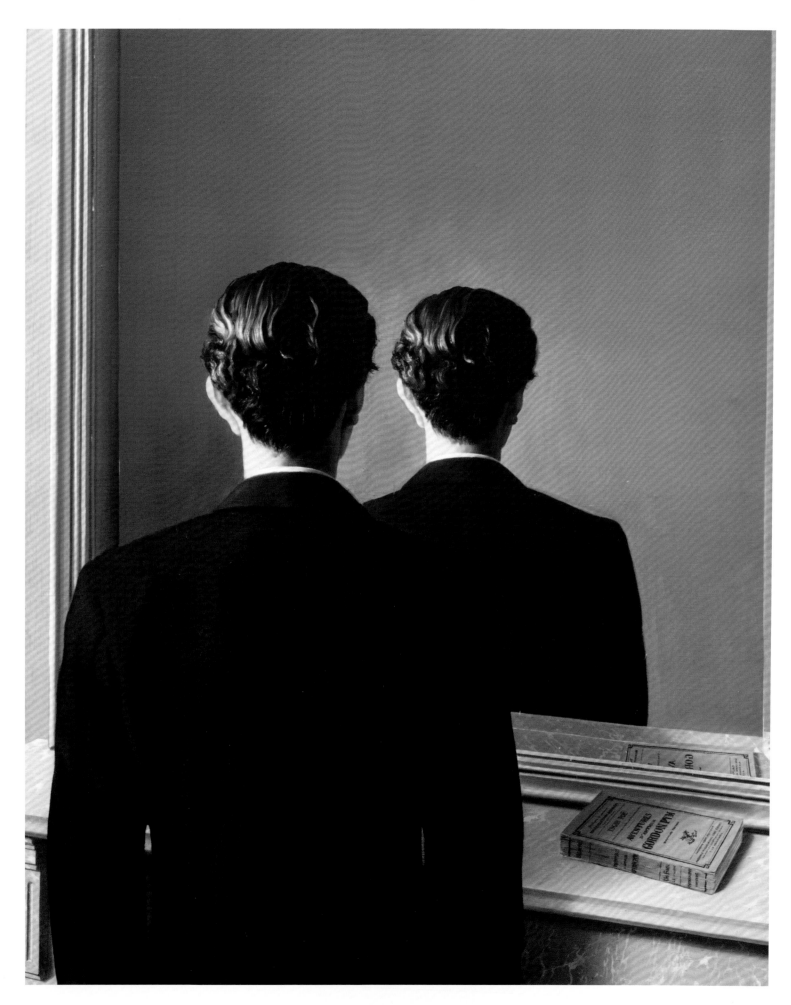

Not to Be Reproduced

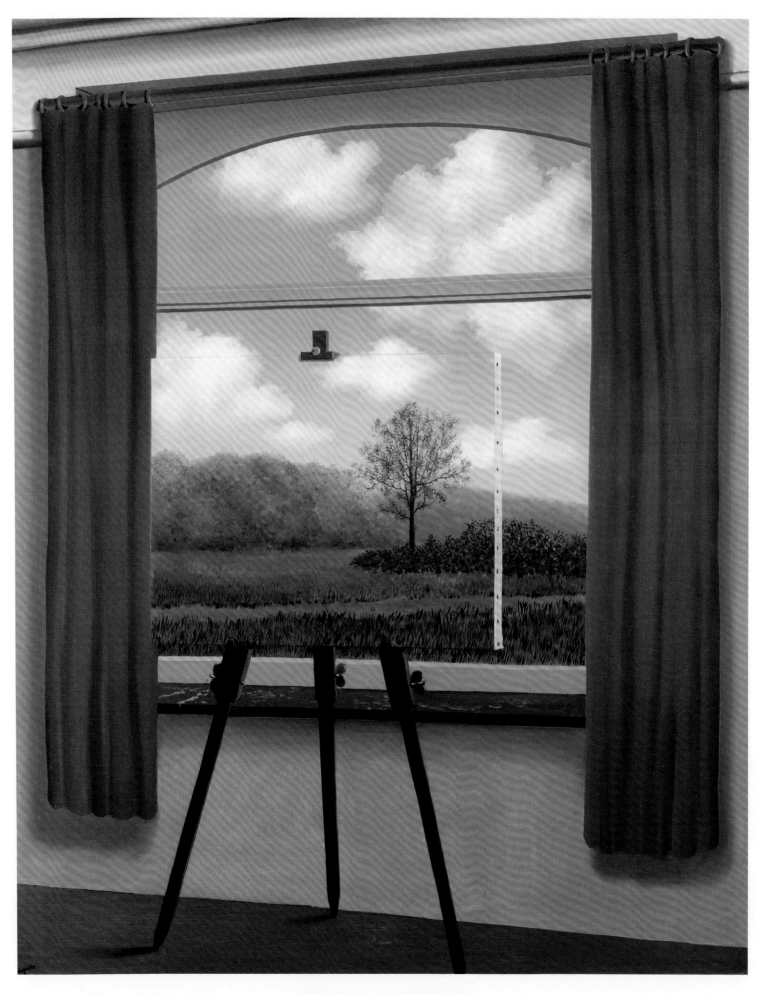

The Human Condition

KERRY JAMES MARSHALL

Born: October 17, 1955 | Alabama, USA

KNOWN FOR | Paintings, Black figures, Black American culture, art history

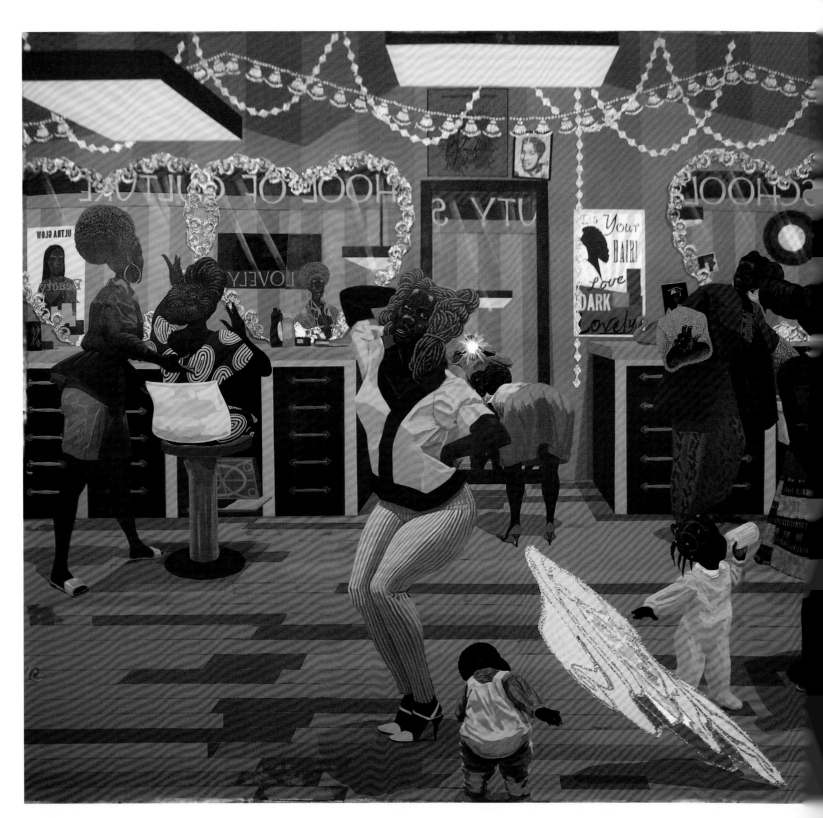

BEAUTY AND CULTURE

Do you have a favorite artwork of something you see or do every day?

Kerry James Marshall creates colorful scenes that show people going about their daily lives. He likes to make paintings that share parts of his Black American culture and to represent Black beauty in art. In *School of Beauty, School of Culture*, Marshall shows a beauty school filled with people. On the walls, he shows posters, which include the words "dark" and "lovely" to celebrate the beauty of Black hair.

Marshall often creates large and detailed paintings that reference connections to other famous paintings from art history. Check out that yellow, red, and white shape at the bottom center of the painting. If you were looking at it from the bottom, right-hand side of the picture, you'd see a cartoon princess! It's inspired by the way Hans Holbein painted a skull in *The Ambassadors* (see page 83). Marshall includes this princess to show a popular idea of beauty often represented in movies. He put it there to remind us that even though we often see images like this one, there is more than one way of being beautiful.

Do you see the reflection of someone taking a photo in the center mirror? Jan van Eyck (see page 56) and Diego Velázquez (see page 174) also painted mirrors that reflect people in a similar way.

School of Beauty, School of Culture

HENRI MATISSE

Born: December 31, 1869 | Le Cateau-Cambrésis, France

KNOWN FOR

Bright colors, paper cutouts

CRAZY WALLPAPER

Which part of this painting is the table and which part is the wallpaper?

Have you ever decorated a room? It looks as if Henri Matisse took red wallpaper printed with blue plants and flowers and laid it over the entire room, covering the table as well as the wall. Now have a look at the lush landscape in the background. Is it a painting or a window? It looks like it could be either!

The whole room seems to be moving with its swirling patterns of branches, flowers, and leaves. Calmly standing on the right is a woman, carefully placing a bowl of fruit on the table. She is very still, almost as still as the two glass bottles on the table. By putting swirling patterns together with still objects, Matisse has created a picture that seems to be moving bond and still at the same time.

Matisse loved to explore ways of painting that play with the way we see different objects and space. By not adding shading to most of the objects in this painting, he has made things look flatter. Shading is when an artist shows shadows or light on the objects in a picture to help make them look three-dimensional. If you look at the chairs, fruit, and even the woman in Matisse's painting, you'll notice that the artist has drawn an outline around most things, which helps us see where one object ends and another begins.

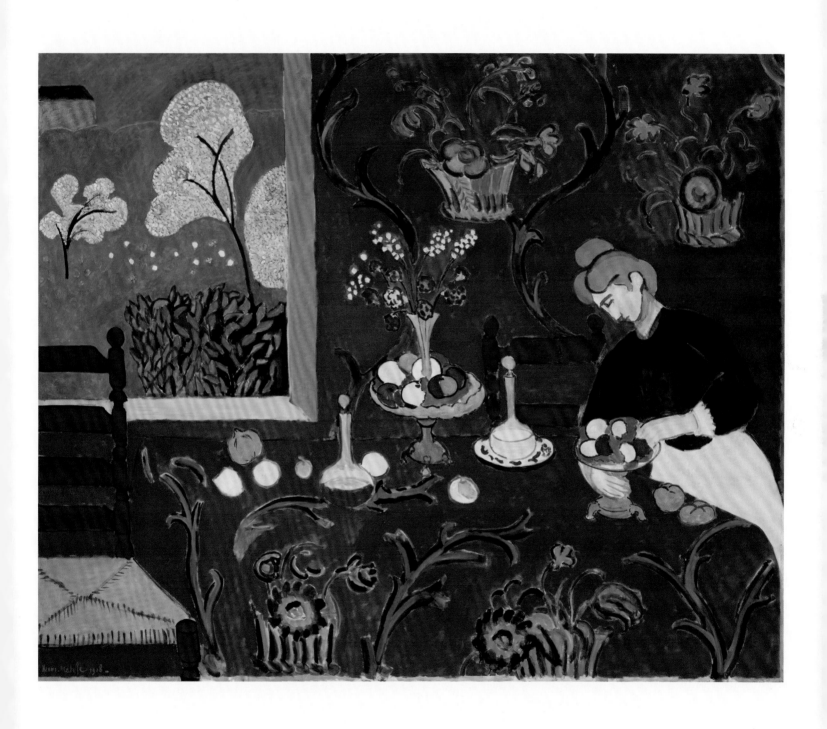

Harmony in Red

JOAN MIRÓ

Born: April 20, 1893 | Barcelona, Spain

KNOWN FOR

Abstract shapes, Surrealism, symbolism, automatic drawing

EXPERIMENTAL SHAPES

What do you see when you look at this painting by Joan Miró? This picture is called *Women and Bird in the Moonlight*, which gives us some helpful clues!

We can see a big blue crescent moon and a white star, which tells us it's probably nighttime, but where are the women and the bird? The artist has chosen to creatively draw the women and bird in a way that doesn't look exactly like real life, so we have to be equally creative to figure out what's what! Does anything look like a bird or women to you? Perhaps the pairs of little circles are sets of eyes. Perhaps the large black shapes are the women's skirts or dresses. But where is the bird? Maybe it's that strange white shape in the lower right-hand corner. Perhaps that's a red beak and three, hairlike "feathers" on its round back. Nobody can say for certain. What's your guess?

Joan Miró's art teacher once asked him to try drawing simple shapes wearing a blindfold. The result might have looked something like the shapes in this picture.

Miró loved to experiment, and some of the ideas for his paintings came from a similar technique called automatic drawing. This is when an artist draws randomly on a piece of paper and tries not to think too hard about what their hand is doing.

Try drawing a woman and a bird with your eyes closed and see what it looks like! What interesting shapes did you create?

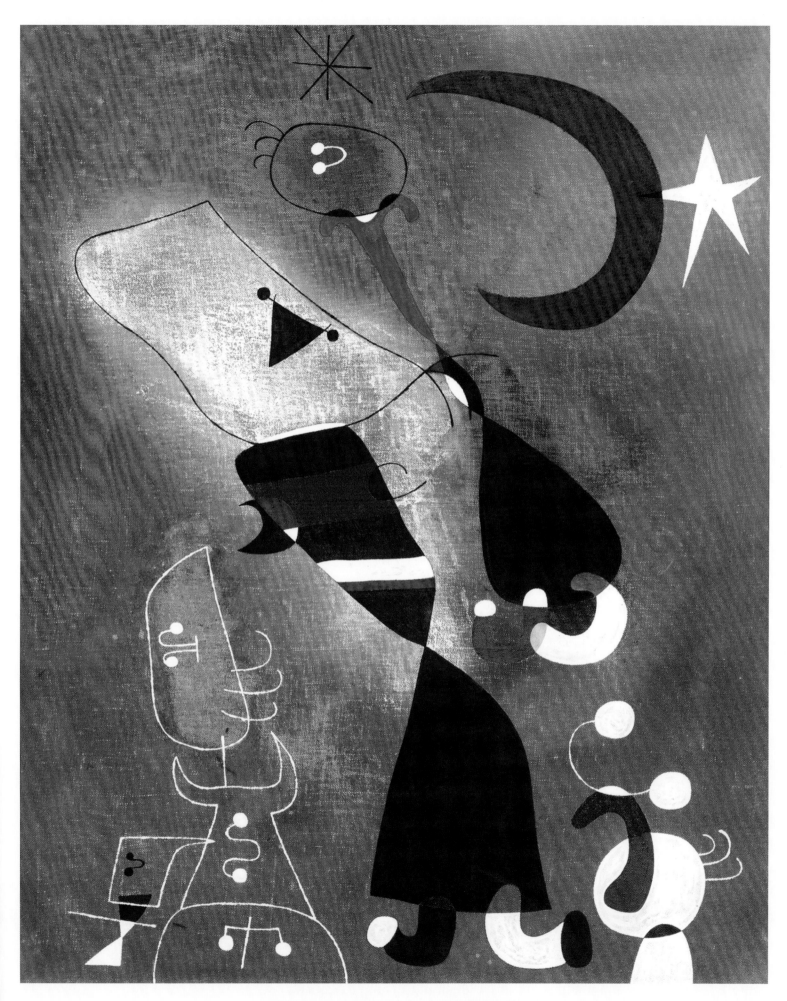

Women and Bird in the Moonlight

CLAUDE MONET

Born: November 14, 1840 | Paris, France

KNOWN FOR

Impressionism, paintings of gardens, landscapes

A GARDEN

Does this picture look a little fuzzy to you? Perhaps it isn't crisp and detailed, but does it give you the feeling—or the impression—of what it was like to be in the artist's garden?

Claude Monet loved gardens. He lived in a big house in Giverny, just outside Paris, France, where he created the most beautiful landscape. There were flower beds overflowing with plants, a lily pond, and this Japanese-style bridge. He was so inspired by the beauty of his gardens that he spent more than 40 years painting pictures of them!

Unlike some of the other artists in this book, Monet wasn't interested in showing us details. He wanted to give the *feeling* of being in a garden rather than painting every flower and leaf. Look at the difference between Monet's leaves and the ones painted by Henri Rousseau (on page 148). Rousseau's leaves are clearly

painted with crisp outlines. In Monet's painting, it's difficult to tell where the flowers of the lilies end and the leaves begin.

Even though there is very little sharp detail in this picture, we know that there are weeping willows hanging behind the bridge and lilies floating across the water. Monet used delicate dabs of color to capture the flickering sunlight shining through the leaves of the trees onto the lily pond. By choosing his colors carefully, he was able to create the light, airy impression, or feeling of a summer's day. Because he painted in this way, he was called an Impressionist painter.

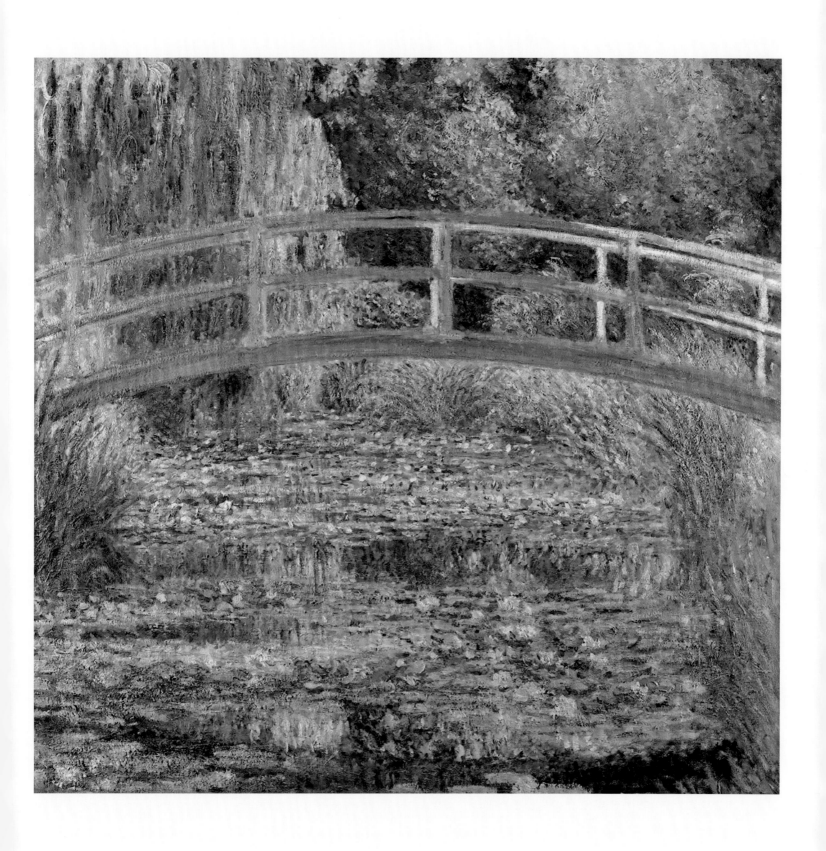

The Water-Lily Pond

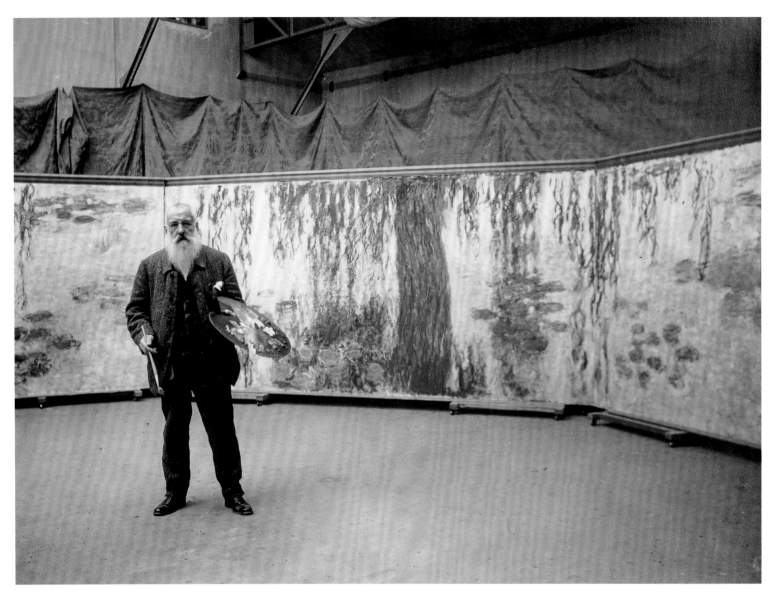

Claude Monet with his palette in front of his work *Water Lilies*

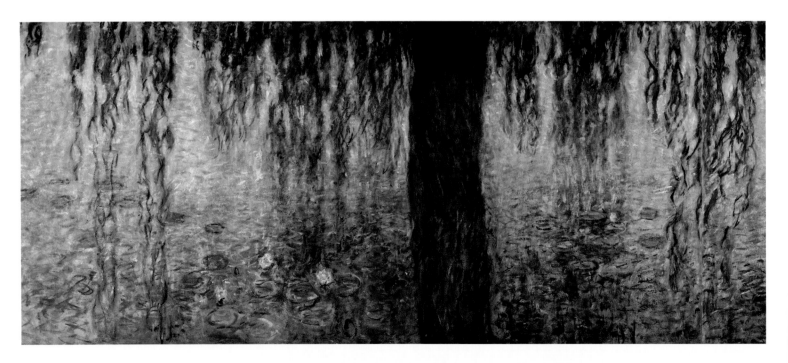

Detail of *The Water Lilies–Clear Morning with Willows*

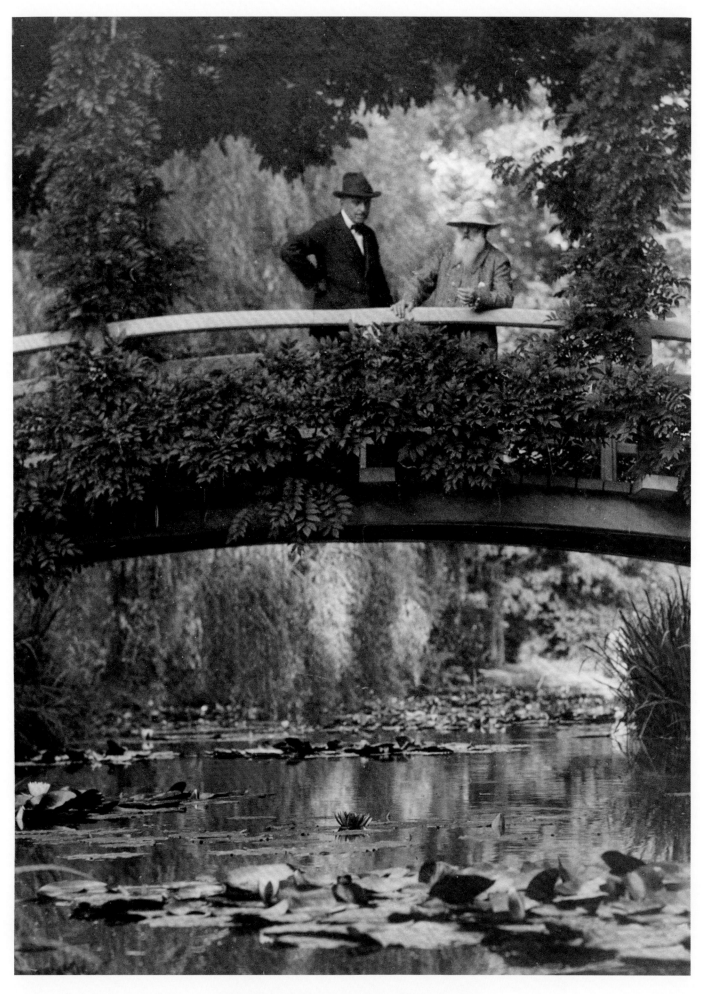

Monet with a friend on the bridge

BERTHE MORISOT

Born: January 14, 1841 | Bourges, France

KNOWN FOR

Family scenes, Impressionist painting

MIRROR IMAGE

Look closely at the mother and baby in this picture. What do you notice about their poses?

Do you know a baby as young as this one? Perhaps you have a tiny brother or sister yourself? If so, you'll know that babies sleep quite a lot, and when they do, you have to be quiet around them. Would you say the atmosphere in the room is calm and quiet? How does the artist make it look that way?

This mother is watching tenderly as her baby sleeps. The artist, Berthe Morisot, has painted a transparent lace canopy so that we can see through it. She must have painted the baby first and then very delicately added a thin layer of white and cream paint over the baby and crib. How does the lace canopy add to the atmosphere in the room?

Look at how both mother and baby have one hand on their cheek and one arm bent at the elbow. They are like a mirror image of each other! Why do you think Berthe Morisot painted them this way?

Morisot was one of a group of artists called Impressionists, which means that she used quick, loose brushstrokes in her work. Look at the washy blend of blue, cream, and pink paint in the netting over the baby's crib. Like other artists who worked in this style, Morisot liked to go outside and paint in the open air, but she is best known for pictures of her own family. The mother in this painting is Morisot's sister Edma with her baby daughter Blanche.

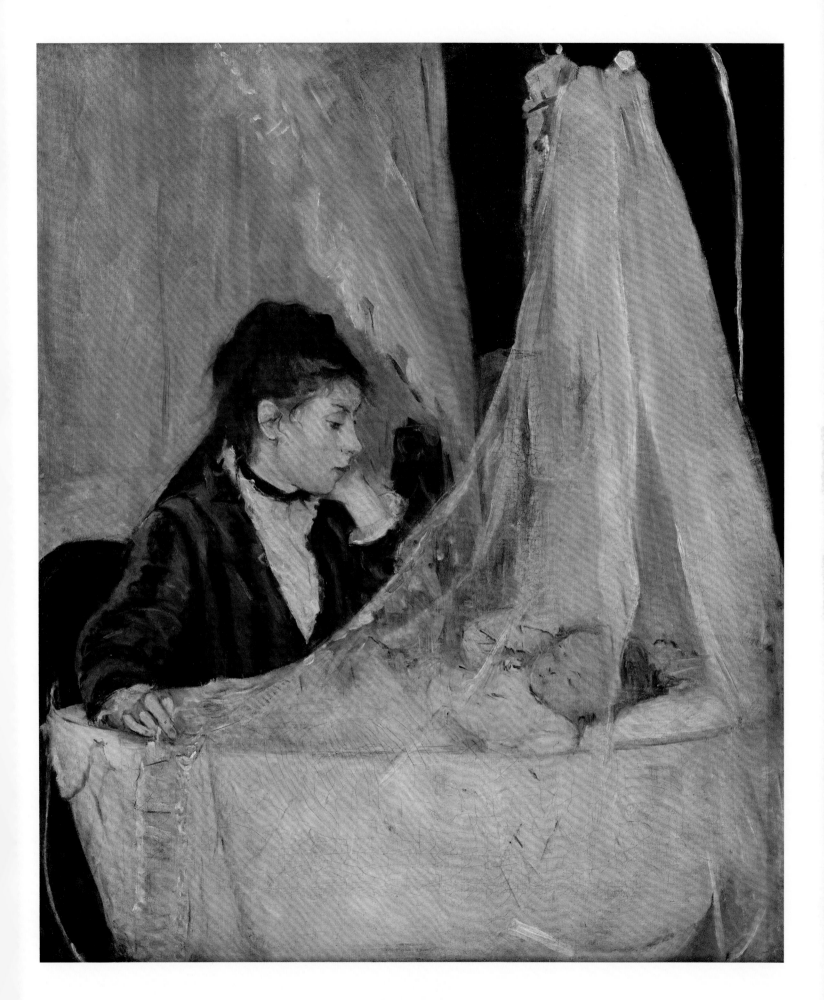

The Cradle

GEORGIA O'KEEFFE

Born: November 15, 1887 | Wisconsin, USA

KNOWN FOR | Interesting perspectives, clouds, abstract art based on real life

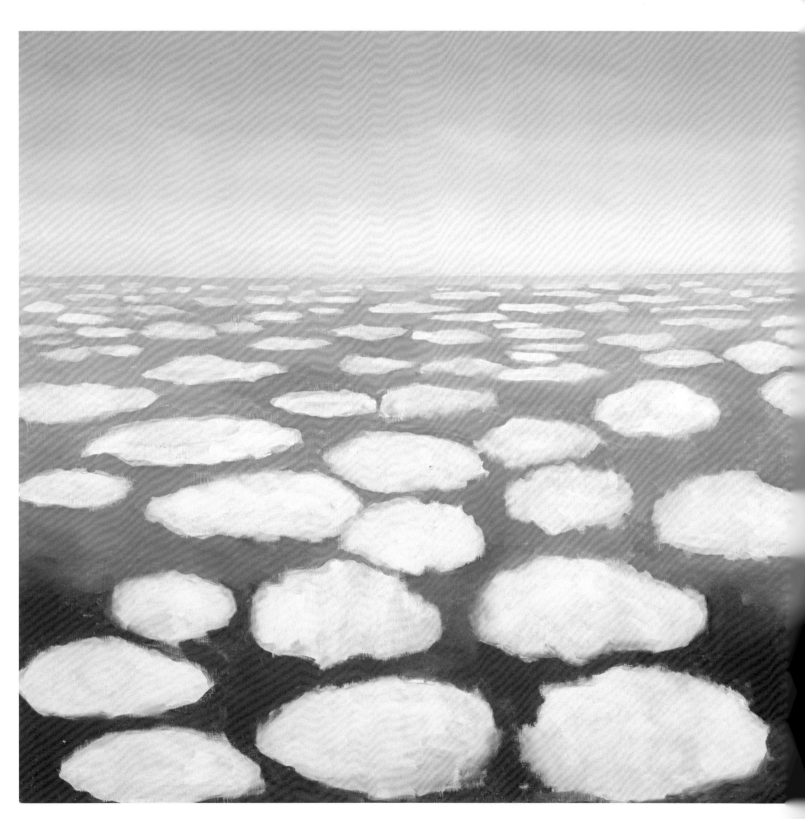

DIFFERENT PERSPECTIVES

Seeing things from new angles can change how we think about them.

Imagine that you've just taken off in an airplane. First, you whoosh up into the air and see a city shrinking below you. Then, everything outside the window goes white before you push through the clouds and are on top of the world! If you looked out the window, your view might look like this painting by Georgia O'Keeffe, with a hazy blue sky above and blobs of white clouds hovering beneath you.

O'Keeffe painted subjects from new perspectives. With *Above the Clouds I*, she painted clouds from a whole new angle—not from the ground, looking up at the sky, but from above the clouds, looking down on Earth! She was inspired to paint pictures of clouds after her experiences flying in the 1950s. At that time, traveling by plane was still new and special. The artist must have been excited to share the amazing sights, especially of seeing clouds from above, which was a perspective that would have been new to many people.

Things can look completely different when you're lying on the ground compared to when you're standing up. If you were to look at something from a new, interesting angle, what would it be?

Above the Clouds I

KNOWN FOR | Surrealism, found objects

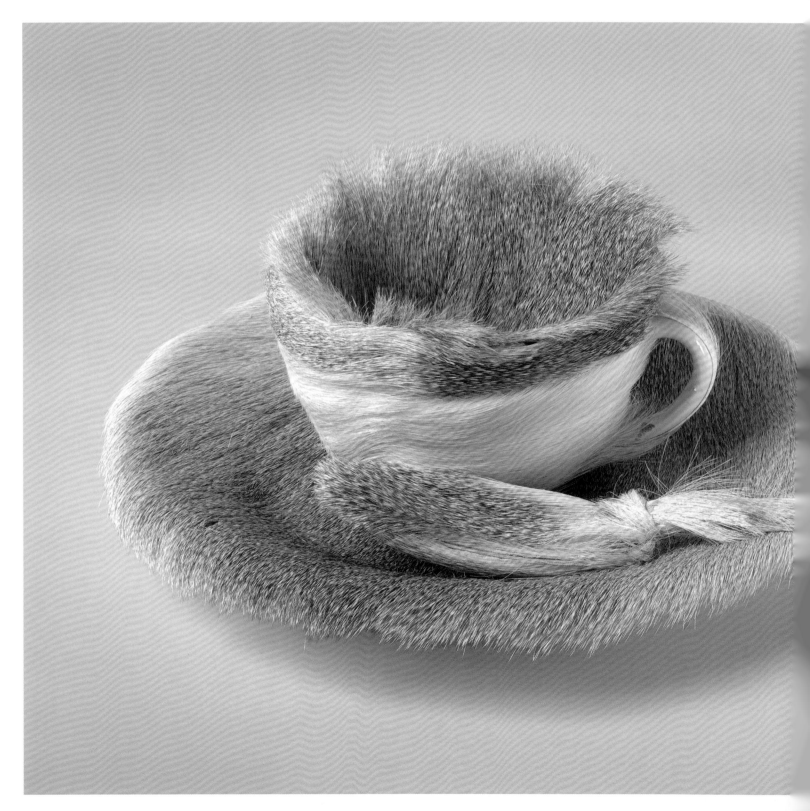

UNUSUAL COMBINATIONS

The outrageous artworks of Meret Oppenheim make us see everyday objects in unexpected ways.

Can you imagine how it would feel to take a sip from this cup? We expect teacups to be solid and smooth for easy drinking, but Meret Oppenheim covered these dishes in soft gazelle fur. When this sculpture was exhibited in 1936, one woman was so shocked by the design that she fainted!

Object is a famous example of Surrealist sculpture. In paintings by Surrealists like René Magritte (see page 102), we can see that these artists loved to create unusual combinations. Oppenheim worked in a similar way. She often combined objects or made imaginative changes to them that were funny and smart. Placing fur around a teacup would not feel nice on your lips, but it would certainly be a creative way to keep a drink hot! When existing items are reused to create art in this way, they are called "found objects." Some of her found object sculptures include a pair of shoes tied together and a glass mug with a squirrel tail for a handle. Combining objects with different purposes can give them a fun new meaning or turn them into whimsical creations with no real purpose.

Can you think of any bizarre combinations you could create?

Object

NAM JUNE PAIK

Born: July 20, 1932 | Seoul, Korea (now South Korea)

KNOWN FOR

Video art, robots, televisions, art, and technology

TELEVISIONS AND TECHNOLOGY

Did you know your television could be used as a work of art? Nam June Paik was the first person to create artworks from TVs and videos, so today people call him the "father of video art."

Nam June Paik helped people see video in a whole new way by combining art and technology. He arranged TVs into many different shapes, including walls, towers, and even robots! The televisions in his sculptures could show films he recorded, videos he found, or abstract (not realistic) patterns he created.

Paik's largest artwork is called *The More, The Better*. It's a giant tower using 1,003 television sets. It's about as tall as 10 stacked refrigerators! He created this installation (an artwork that has been specially made to transform a place) for the 1988 Olympics in his hometown of Seoul, South Korea. Many of the screens show videos celebrating Korean culture.

Paik also liked making robot sculptures because he thought they could help people see a connection between humans and technology. (Take a look some of his robots on the next page.) His first robot was able to walk and talk, and could even go to the toilet—it pooed beans! His later robots didn't move, but they still looked lively. *Untitled (Bakelite Robot)* may look like it's made of televisions, but it's actually made from old radios the artist found in thrift shops. (Bakelite is an early plastic material.) He removed the insides and added screens. These screens bring the sculpture to life by showing videos of robot toys and science fiction films.

What would you show if you had a TV sculpture?

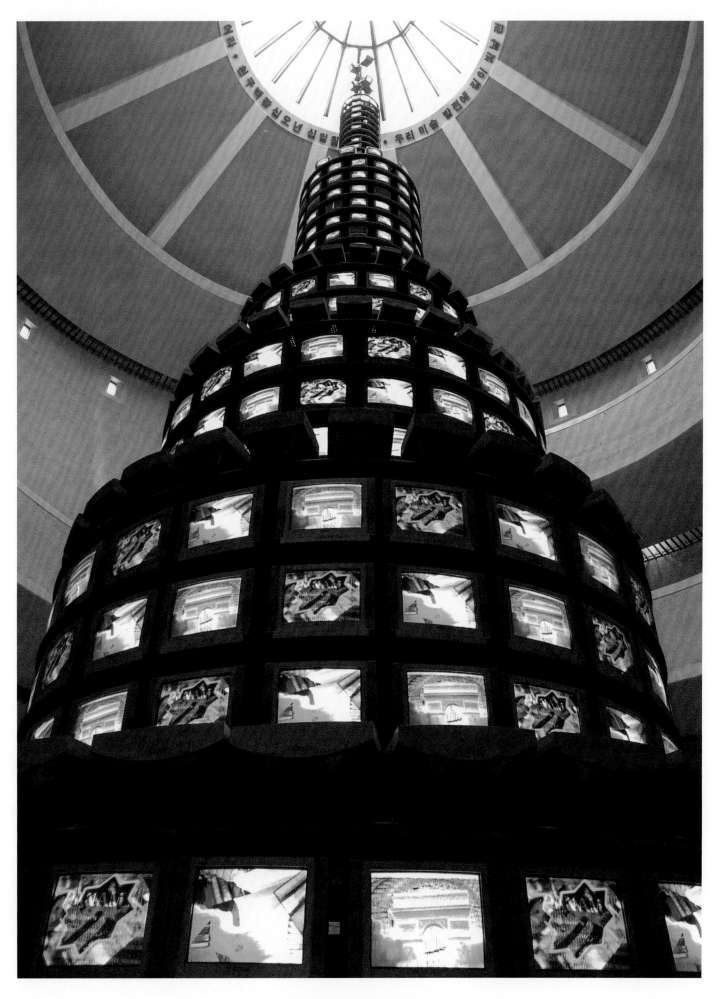

The More, The Better

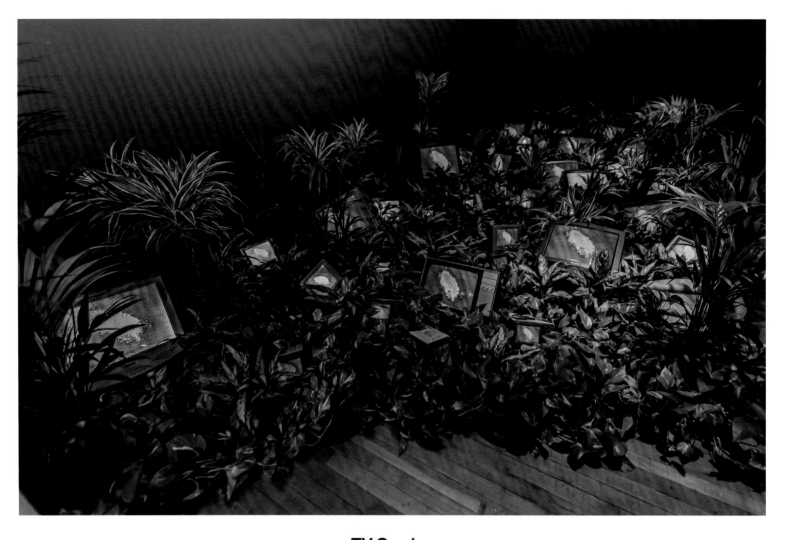

TV Garden

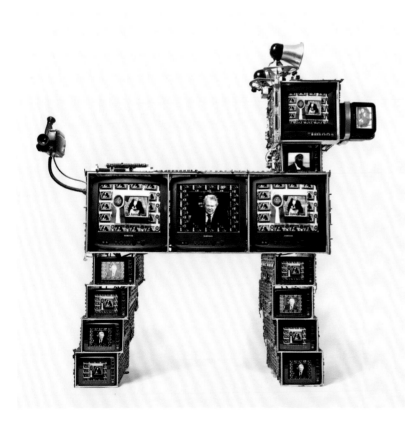

Watchdog II

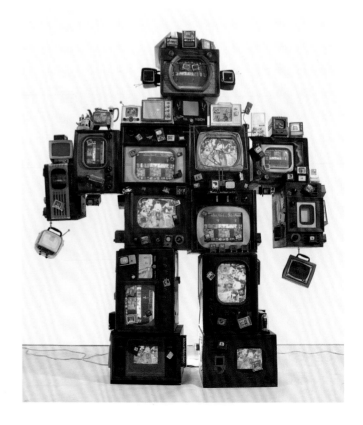

TV Is Kitsch

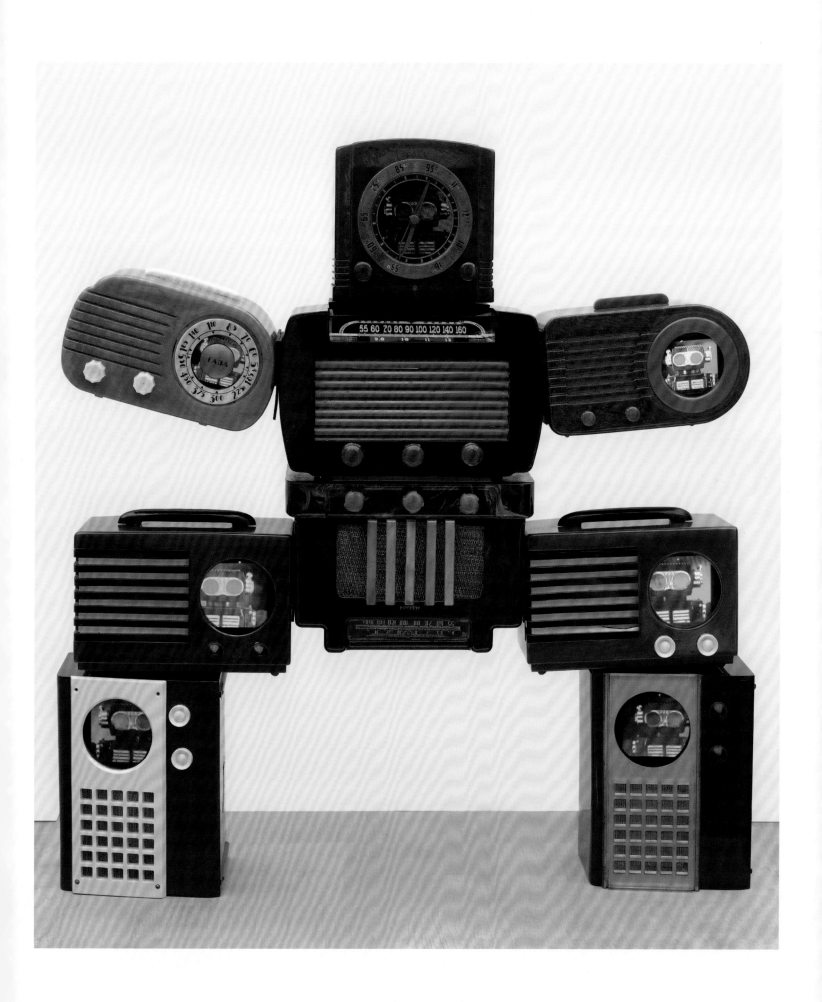

Untitled (Bakelite Robot)

CLARA PEETERS

Born: Around 1590 | Antwerp, Belgium

KNOWN FOR

Still lifes, food, flowers, hidden self-portraits

STUNNING STILL LIFES

Can you find the hidden self-portrait and signature? The incredible details in Clara Peeters's still life paintings are so lifelike, they almost look like photographs.

Clara Peeters is best known for her paintings of delicious foods, flowers, and fancy objects. She also hid her self-portrait and signature in some of her paintings! Look at the zoomed-in picture of a lid from a brown jug in one of her pictures. You can see the top half of her face and the white hat she is wearing. She hid portraits like this of herself in at least eight of her paintings. She also signed this painting in an interesting place. Instead of writing her name in a corner, like many other artists do, she painted it on the knife. This clever detail makes it look like her name is engraved on the handle.

Take a look at the full painting on the next page and see if you can spot the self-portrait and signature. *Still Life with Cheeses, Almonds, and Pretzels* is one of Peeters's many still life paintings—"still lifes" are what we call pictures of objects, such as flowers, food, and dishes. The items on this table show us that this meal was for a wealthy person. Look at the blue-and-white plate made of delicate porcelain. This dish would have come all the way from China. The glass cup on the right has a gold rim and was made in Venice, Italy, a city famous for its beautiful—and expensive—glassware.

The meal in this picture includes a gigantic wheel of cheese, pretzels, bread, crunchy almonds, and sweet figs. If you made a still life of your favorite foods, what would be on your table?

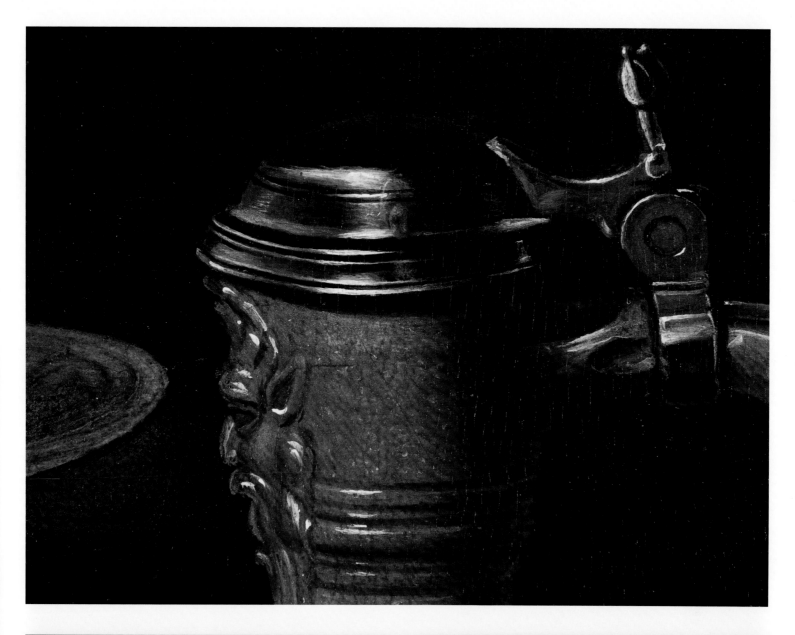

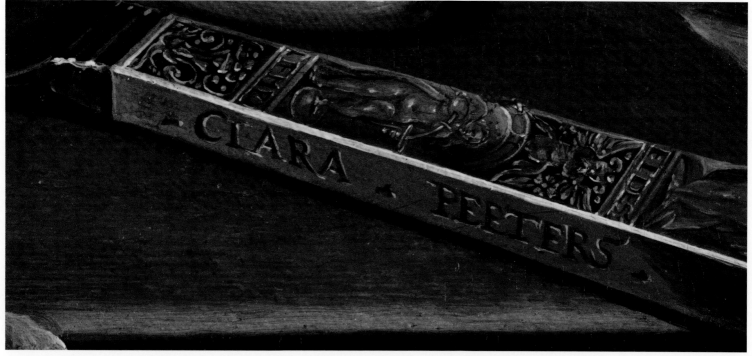

Details of *Still Life with Cheeses, Almonds, and Pretzels*

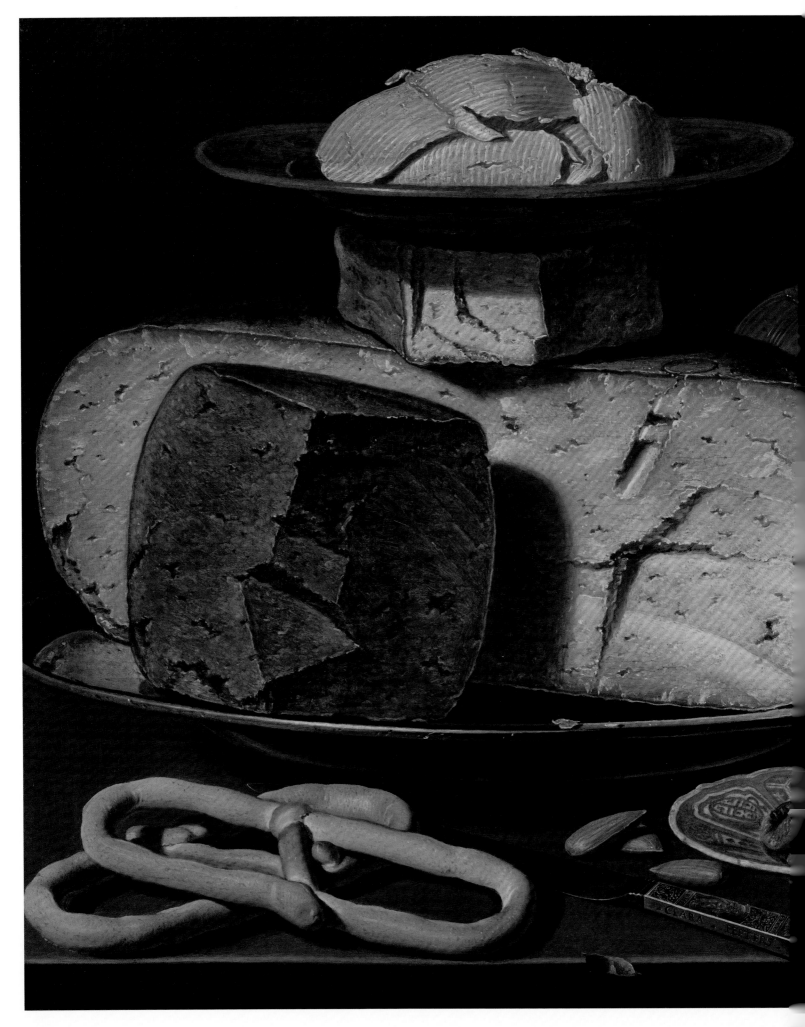

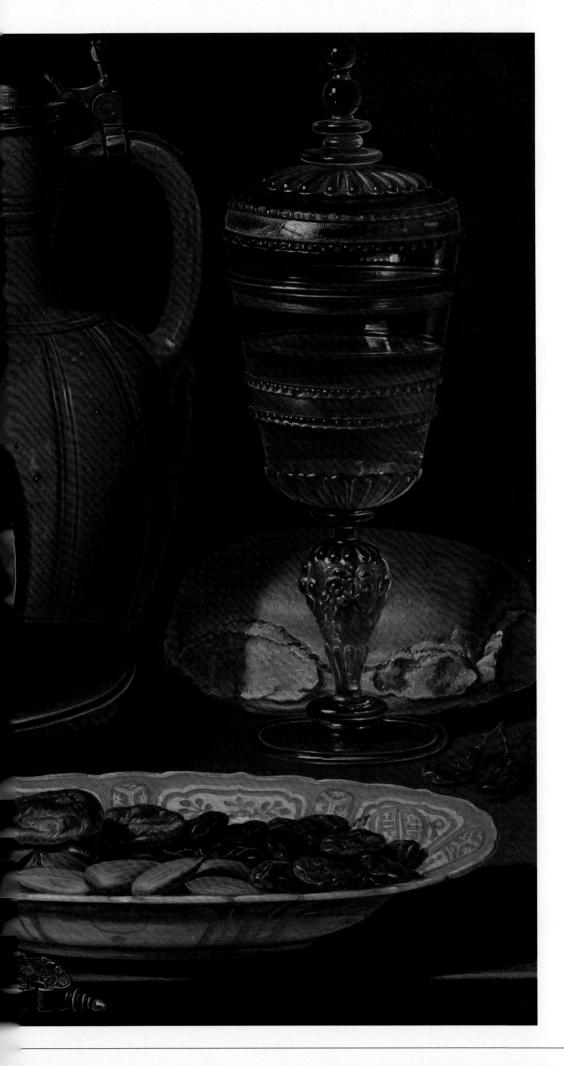

Still Life with Cheeses,
Almonds, and Pretzels

PABLO PICASSO

Born: October 25, 1881 | Málaga, Spain

KNOWN FOR

Modern art, Cubism

TEARS

Have you ever seen yourself cry? Do you frown, or scrunch your face? Do you get hot, with flushed cheeks? Do your eyes and mouth change shape?

Perhaps all of these things are happening to this weeping woman—her face looks as if it has changed in shape and color from crying so hard.

Pablo Picasso liked to invent new ways of drawing people and things. The results could be quite strange: For example, this woman's mouth is turned in a different direction from the rest of her face. Her eyes seem to be looking straight at us, but her lips and teeth are in profile, which means they are seen from the side. It's as if you can see her from two different directions at the same time. This kind of art is called Cubism, and Picasso was one of the first artists to paint in this new style.

Picasso wanted to show this woman's unhappiness and tears rather than to create an exact portrait of her face. The jagged shapes that look like pieces of glass, the bright colors, and the thick black outlines make us think of strong feelings, like anger or sadness. Can you imagine her sobs and her tears?

She looks as if she might be holding a handkerchief. She's wearing a red hat with a flower in it, and her hair is neatly combed, as if she is dressed for an important occasion.

What do you think has upset her so much?

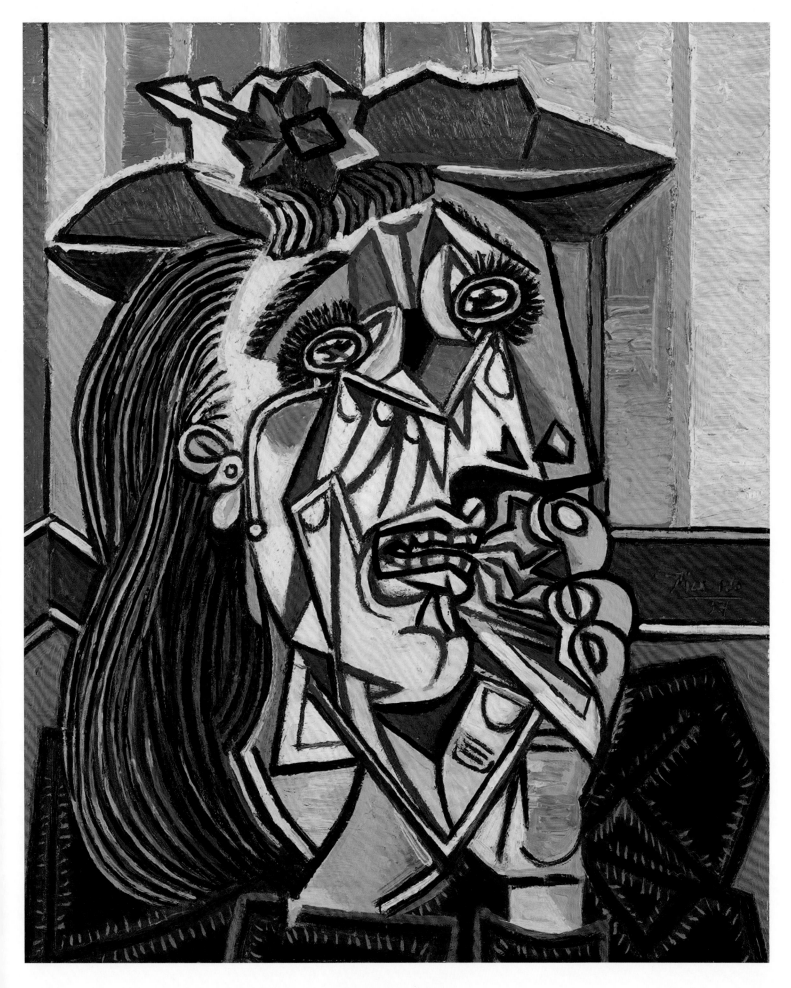

Weeping Woman

JACKSON POLLOCK

Born: January 28, 1912 | Wyoming, USA

KNOWN FOR

Pouring and splashing paint, action painting, Abstract Expressionism

SPLAT

What a mess! Splotches, splashes, and dribbles of paint are all over the floor!

Jackson Pollock's paintings look messy and haphazard, but did you know that they were very carefully planned? In fact, he cared very much where the paint would fall and which colors he used. Pollock didn't stand in front of a canvas to paint. When he painted, he dribbled paint onto a canvas on the floor as he moved around. This is called "action painting."

Take a look at his painting on the next page. He sometimes made so many layers of different colors land on top of each other that the paint became very thick. But then he kept other parts of the canvas completely bare. With a flick of his wrist, he let the paint fall off his brush in loops and swirls, landing with a SPLAT onto the canvas.

Pollock's paintings are abstract (they don't represent anything that we can recognize from real life.) They do, though, tell us a bit about how the artist was expressing his energy and emotions. Art in this style is called Abstract Expressionism.

What do you think Pollock was feeling when he painted *Number 1*? Excitement? Confusion? Anger?

Pollock signed this painting in two different ways—with his name and with his hands.

Can you find these signatures?

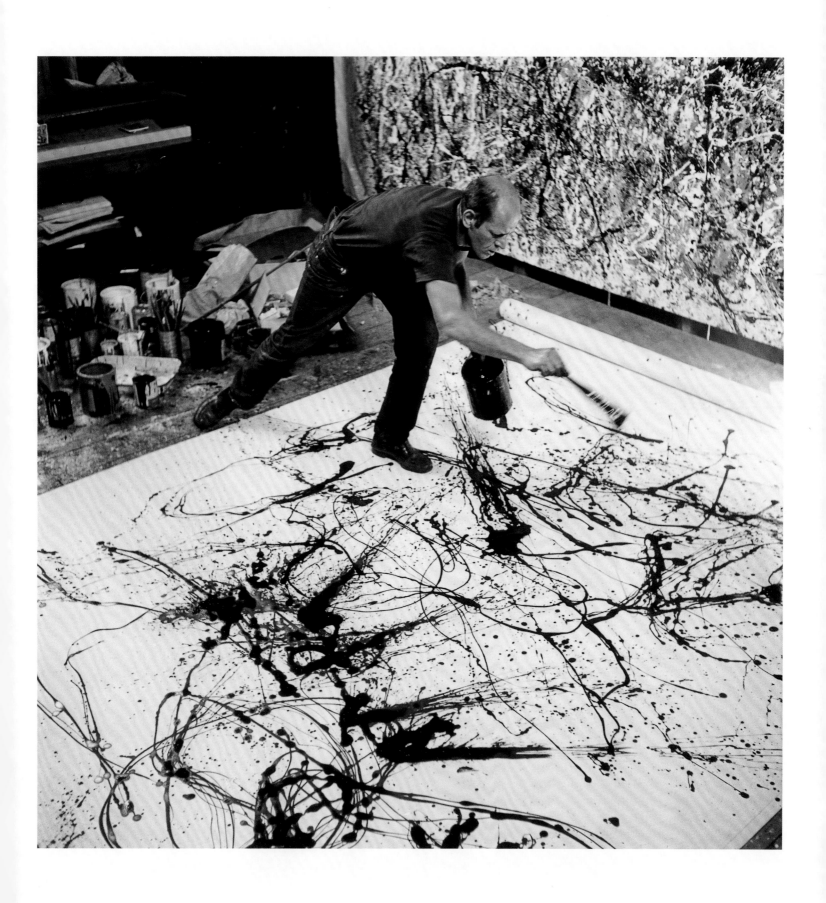

Jackson Pollock painting

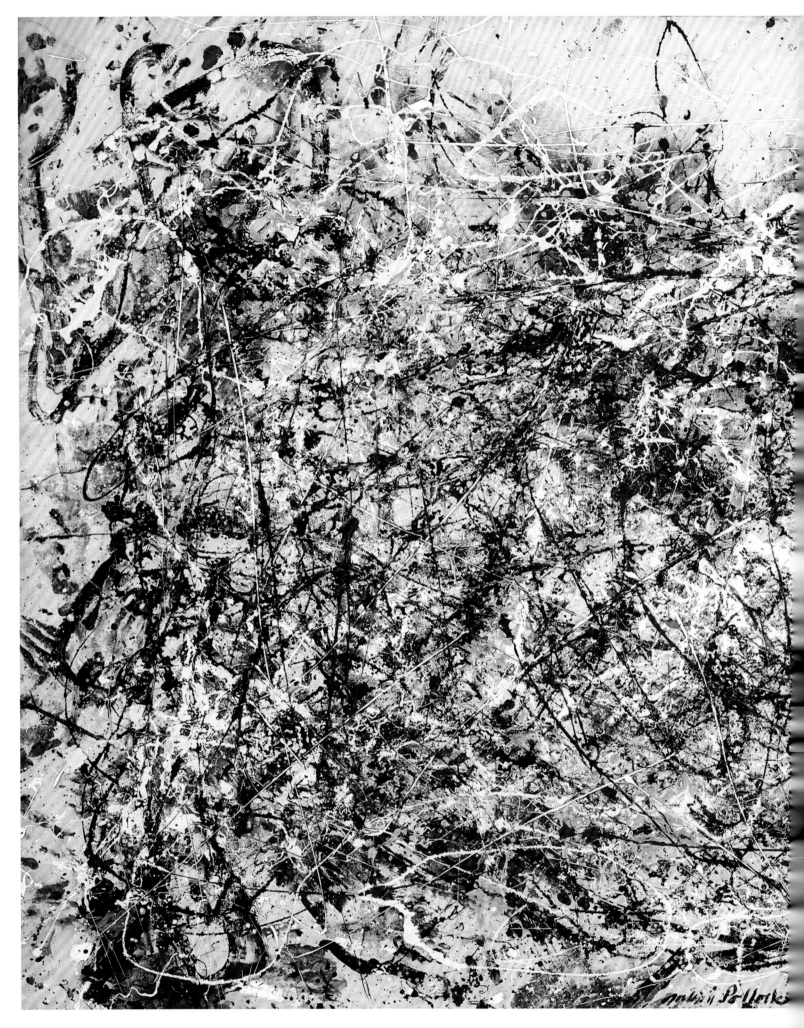

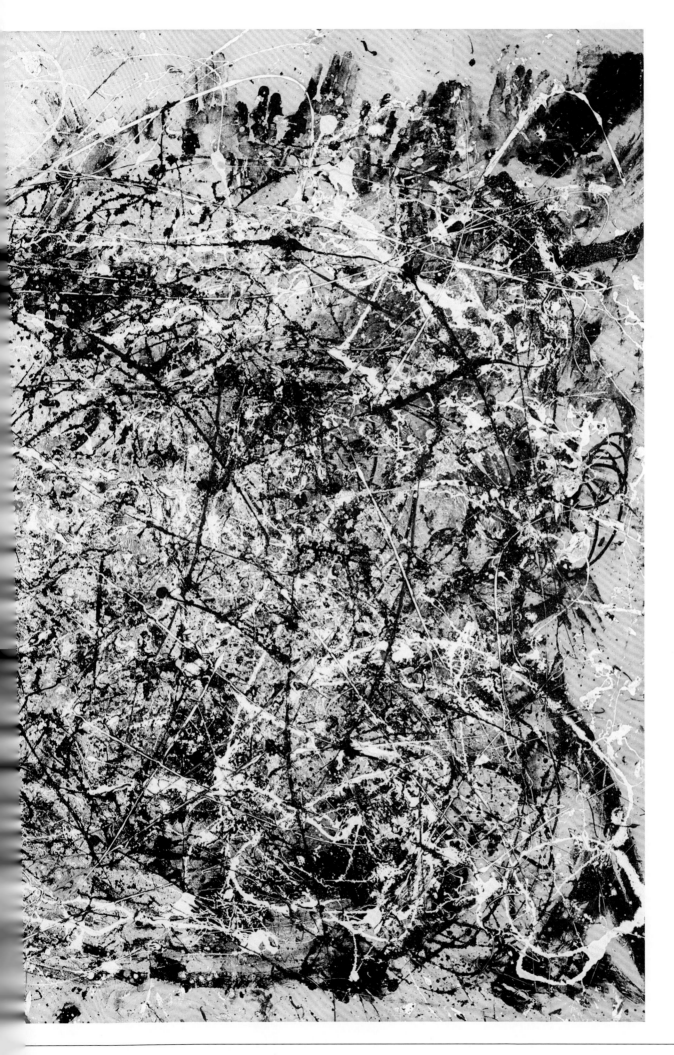

Number 1

RAPHAEL

Born: Around 1482 | Urbino, Italy

KNOWN FOR

Italian painting, architecture, Renaissance

CLASSROOM

This painting is called *The School of Athens*, but what kind of school could this be? Where are the desks? Where is the teacher?

The two men in the center appear to be in an intense discussion, with a crowd surrounding them. But there's a man lounging on the steps reading a piece of paper, and another man appears rather bored. He's not even looking at what he is writing.

If you think this looks like a rather unusual classroom, that's because these people are not students—they are actually all teachers! In fact, they are some of history's greatest thinkers: mathematicians, scientists, geographers, artists, and inventors—most of them from ancient Greece. Although some lived more than two thousand years ago, their ideas are still taught in schools today.

This group of impressive thinkers lived during what is sometimes called the Classical period. Many of them weren't alive at the same time, but Raphael, the artist who made this painting, painted them together to celebrate Classical ways of thinking, which were becoming popular again during the Renaissance period.

Some of the famous people you can spot are:
• The philosophers Plato and Aristotle
• The mathematician Pythagoras
• The astronomer Ptolemy
• And the artist Raphael himself!

You can see the entire painting on the next page. See if you can guess who is who!

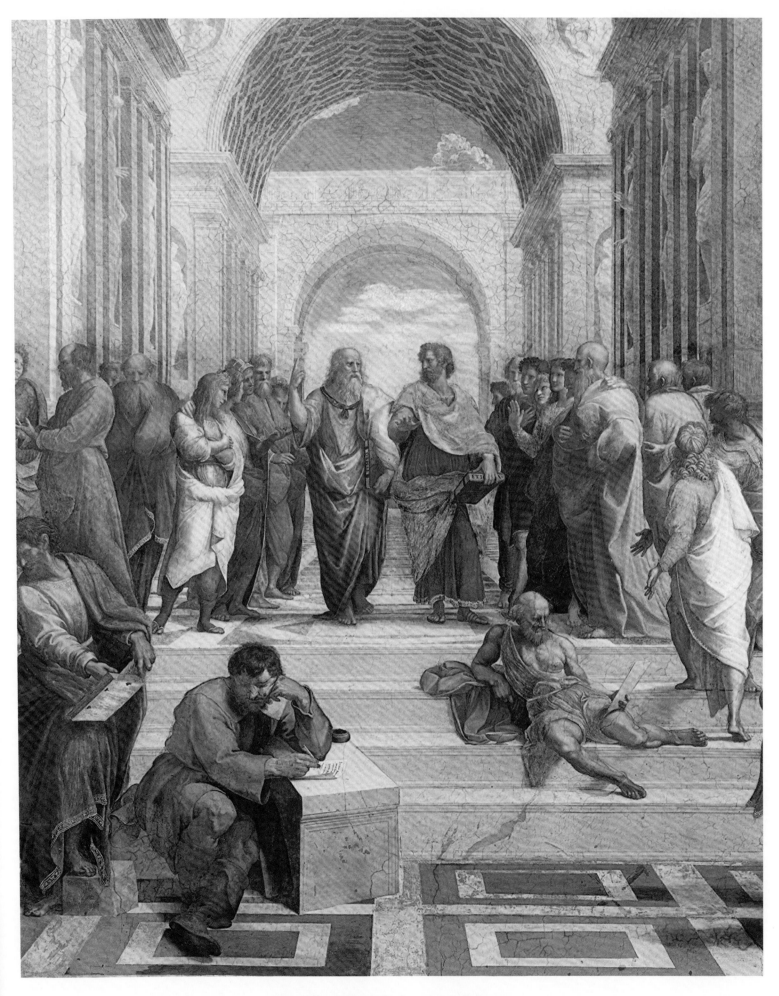

Detail of *The School of Athens*

At the center of the painting, the famous philosopher Plato is shown with his finger pointing up and in conversation with Aristotle. On the bottom left, we can spot the mathematician and philosopher Pythagoras studying a large book. Holding a sphere on the right side is the mathematician, astronomer, and geographer Ptolemy.

Raphael must have thought he was pretty special, too, because he included himself among these great teachers. You can find him on the far right. He is the second man in from the edge of the picture, and he's looking straight at us. Raphael also hides some amazing artists from his own time (the Renaissance period) in plain sight. Raphael used the famous Leonardo da Vinci (see page 100) as his model for how Plato looks! For the philosopher Heraclitus, Raphael used the Renaissance artist Michelangelo as a model— he is shown at the bottom of the painting leaning on a white block.

It's easy to get carried away looking at all the different people in this painting. But don't miss the absolutely enormous room they are standing in. In fact, this work, called a fresco, was painted directly onto a large wall. If you stood right next to it, the men in the foreground would be about the same height as you. No wonder the whole thing took Raphael over a year to finish.

The School of Athens

BRIDGET RILEY

Born: April 24, 1931 | London, United Kingdom

KNOWN FOR

Op art paintings

MOVING PICTURES

Does this picture look as if it is moving to you? If it does, then your eyes have been tricked!

If you look at this painting for long enough, the lines almost seem to drift across or wriggle around!

The artist Bridget Riley creates what's called Op art, which is short for "optical art." It's very similar to an optical illusion, which is when your eyes trick your brain into seeing something differently than how it really is. She's interested in how our eyes work when we look at things. The scientific word for this is "optics."

Cataract 3 is painted on a flat canvas, but by carefully aligning red and gray wavy lines of different sizes and shapes, Riley has created

an optical illusion—so our eyes think it is wavy, not flat.

Take a look at some of her other works on the next two pages for some more visual tricks. Try to relax your eyes as you look at each painting, and try to focus on different parts of the picture. See how Riley plays with shapes and colors to create a sense of movement. How does that affect the way they appear?

Cataract 3

In which direction do these pictures look like they are moving?

Fall

The longer you look at it, the lines in the picture on the left seem to wriggle down the picture. And if you look at the very center of the picture below, you can see how the artist has varied the position of the circles and ovals to create a sense of movement, or two sides splitting apart. This is what the title of the work, *Fission*, means.

Fission

FAITH RINGGOLD

Born: October 8, 1930 | New York City, USA

KNOWN FOR

Black history, quilts, storytelling, women's stories

STITCHING STORIES

There are many ways to tell a story. You can write it down, say it out loud, or show it through art. Faith Ringgold shares stories by making quilts.

Faith Ringgold first learned how to make quilts from her mother. Together, they stitched her first story quilt called *Echoes of Harlem*. Then Ringgold painted 30 faces on the top. She wanted to show some of the different people who lived in Harlem, in New York City, where she grew up.

Ringgold likes to make quilts because they are a special part of Black American traditions. Quilts can be made from scraps of fabric, old blankets or clothes, which often hold meaningful memories.

Sometimes, a group of people will work together to make a quilt—that's called a quilting bee. Turn the page to see *The Sunflowers Quilting Bee at Arles*, where Ringgold shows an imaginary

sewing session that includes famous Black women from history. They're all busy making a quilt covered in sunflowers while sitting in a field of them. They are in a French town called Arles, which is where the painter Vincent van Gogh once lived. To the right, you can see him standing with a vase of flowers, similar to the ones in his famous sunflower paintings (see page 71).

This is one of 12 quilts from a series called *The French Collection*. In these, Ringgold reveals the story of a fictional character named Willia Marie Simone, who traveled from Harlem to France and became an artist. In the writing on this quilt, Willia tells the story of how she met the fabulous women in this picture.

Echoes of Harlem

The Sunflowers Quilting Bee at Arles shows eight real women from history who fought to make the world better. Can you recognize any of the women in this story quilt?

MADAM C. J. WALKER

First American woman to become a self-made millionaire

SOJOURNER TRUTH

Fought against slavery and for women's rights

IDA B. WELLS

Journalist and civil rights leader

FANNIE LOU HAMER

Fought for civil and women's rights

HARRIET TUBMAN

Activist who fought against slavery

ROSA PARKS

Civil rights leader

MARY McLEOD BETHUNE

Fought for civil and women's rights

ELLA BAKER

Civil rights leader

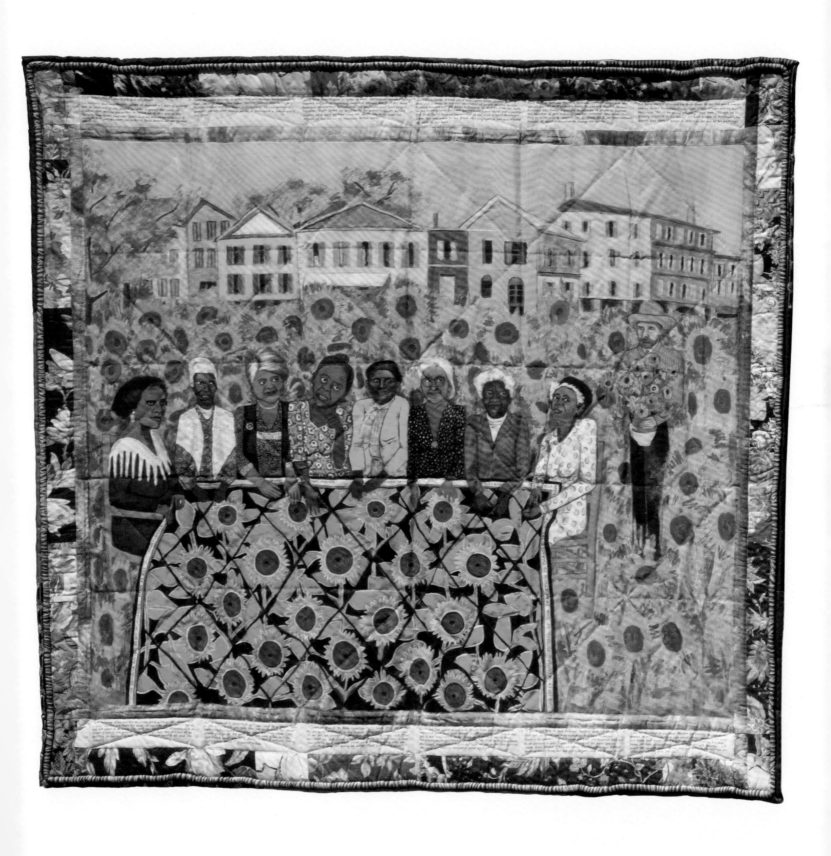

The Sunflowers Quilting Bee at Arles

HENRI ROUSSEAU

Born: May 21, 1844 | Laval, France

KNOWN FOR

Jungle scenes, wild animals, self-taught artist

IMAGINED JUNGLE

Why do we think that Henri Rousseau probably never saw a real jungle? There are some clues in his pictures!

Everything in this picture seems a little strange. It's as if every eye and every leaf are turned toward us, awaiting our arrival! Have these monkeys been expecting us?

Even though he probably never left his home country of France, Henri Rousseau's paintings show thick jungles, full of tropical plants and wild animals. Rousseau most likely studied animals at the zoo, instead of in a real jungle. Maybe that's why these animals all seem to be looking at us. Have you ever been to the zoo? Sometimes it feels as if the animals have come out to watch us, just as we have come to watch them. Every monkey in this picture, as well as the bird sitting on the branch, is staring at us.

Look at that upside-down milk bottle in the foreground: you wouldn't find that in the jungle, but you might find it in the zoo.

Rousseau also visited botanical gardens to study tropical plants for his pictures. This one contains the leaves from lots of different kinds of plants. Some are long and thin. Some are oval or pear-shaped. It's as if he gathered all the plants and animals he had studied and painted them into one scene.

Rousseau became a painter later in life. He taught himself to paint! This painting may have been an exercise in how well he could paint plants and animals.

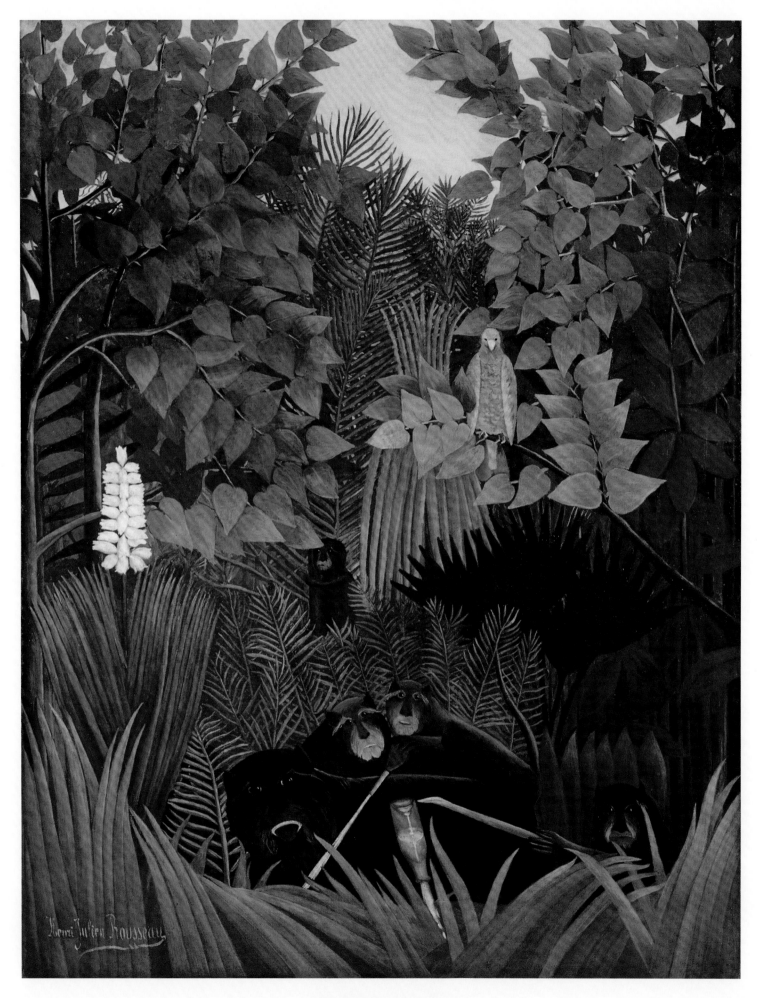

The Merry Jesters

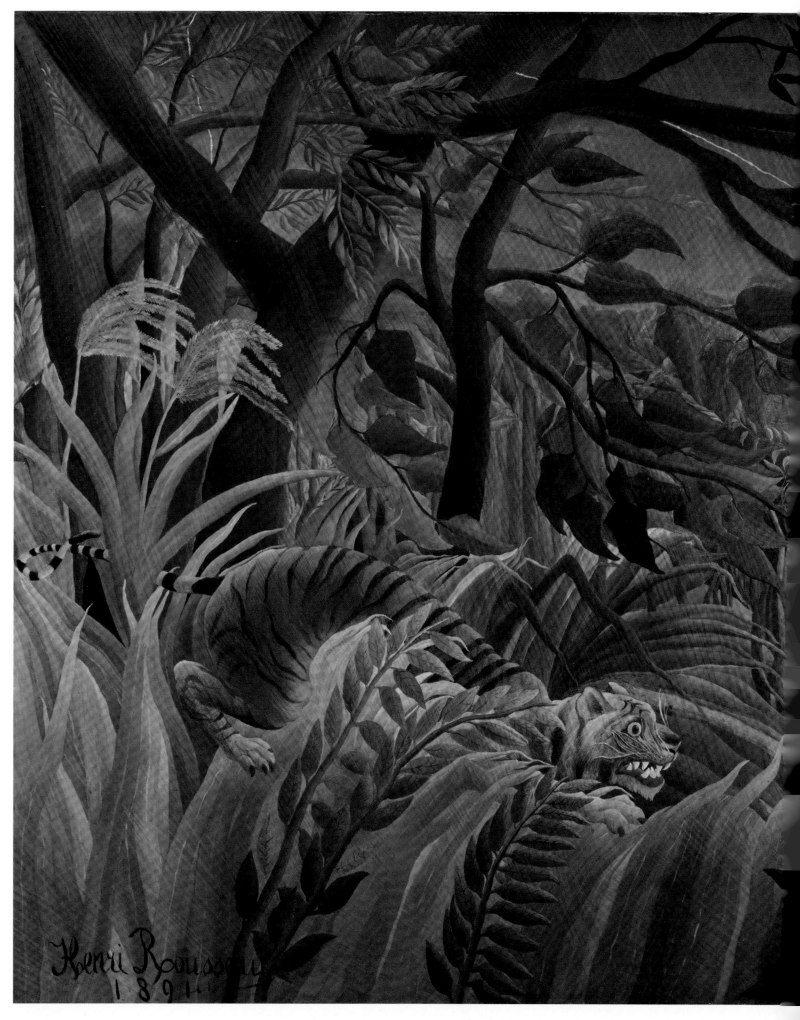

How would you describe the tiger's expression in this picture? The title of this work is *Surprised!* and it is one of Rousseau's most famous paintings. The tiger's eyes are wide, as though the animal is shocked. Look at the lightning flashing across the sky and the streaks of rain across the canvas. Maybe the tiger has just been surprised by a thunderous CRACK! Or does the animal look like it's getting ready to pounce on something? Perhaps it's the tiger's prey that's in for a big surprise? We can't see what's beyond the canvas, so perhaps Rousseau left the surprise to our imagination.

The plants at the bottom of this picture aren't typical jungle plants—some were based on houseplants! Rousseau made them bigger so that they would look like large jungle plants. He studied at his local botanical garden and referenced various illustrations in prints and books to create this painting.

How would you go about drawing a jungle scene? Would you look at pictures of jungles and animals or visit a zoo? Maybe you would paint it from your imagination!

Surprised!

GEORGES SEURAT

Born: December 2, 1859 | Paris, France

KNOWN FOR

Painting with tiny dots (pointillism)

SPOTS

The painting on the following pages is all about spots. There are also plenty of things for you to "spot"!

This painting is actually made up of thousands of tiny spots, or dabs, of paint! Georges Seurat said that he made this and other paintings with "points" of paint. So his style of painting was called "pointillism".

Most painters who lived at the same time as Seurat mixed their paints to make new colors. For example, if you wanted to make green paint, most people would mix together yellow and blue. Seurat did not. He used a small brush to put tiny dots of each color directly onto the canvas. He discovered that if you place different colored dots close to one another on a painting and stand back from it, your eyes blend the colors for you. If you look at this painting up close, you see lots of tiny dots of different colors. From a distance, however, you can see people taking a stroll on a Sunday afternoon!

Have a look over the page. Can you spot:
- a girl with a small bunch of flowers?
- a lady fishing?
- a man playing a trombone?
- eight parasols—seven open and one closed?
- a lady taking a monkey for a walk?
- a team of rowers in a boat?

Seurat liked dots so much that he covered the painting's border with them too!

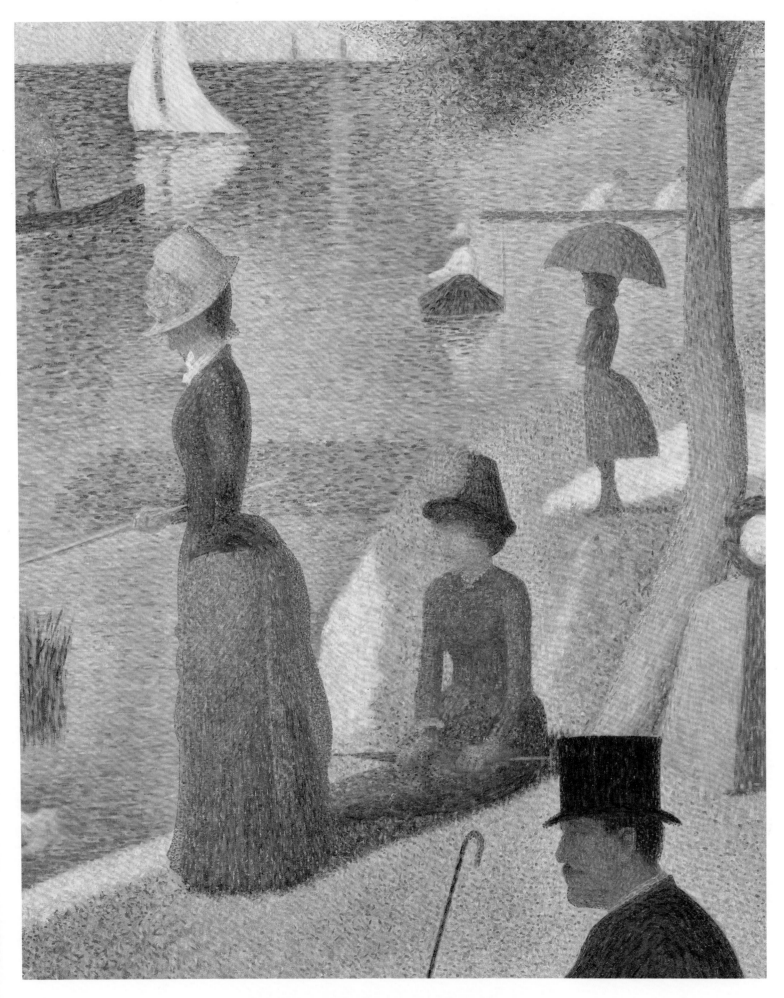

Detail of *A Sunday on La Grande Jatte*

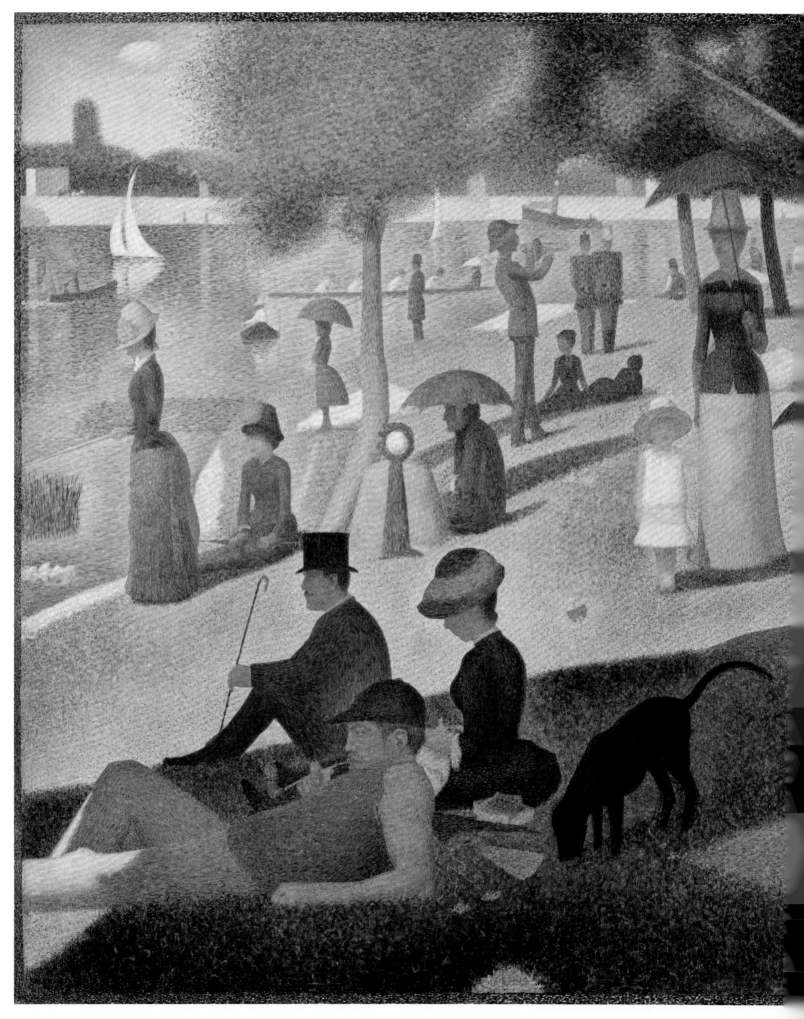

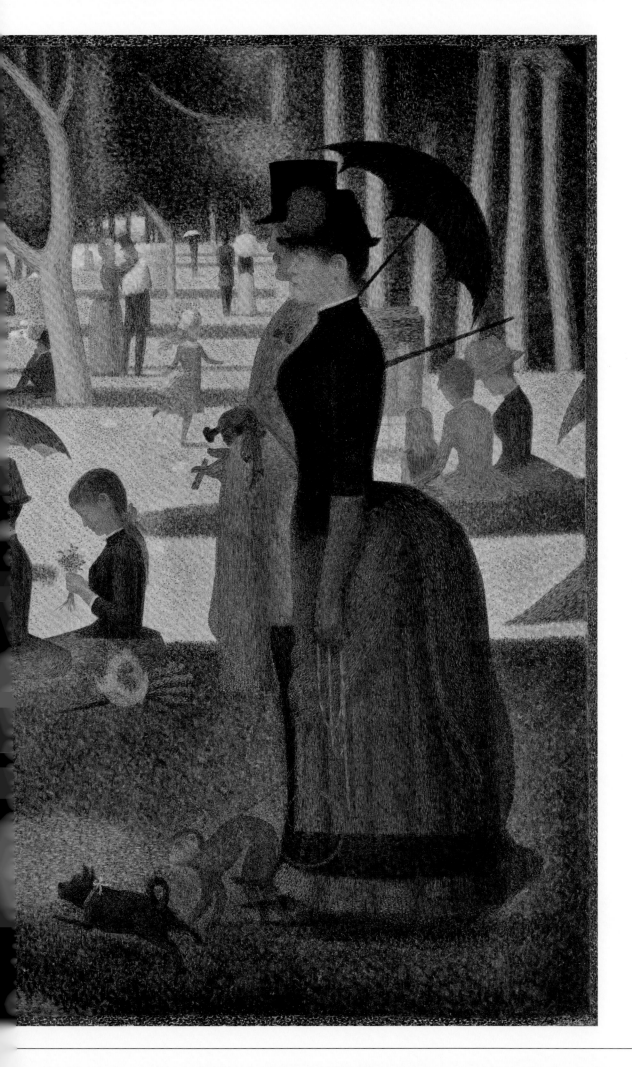

*A Sunday on
La Grande Jatte*

AMRITA SHER-GIL

Born: January 30, 1913 | Budapest, Hungary

KNOWN FOR

Modern Indian art, pictures of village life, portraits of women

LIFE IN YOUR COUNTRY

How would you draw what life is like where you live? Who would you draw? What would it be about?

Amrita Sher-Gil grew up in two different countries with different cultures and combined some of the art styles of both places in her paintings. She was born in Hungary, just like her mother, and later moved to India, where her father was from. When she was only eight years old, she started taking art lessons. She was so talented that she studied painting in Paris after moving there with her family.

Group of Three Girls was the first painting she made after she finished art school in Paris and returned to India. It's a picture of three of her cousins. She depicted them in bright, bold colors, but they look very calm, as though they are thinking quietly.

What do you imagine the girls in this painting are thinking about?

During Sher-Gil's lifetime, many artists in India were exploring new ways to reflect modern Indian life through painting. Many of her paintings show what life was like for the women and poor people who lived in the Indian villages.

Sher-Gil became ill and died when she was only 28 years old. Even though she had a short career, her work is so admired that it has been labeled a "national art treasure," which means that her paintings must remain in India and cannot be sold outside the country.

Group of Three Girls

AMY SHERALD

Born: August 30, 1973 | Georgia, USA

KNOWN FOR

Painting photographs, portraits, Black lives

PHOTOGRAPHY MEETS PAINTING

Say cheese! Amy Sherald is inspired by photographs to create bright and joyful paintings of Black Americans in their daily lives.

Amy Sherald's portraits are so lifelike that they almost look like photos! Photography is actually an important inspiration for the artist, who creates colorful pictures of people in simple poses doing everyday activities.

Did you notice that Sherald uses shades of gray to paint people's skin? This is similar to how people look in black-and-white photographs. All her paintings feature Black Americans, but she paints their skin in this way to encourage people not to focus on their color or to judge others because of their race.

Many of Sherald's paintings start from a photograph. If she sees an interesting person, she may ask them to model for a painting by having them pose for photos. Sometimes she gives people clothes or props to use in order to bring her ideas to life. She then uses the pictures as a guide for her oil paintings.

Sherald's portraits often show people in front of a bright, blank background, which helps them stand out, but she also shows people in fun settings, like a rocket launch (turn the page to take a look). Most of all, she likes to capture moments that show everyday people doing everyday things.

Do you have any photographs that you would like to turn into a painting?

What's different about Alice is that she has the most incisive way of telling the truth

Precious jewels by the sea

Planes, rockets, and the spaces in between

CINDY SHERMAN

Born: January 9, 1954 | New Jersey, USA

KNOWN FOR

Early selfie photographs, dressing up, identity

DRESSING UP

Can dressing up really be art?
Cindy Sherman certainly thinks so!

Cindy Sherman appears in almost all of her photographs—but she looks different every time. In each portrait (she has made hundreds!), the artist wears different clothes, makeup, and hairstyles before taking a picture of herself. In this way, she creates many different characters. Take a look at some of her pictures on the next few pages. Can you believe they're all actually the same person? She can be young or old, silly or sad. Every character could have their own unique story!

Sherman uses clothes and makeup, as well as different props and settings (some real and some imagined), to create the identity of the person in the photograph—and she casts herself as the star of each one!

But Sherman doesn't try to tell us everything about a character. In fact, these photographs are all untitled. She leaves many things to our imagination. The photographs could be a scene from a film—but we don't know which film, who the character is, or what has happened.

See if you can make up a story about one of the characters. What kind of movie would they be in? Who would they be?

Untitled

Untitled #96

Untitled #416

Untitled Film Still #35

Untitled #210

Untitled (Self-Portrait with Sun Tan)

Untitled #119

WHAT A MAP CAN TELL

What do you expect to see in a map?

Maps show us where to find different places and can guide us when we're traveling. But maps can also help us shape the way we see the world!

Like many maps, this painting called *State Names* by Jaune Quick-to-See Smith has words written on it, but these place names are different from what you might usually find on a map of Canada, Mexico, and the United States. Smith has made this painting to share the history of some of North America's native cultures.

Do you notice that some of the names are missing? Some of the lines between states are also blurred and hard to see. Smith has only included the names of places that come from Native American words. The dripping paint covers up the borders of different states because these lines didn't exist before European settlers arrived in the late 1400s. These people were called colonists because they took over the land so they could live there themselves. So what was there before? Smith's paintings encourage us to think about who originally lived on the land before it was taken from them and how history has many layers.

Think about the names of the places near your home. Do you know where they come from?

State Names

TARSILA DO AMARAL

Born: September 1, 1886 | São Paulo, Brazil

KNOWN FOR

Modern Brazilian art

COMBINING INSPIRATIONS

Do you think this picture is shocking? Have you ever seen anything like it before?

This painting *Abaporu* is *meant* to be surprising! Tarsila do Amaral made it as a birthday gift for her husband. She wanted to create an unusual picture that would startle him, and it worked! Look at the size of this person's giant foot compared to their tiny head. Their body is completely stretched. They look like a giant sitting next to this cactus.

Tarsila's husband became so excited about it that it inspired a whole new modern Brazilian art style called the Anthropophagic Movement. In this movement, Brazilian artists gathered ideas and influences from European artists and transformed them into their own unique style of art. Tarsila was inspired by artists from different parts of

the world. At first, she learned how to paint in an Impressionist style (see Berthe Morisot on page 116). Later, during one of her visits to Paris, she met artists who were inspired by African art and who were working in new movements, like Cubism (see Pablo Picasso on page 130). Seeing these artworks gave her the idea to combine modern European styles with traditional art forms and subjects from her home country of Brazil. The giant-like figure comes from stories Amaral heard growing up, and the colors in the picture are the same ones used in the Brazilian flag.

Are there any art styles in this book that you would like to try mixing together?

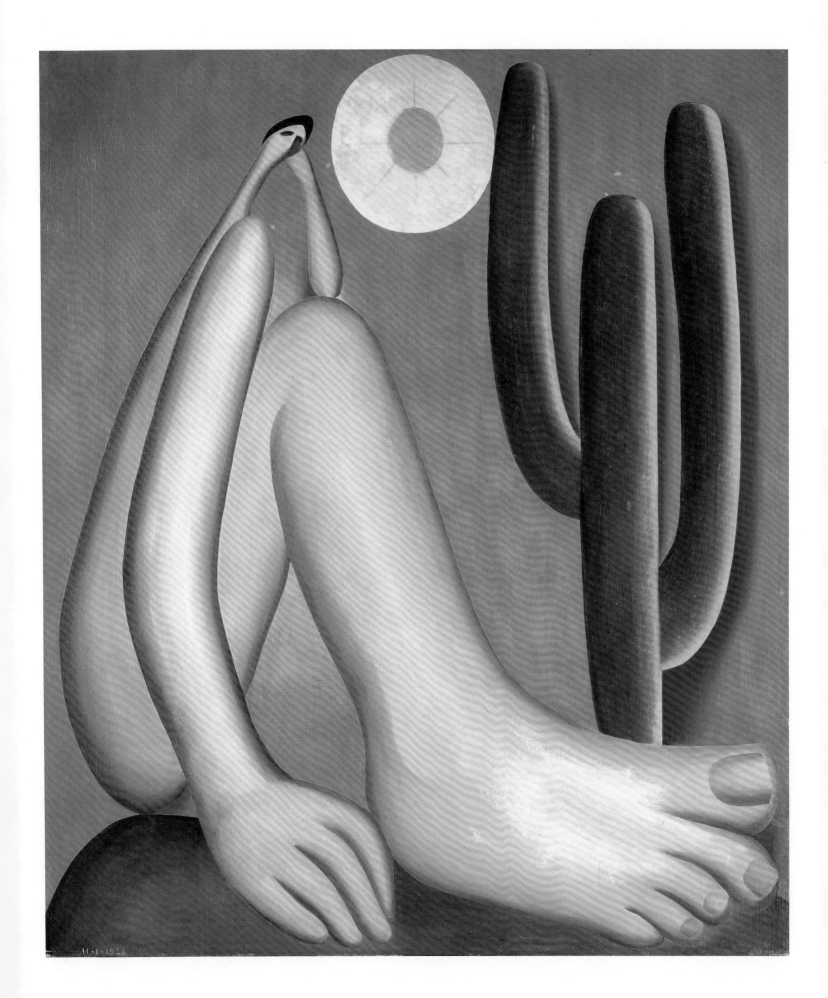

Abaporu

J. M. W. TURNER

Born: April 23, 1775 | London, United Kingdom

KNOWN FOR | Landscapes, seascapes, weather

A STORM

Hold on tight! The wind is howling, the waves are raging, and a snowstorm is swirling all around!

At first, this painting looks like a blur, but you can just make out the black line of a ship's mast, with its tiny triangular flag at the top. This painting shows a small paddle steamer, desperately trying to keep afloat as it is being thrown about by waves. J. M. W. Turner's big, washy brushstrokes help give a feel for all the wind and water whooshing through the air.

Before painting this picture, Turner did a lot of research. There's a story that he tied himself to the mast of a steamship for four hours as it sailed in bad weather. He really wanted to know what it would feel like to be out on a boat in rough seas and to be lashed by the full force of the violent winds and immense waves of a raging storm.

Turner loved painting the weather. He was painting storms and shipwrecks during a time, over 150 years ago, when people would have risked their lives on ships like these. Can you imagine being on board in a terrible snowstorm, as huge waves sweep around you, icy water floods the decks, and your boat is tossed by the raging sea? His pictures might give you an idea of what that would look and feel like.

Snowstorm: Steam-Boat off a Harbor's Mouth

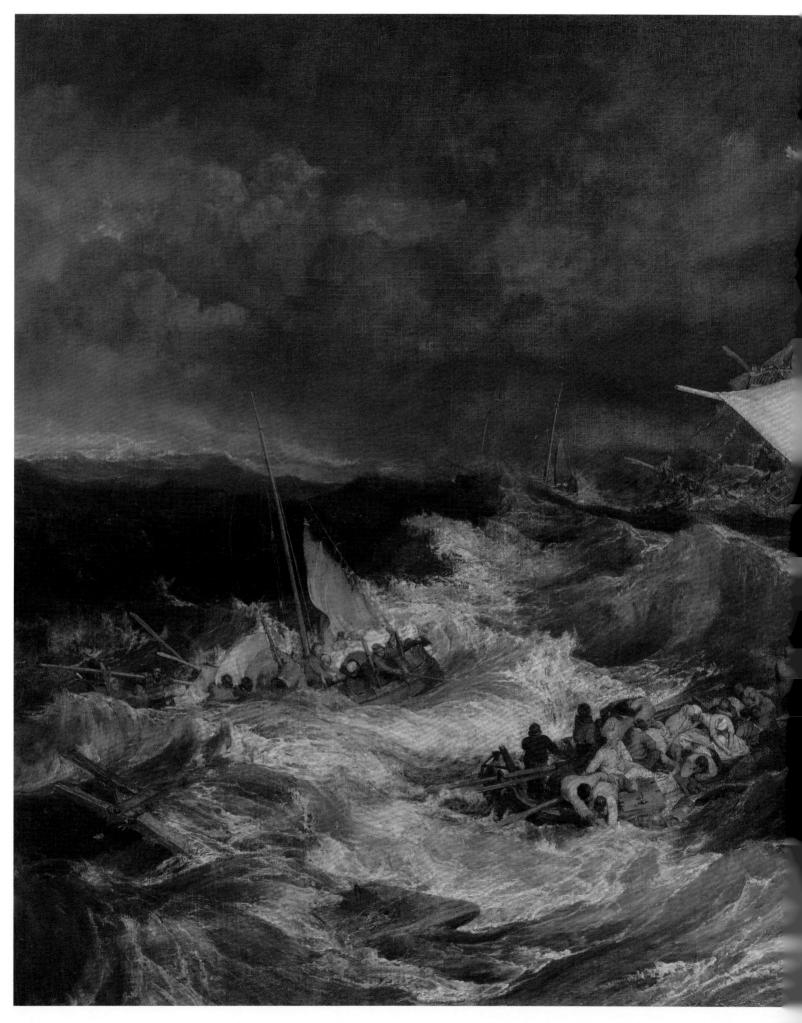

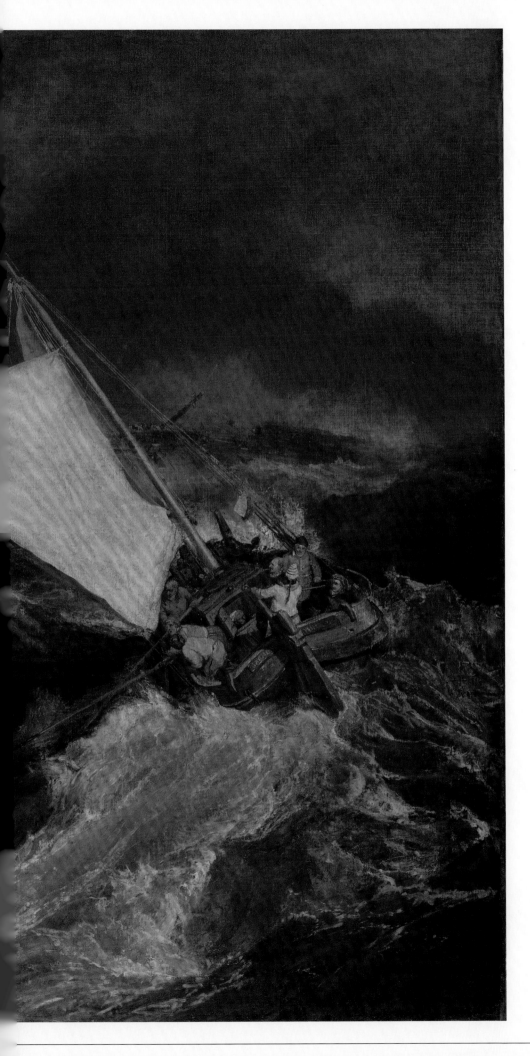

In *The Shipwreck*, we can see
the boat and its crew much more
clearly, but the sea is still choppy.
You can just imagine what the
blustering winds would have felt
like from this picture.

The Shipwreck

DIEGO VELÁZQUEZ

Born: June 6, 1599 | Seville, Spain

KNOWN FOR

Portrait paintings, dramatic lighting

ALL ABOUT PORTRAITS

What is everyone looking at? Are they looking at you? The clue is in the painting!

If it feels like most of the people in this picture are looking at you, you're sort of right, but in this painting, we are standing in the place of someone else. Someone who is looking *into* the room.

We see a little girl with blonde hair in the center. This is Margarita-Teresa, the five-year-old daughter of the King and Queen of Spain. Her *meninas*, or maids of honor, are looking after her. But Margarita is looking out toward us, and she's not the only person looking in our direction. On the far left, the person who is looking our way is holding paintbrushes and a palette and is standing in front of a very large canvas. This is Diego Velázquez, the painter. He looks as if he is in the middle of painting something.

He is looking at us. Is he painting us?

The answer is above Margarita's head, on the back wall. Do you see that frame with two people? It's not a picture—it's a mirror. In the mirror we can see the reflection of the king and queen of Spain, and if this were a real room, we would be standing right where they are! That's who Velázquez is painting.

This picture is all about portraits. It contains a self-portrait (a painting of the artist himself) and a portrait of the king and queen (visible in thé mirror), their royal court, and their daughter with her maids keeping her entertained while her parents sit for their own portrait.

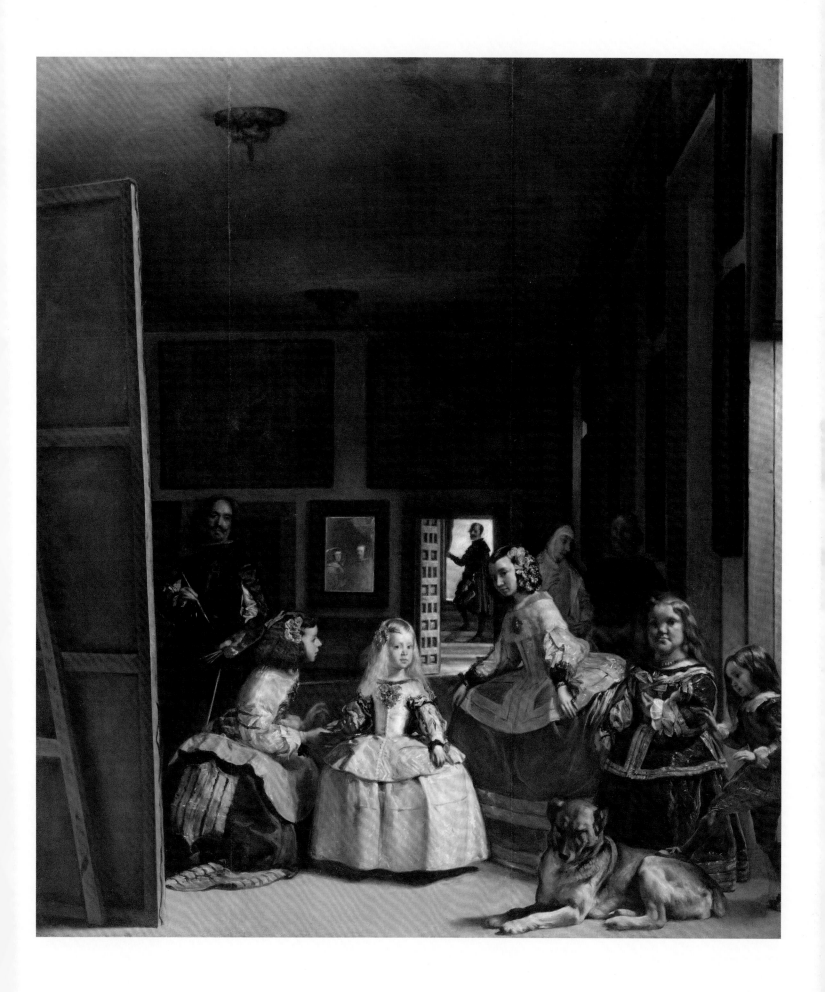

Las Meninas

KNOWN FOR

Pop art, film director, celebrities, prints

MOVIE STAR

Who's your favorite movie star or pop star? If you were an artist, what kinds of pictures would you make of them?

Andy Warhol was a big fan of many famous people. Some of his most well-known pictures were of the glamorous movie star Marilyn Monroe. He made over 70 portraits of her! Each one was a little bit different. Warhol created them by first making copies of a black-and-white publicity photograph of the actor. He then colored each in a different way. In this version, he made Marilyn's hair yellow, her eyeshadow blue, and the background orange. Take a look at the pictures on the following pages and spot the differences!

Warhol colored each picture in a different way using a technique called silk screening. When businesses want to print the same design on lots of signs or boxes, they sometimes use the process of silk screening. Warhol liked that idea, and he even called his studio The Factory.

Warhol was called a Pop artist, because he made art from pictures of "popular" things. He loved to make pictures of people and objects everybody could recognize, whether it was a dollar bill, the singer Elvis Presley, or a can of Campbell's soup he ate for lunch. He was fascinated by the idea of fame. He once said that everyone in the world will be famous for 15 minutes.

What would you like to be famous for?

Peach Marilyn

Blue Marilyn

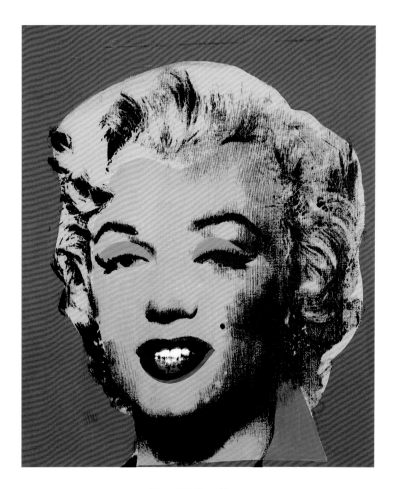

Red Marilyn

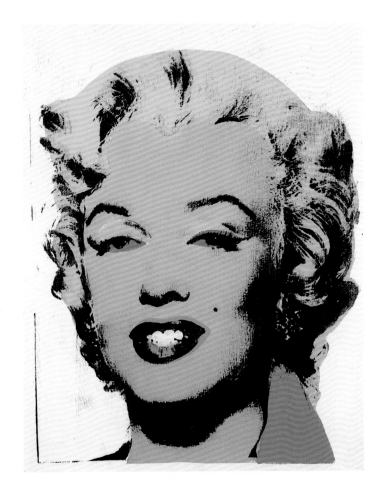

Lemon Marilyn

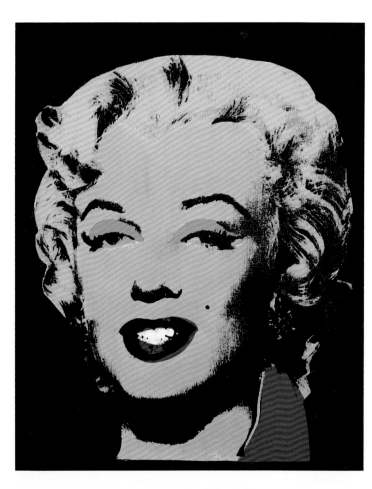

Licorice Marilyn

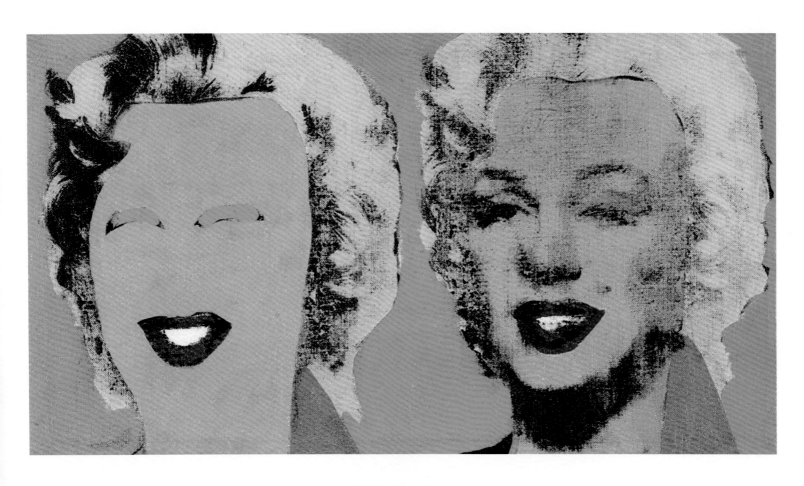

Two Marilyns

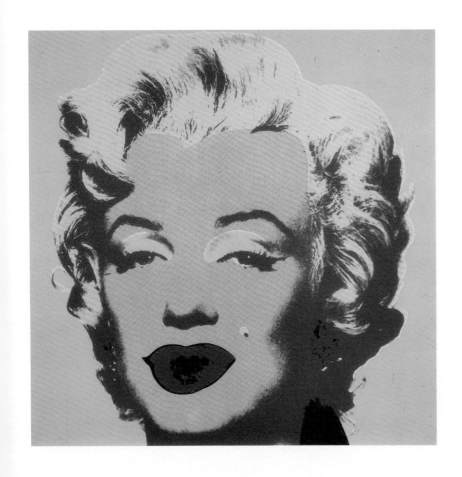

Marilyn

Black-and-white publicity
photograph of Marilyn Monroe

RACHEL WHITEREAD

Born: April 20, 1963 | London, UK

KNOWN FOR

Installation art

INSIDE OUT

Imagine turning a building inside-out! When Rachel Whiteread makes sculptures, she shows us the empty spaces we don't usually notice.

If you pressed your hand into a big mound of clay, you would leave an impression. Even though your hand isn't there anymore, we would still see its size and shape. The empty area where your hand was is called negative space. Negative space is also the phrase we use in art to describe empty areas, like a hole in a sculpture or the space around an object. Positive space is just the opposite! It's all of the parts that you *can* see.

Rachel Whiteread creates sculptures that help us see negative spaces more clearly. She does this by pouring plaster, concrete, and other materials into empty spaces and letting them harden. Then she takes off the outside layer to reveal what's inside.

Look at the sculpture on the opposite page. What do you think it is? It might seem a bit familiar, but it also looks unusual. The sculpture is of a staircase! You can see the usual zigzag shape in front, but behind this, Whiteread has also revealed the empty space *above* the stairs. We're seeing the positive and negative space of the staircase side-by-side.

Have a look at *Chicken Shed* on the next page. For this work, Whiteread filled a whole shed with liquid concrete, let it harden, and then took away its walls and roof to show the negative space inside. You can even see where the frames of the doors and windows used to be by the shapes they left in the concrete!

Untitled (Stairs)

Chicken Shed

YIN XIUZHEN

Born: August 21, 1963 | Beijing, China

KNOWN FOR

Cities, traveling, clothes, suitcases, memories, soft sculpture

TEXTILE TOWNS

Did you know sculptures can be soft? Rather than use stone or wood, or other hard material, Yin Xiuzhen makes soft sculptures of tiny cities using old, well-worn clothes, fabric, and suitcases!

Yin Xiuzhen makes miniature versions of famous cities from all around the world that fit perfectly inside an open suitcase. Each one is built using clothes worn by the people who live there, meaning people's old socks, tights, T-shirts, shoelaces, and even pajamas are turned into mini skyscrapers, towers, roads, and parks! This gives each sculpture a special connection to its city. The artist had the idea to make these soft sculptures after spending a lot of time traveling and keeping her important items in a suitcase.

Yin has made models of many cities, including New York, USA and Melbourne, Australia, and often includes famous buildings that make each place easier to recognize. Are there any clues that tell you which city this is?

It's a sculpture of Tokyo, Japan. It includes Tokyo Tower (a famous radio and TV broadcasting tower), and in the background, you can see the snow-capped peak of Japan's most famous mountain, Mount Fuji. (For more art of Mount Fuji, see pages 78–81.)

If Yin made a sculpture of your town, or one nearby, what landmarks do you think she would include? And which clothes would you share from your wardrobe?

Portable City: Tokyo

THERE'S SO MUCH ART TO DISCOVER—THIS IS JUST THE START!

AND THERE ARE MANY MORE COOL THINGS TO LEARN. DID YOU KNOW THAT:

- Art used to be an Olympic competition
- A painting by Henri Matisse was once hung upside down in the Museum of Modern Art for 47 days
- Louise Bourgeois made her first sculpture out of bread when she was a child
- Jackson Pollock once worked as a statue cleaner
- Some of the smallest handmade sculptures in the world are so tiny that you have to look through a microscope to see them

YOU CAN CONTINUE YOUR ART EXPLORATION AT YOUR NEAREST GALLERY OR MUSEUM.

PICASSO FAMOUSLY SAID, "EVERY CHILD IS AN ARTIST." WHAT KIND OF ARTIST WOULD YOU WANT TO BE?

WHAT WOULD YOU CREATE?

The artists in this book created so many types of art. Did any of the drawings, paintings, sculptures, prints, or installations inspire your creativity?

WHAT MATERIALS WOULD YOU USE TO MAKE YOUR ART?

You don't have to have a paintbrush and canvas to make art—you can make art with anything! What were some of your favourite materials that artists used in this book?

WHAT STYLE WOULD YOUR ART BE?

Whether you use a lot of action to create an artwork like Helen Frankenthaler or you paint tiny details like Basawan, there are many styles of art. From lifelike pictures to unreal shapes and splashes—the choice is yours!

WHERE WOULD YOU PUT YOUR WORK OF ART?

Art isn't just for galleries and museums—it's all around you! You can find it on buildings, television screens, clothing, and more. You can decide the perfect home for your masterpieces.

NOW, WHAT WILL YOU CREATE?

**WANT TO KNOW MORE ABOUT
THE WORKS IN THIS BOOK?**

HILMA AF KLINT
Page 9
The Ten Largest, No. 7, Adulthood, Group IV, 1907
Oil on canvas
315 × 235 cm / 124 × 92½ in
The Hilma af Klint Foundation, Stockholm,
Sweden

Pages 10–11
The Ten Largest, Group IV, 1907
Installation view at City Gallery Wellington
Te Whare Toi, New Zealand

EL ANATSUI
Page 13
Ink Splash II, 2012
Aluminium and copper
Approx. 285 × 373 cm / 112¼ × 146¾ in
Tate, London, UK

GIUSEPPE ARCIMBOLDO
Page 15
Summer, 1573
Oil on canvas
76 × 63 cm / 30 × 24¾ in
Louvre, Paris, France

Page 16
Spring, 1573
Oil on canvas
76 × 63 cm / 30 × 24¾ in
Louvre, Paris, France

Page 17
Fall, 1573
Oil on canvas
76 × 63 cm / 30 × 24¾ in
Louvre, Paris, France

Winter, 1573
Oil on canvas
76 × 63 cm / 30 × 24¾ in
Louvre, Paris, France

BASAWAN
Page 19
Akbar's Adventures with the Elephant Hawai,
from the *Akbarnama,* c.1590–95
Watercolor
33 × 20 cm / 13 × 7 ⅞ in
Victoria and Albert Museum, London, UK

JEAN-MICHEL BASQUIAT
Page 21
Horn Players, 1983
Acrylic and oil stick on three canvas panels
mounted on wood supports
243.8 × 190.5 cm / 96 × 75 in
The Broad, Los Angeles, USA

Pages 22–23
Grillo, 1984
Oil, acrylic, oil stick, collage, and nails on wood
Quadriptych, 243.8 × 537.2 × 47 cm /
96 × 211 ½ × 18½ in

ROSA BONHEUR
Page 25
A Lion's Head, c.1870–91
Oil on canvas
80.5 × 64.2 cm / 31¾ × 25¼ in
Royal Collection Trust, London, UK

Pages 26–27
The Horse Fair, 1852–55
Oil on canvas
244.5 × 506.7 cm / 96¼ × 199½ in
The Metropolitan Museum of Art, New York, USA

SANDRO BOTTICELLI
Pages 28–29
Spring, c.1470–80
Tempera on wood panel
175.5 × 278.5 cm / 69¼ × 109½ in
Uffizi Gallery, Florence, Italy

LOUISE BOURGEOIS
Page 31
Maman, 1999, cast, 2003
Bronze, stainless steel and marble
927 × 891 × 1024 cm / 30 ft 5 in ×
29 ft 4 in × 33 ft 6 in
National Gallery of Canada, Ottawa, Canada

PIETER BRUEGEL
Pages 32–33
Peasant Wedding Feast, c.1566–67
Oil on wood panel
114.3 × 162.6 cm / 45 × 64 in
Kunsthistorisches Museum, Vienna, Austria

ELIZABETH CATLETT
Page 35
Sharecropper, 1952
Linoleum cut
44.8 × 43 cm / 17⅝ × 16¹⁵⁄₁₆ in
Museum of Modern Art, New York, USA

JUDY CHICAGO
Page 37
The Dinner Party, 1979
Mixed media
91.4 × 1463 × 1463 cm / 36 × 576 × 576 in
Brooklyn Museum, New York, USA

Page 38
The Dinner Party, Elizabeth Blackwell place
setting, 1979
Mixed media
Brooklyn Museum, New York, USA

The Dinner Party, Ethel Smyth place setting, 1979
Mixed media
Brooklyn Museum, New York, USA

The Dinner Party, Caroline Herschel place
setting, 1979
Mixed media
Brooklyn Museum, New York, USA

The Dinner Party, Sojourner Truth place
setting, 1979
Mixed media
Brooklyn Museum, New York, USA

CHRISTO & JEANNE-CLAUDE
Page 41
Surrounded Islands, Biscayne Bay, Greater
Miami, Florida, 1980–83
603,850 sq. m / 6.5 million sq. ft of pink fabric
floating around 11 islands
Now dismantled

Pages 42–43
The Pont Neuf Wrapped, Paris, 1975–85
40,876 sq. m / 439,989 sq. ft of woven nylon and
13,076 m / 42,900 ft of rope
Now dismantled

SALVADOR DALÍ
Pages 45–47
The Persistence of Memory, 1931
Oil on canvas
24.1 × 33 cm / 9½ × 13 in
Museum of Modern Art, New York, USA

EDGAR DEGAS
Pages 48–49
The Rehearsal, c.1877
Oil on canvas
58.4 × 83.8 cm / 23 × 33 in
Burrell Collection, Glasgow, Scotland

ROBERT S. DUNCANSON
Pages 51–53
Landscape with Rainbow, 1859
Oil on canvas
76.3 × 132.7 cm / 30 × 52¼ in
Smithsonian American Art Museum,
Washington, D.C., USA

ALBRECHT DÜRER
Page 55 (clockwise from top left)
Self-portrait at the age of thirteen, 1484
Silverpoint on paper
27.3 × 19.5 cm / 10¾ × 7¾ in
Graphische Sammlung Albertina, Vienna, Austria

Self-Portrait at 28, 1500
Oil on panel
67 × 49 cm / 26½ × 19¼ in
Alte Pinakothek, Munich, Germany

Self-portrait, 1498
Oil on panel
52 × 41 cm / 20½ × 16 in
Prado, Madrid, Spain

Portrait of the Artist with a Thistle Flower, 1493
Painting
56 × 44 cm / 22 × 17¼ in
Louvre, Paris, France

JAN VAN EYCK
Page 57
The Arnolfini Portrait, 1434
Oil on wood panel
81.8 × 59.7 cm / 32¼ × 23½ in
National Gallery, London, UK

MONIR SHAHROUDY FARMANFARMAIAN
Page 59
Third Family Hexagon, 2011

Reverse painted glass, mirrored glass, and plaster
122 × 122 cm / 48⅛ × 48⅛ in
Collection of the Estate of Monir Shahroudy
Farmanfarmaian

Pages 60–61
Lightning for Neda, 2009
Mirror mosaic, reverse-glass painting, plaster
on wood
Six panels: 300 × 1200 × 25 cm / 118 ×
473 × 9¾ in (overall)
Queensland Art Gallery Foundation, Australia

HELEN FRANKENTHALER
Page 63
Flood, 1967
Acrylic on canvas
315.6 × 356.9 cm / 124¼ × 140½ in
Whitney Museum of American Art, New York,
USA

Page 64–65
Helen Frankenthaler at work on a large canvas,
1969

ARTEMISIA GENTILESCHI
Page 67
Esther before Ahasuerus, 1620s
Oil on canvas
2.1 × 2.7 m / 6 ft 10 in × 8 ft 11¾ in
The Metropolitan Museum of Art, New York, USA

ALBERTO GIACOMETTI
Page 69
Walking Man, 1960
Bronze
183 cm / 72 in high
Private collection

VINCENT VAN GOGH
Page 71
Sunflowers, 1888
Oil on canvas
92.1 × 73 cm / 36¼ × 28¾ in
National Gallery, London, UK

Pages 72–73
The Starry Night, 1889
Oil on canvas
73.7 × 92.1 cm / 29 × 36¼ in
Museum of Modern Art, New York, USA

Self-Portrait with Bandaged Ear, 1889
Oil on canvas
60.5 × 50 cm / 23¾ × 19½ in
The Courtauld, London, UK

FÉLIX GONZÁLEZ-TORRES
Page 75
'Untitled' (Portrait of Ross in LA), 1991
Sweets, individually wrapped in multicolored
cellophane
Dimensions variable
Art Institute of Chicago, Illinois, USA

DAVID HOCKNEY
Page 77
A Bigger Splash, 1967

Acrylic on canvas
242.5 × 243. 9 × 30 cm / 95 ½ × 96 × 11 ¹³⁄₁₆ in
Tate, London, UK

KATSUSHIKA HOKUSAI
Pages 78–79
South Wind, Clear Sky (Gaifū kaisei), also known
as *Red Fuji*, from the series *Thirty-six Views of
Mount Fuji (Fugaku sanjūrokkei)*, c.1830–32
Woodblock print, ink and color on paper
24.4 × 35.6 cm / 9⅝ × 14 in
The Metropolitan Museum of Art, New York, USA

Page 80 [top]
*Under the Wave off Kanagawa (Kanagawa oki
nami ura)*, also known as *The Great Wave*, from
the series *Thirty-six Views of Mount Fuji (Fugaku
sanjūrokkei)*, c.1830–32
Woodblock print; ink and color on paper
25.7 × 37.9 cm / 10⅛ × 14¹⁵⁄₁₆ in
The Metropolitan Museum of Art, New York, USA

[bottom]
*Sekiya Village on the Sumida River
(Sumidagawa Sekiya no sato)*, from the
series *Thirty-six Views of Mount Fuji (Fugaku
sanjūrokkei)*, c.1830–32
Woodblock print; ink and color on paper
25.4 cm × 38.7 cm / 10 × 15¼ in
The Metropolitan Museum of Art, New York, USA

page 61 [top]
Kajikazawa in Kai Province (Kōshū Kajikazawa),
from the series *Thirty-six Views of Mount Fuji
(Fugaku sanjūrokkei)*, c.1830–32
Woodblock print; ink and color on paper
25.4 × 38.4 cm / 10 × 15⅛ in
The Metropolitan Museum of Art, New York, USA

[bottom]
*Mitsui Shop at Surugachō in Edo (Edo
Surugachō Mitsui mise ryaku zu)*, from the
series *Thirty-six Views of Mount Fuji (Fugaku
sanjūrokkei)*, c.1830–32
Woodblock print; ink and color on paper
25.4 × 38.1 cm / 10 × 15 in
The Metropolitan Museum of Art, New York, USA

HANS HOLBEIN THE YOUNGER
Page 83
The Ambassadors, 1533
Oil on oak
207 × 209.5 cm / 81½ × 82½ in
National Gallery, London, UK

WINSLOW HOMER
Pages 84–85
Snap the Whip, 1872
Oil on canvas
30.5 × 50.8 cm / 12 × 20 in
The Metropolitan Museum of Art, New York, USA

ITŌ JAKUCHŪ
Page 87
Fish and Octopus from *Doshoku Sai-e (Colorful
Realm of Living Beings)*, c.1766
Silk painting
142.6 × 79.4 cm / 56 × 31¼ in

The Museum of Imperial Collections, Sannomaru
Shozokan, Japan

Fish from *Doshoku Sai-e (Colorful Realm of
Living Beings)*, c.1766
Silk painting
142.6 × 79.4 cm / 56 × 31¼ in
The Museum of Imperial Collections, Sannomaru
Shozokan, Japan

FRIDA KAHLO
Page 89
Self-Portrait with Changuito, 1945
Oil on masonite
56 × 41 cm / 22 × 16 in
Fundacion Dolores Olmedo, Mexico City, Mexico

Page 90
Self-Portrait with Monkey, 1907
Oil on masonite
40.6 × 30.5 cm / 16 × 12 in
Buffalo, Albright-Knox Art Gallery, NY, USA

Page 91
Frida Kahlo Museum (The Blue House, La Casa
Azul) Garden, Coyoacán, Mexico City, Mexico

WASSILY KANDINSKY
Pages 92–93
Composition VII, 1913
Oil on canvas
200.7 × 302.3 cm / 78¾ × 119 in
Tretyakov State Gallery, Moscow, Russia

EMILY KAME KNGWARREYE
Page 95
Emu Woman, 1988–89
Synthetic polymer paint on linen
92 × 61 cm / 36¼ × 24 in
Janet Holmes à Court Collection, West Perth,
Australia

YAYOI KUSAMA
Page 97
All the Eternal Love I Have for the Pumpkins,
2016
Mixed media
415 × 415 × 293.7 cm / 163½ × 163½ × 115½ in

Pages 98–99
Infinity Mirrored Room – Brilliance of the Souls,
2014
Mixed media
415 × 415 × 287.4 cm / 13 ft 7½ in × 13 ft 7½ in ×
9 ft 5 in

LEONARDO DA VINCI
Page 101
Mona Lisa, 1503–6
Oil on wood panel
77 × 53 cm / 30¼ × 21 in
Louvre, Paris, France

RENÉ MAGRITTE
Page 103
The Treachery of Images (This Is Not a Pipe),
1929
Oil on canvas

60.3 × 81.3 × 2.5 cm / 23¾ × 31¹⁵⁄₁₆ × 1 in
Los Angeles County Museum of Art, USA

Page 104
Not to Be Reproduced, 1937
Oil on canvas
81 × 65.5 cm / 31¾ × 25¾ in
Museum Boijmans Van Beuningen, Rotterdam,
Netherlands

Page 105
The Human Condition, 1933
Oil on canvas
100 × 81 cm / 39¼ × 31¾ in
National Gallery of Art, Washington, D.C., USA

KERRY JAMES MARSHALL
Page 106
School of Beauty, School of Culture, 2012
Acrylic on canvas
147.3 cm x 274.3 / 108 × 158 in
Birmingham Museum of Art, Alabama, USA

HENRI MATISSE
Page 109
Harmony in Red, 1908
Oil on canvas
180.5 × 221 cm/ 71 ¹⁄₁₆ × 87 in
State Hermitage Museum, St Petersburg, Russia

JOAN MIRÓ
Page 111
Women and Bird in the Moonlight, 1949
Oil on canvas
81.3 × 66 cm / 32 × 26 in
Tate, London, UK

CLAUDE MONET
Page 113
The Water-Lily Pond, 1899
Oil on canvas
88 × 93 cm / 34¾ × 36¼ in
National Gallery, London

Page 114
Claude Monet with his palette in front of his
work *Water Lilies*, 1920s
Gelatin silver print

Page 114
Water Lilies: Clear Morning with Willows, 1914-
1926
Painting, left part of triptych
200 × 425 cm / 78¾ × 167¼ in
Orangerie, Paris, France

Page 115
September 17, 1922
The Lake, which Claude Monet is painting for
his great and final masterpiece *Idyllic Scene at
Vernon*

BERTHE MORISOT
Page 117
The Cradle, 1872
Oil on canvas
56 × 46 cm / 22 × 18 in
Musee d'Orsay, Paris, France

GEORGIA O'KEEFFE
Page 118–119
Above the Clouds I, 1962–63
Oil on canvas
114.62 × 122.56 cm / 36⅛ × 48¼ in
Georgia O'Keeffe Museum, New Mexico, USA

MERET OPPENHEIM
Pages 120–21
Object, 1936
Fur-covered cup, saucer, and spoon
Cup 10.9 cm / 4⅜ in; saucer 23.7 cm / 9⅜ in;
spoon 20.2 cm / 8 in; overall 7.3 cm / 2⅞ in high
Museum of Modern Art, New York, USA

NAM JUNE PAIK
Page 123
The More, The Better, 1988
1,003 monitors, steel structure, four-channel
video, sound, indefinite running time
8.5 m / 60 ft 9 in high
Installation view, National Museum of Modern
and Contemporary Art, Gwacheon, South Korea

Page 124
TV Garden, 1974–77
Immersive installation of plants and cathode ray
tube televisions
Kunstsammlung Nordrhein-Westfalen,
Düsseldorf, Germany. Installation view at Tate,
London, 2019.

Watchdog II, 1997
Aluminium framework, Panasonic video camera,
2 audio speakers, circuit boards, three 13 in
color TVs, one 9 in color TV, nine 5 in color TVs, 2
channel original Paik video
138.4 × 156.4 × 42.8 cm / 54½ × 61½ × 16⅞ in
Private collection

TV Is Kitsch, 1996
13 wood TV cabinets, 2 DVD players, two 5 in
TVs, four 9 in TVs, seven 13 in TVs 2, channel
Paik original video
Mixed media
230 × 74 × 270 cm / 90½ × 29 × 106¼ in
Private collection

Page 125
Untitled (Bakelite Robot), 2002
Video on six monitors in vintage radios
95.2 × 93.3 × 19.7 cm / 35½ × 36¾ × 7¾ in
San Francisco Museum of Modern Art, USA

CLARA PEETERS
Pages 127–29
Still Life with Cheeses, Almonds, and Pretzels,
1615
Oil on panel
34.5 × 49.5 cm / 13½ × 19½ in
Mauritshuis, The Hague

PABLO PICASSO
Page 131
Weeping Woman, 1937
Oil on canvas
60.8 × 50 cm / 24 × 19⅝ in
Tate, London, UK

JACKSON POLLOCK
Page 133
Jackson Pollock painting *Fall Rhythm:
Number 30, 1950* in 1950

Pages 134–35
Number 1, 1948, 1948
Oil on canvas
172.7 × 264.2 cm / 68 × 104 in
Museum of Modern Art, New York, USA

RAPHAEL
Pages 137–39
The School of Athens, 1508–11
Fresco
770 cm / 303 in wide at base
Vatican Museums, Rome, Italy

BRIDGET RILEY
Page 141
Cataract 3, 1967
Emulsion PVA on canvas
221.9 × 222.9 cm / 87⅜ × 87¾ in
British Council, London, UK

Page 142
Fall, 1963
Polyvinyl acetate paint on hardboard
141 × 140.5 cm / 55½ × 55 in
Tate, London, UK

Page 143
Fission, 1962
Tempera on board
88.8 × 86.2 cm / 35 × 34 in
Museum of Modern Art, New York, USA

FAITH RINGGOLD
Page 145
Echoes of Harlem, 1980
Hand-painted cotton
203.2 × 227.3 cm / 80½ × 89½ in
The Studio Museum in Harlem, New York, USA

Page 147
The Sunflowers Quilting Bee at Arles, 1991, from
the series *The French Collection*, Part I, #4
Acrylic on canvas with pieced fabric border
187 × 203.2 cm / 74 × 80 in
New Museum, New York, USA

HENRI ROUSSEAU
Page 149
The Merry Jesters, 1906
Oil on canvas
145.7 × 113.3 cm / 57⅓ × 55½ in
Philadelphia Museum of Art, PA, USA

Pages 150–51
Surprised!, 1891
Oil on canvas
129.8 × 161.9 cm / 51 ⅛ × 63 ¾ in
National Gallery, London, UK

GEORGES SEURAT
Pages 153–55
A Sunday on La Grande Jatte, 1884/86
Oil on canvas

207.5 × 308.1 cm / 81¾ × 121¼ in
The Art Institute of Chicago, IL, USA

AMRITA SHER-GIL
Page 157
Group of Three Girls, 1935
Oil on canvas
99.5 cm x 73.5 / 29 × 39 in
National Gallery of Modern Art, New Delhi, India

AMY SHERALD
Page 159
*What's different about Alice is that she has
the most incisive way of telling the truth*, 2017
Oil on canvas
137.2 × 109.2 × 6.4 cm / 54 × 53 × 2½ in
The Columbus Museum, Columbus, GA, USA

Page 160
Precious jewels by the sea, 2019
Oil on canvas
304.8 × 274.3 × 6.4 cm / 120 × 108 × 2½ in
Crystal Bridges Museum of American Art,
Arkansas, USA

Page 161
Planes, rockets, and the spaces in between,
2018
Oil on canvas
254 × 170.2 cm / 100 × 67 in
Baltimore Museum of Art, MD, USA

CINDY SHERMAN
Page 163
Untitled, 1990
Chromogenic color print
33 × 25.4 cm / 13 × 10 in

Page 164
Untitled #96, 1981
Chromogenic print
61 × 121.9 cm / 24 × 48 in
Museum of Modern Art, New York, USA

Untitled #416, 2004
Chromogenic color print
351 × 123 cm / 55¾ × 48½ in

Untitled Film Still #35, 1979
Gelatin silver print
25.4 × 20.3 cm / 10 × 8 in

Page 165
Untitled #210, 1989
Chromogenic colour print
167.6 × 111.7 cm / 66 × 44 in

Untitled, 2003
Chromogenic color print
66 × 35.5 cm / 26 × 16 in

Untitled #119, 1983
Chromogenic color print
91.4 × 44.4 cm / 36 × 17½ in

JAUNE QUICK-TO-SEE SMITH
Pages 166–67
States' Names I, 2000

Mixed media on canvas
182.9 cm x 121.9 / 48 × 72 in
Smithsonian American Art Museum,
Washington, D.C., USA

TARSILA DO AMARAL
Page 169
Abaporu, 1928
Oil on canvas
85 × 73 cm / 33½ × 28¾ in
Collection MALBA, Museo de Arte
Latinoamericano de Buenos Aires, Argentina

JOSEPH MALLORD WILLIAM TURNER
Pages 170–71
Snow Storm: Steam-Boat off a Harbor's Mouth,
exhibited 1842
Oil on canvas
91.4 × 121.9 cm / 3 × 4 ft
Tate, London, UK

Pages 172–73
The Shipwreck, exhibited 1805
Oil on canvas
170.5 × 241.6 cm / 67⅛ × 95⅛ in
Tate, London, UK

DIEGO VELÁZQUEZ
Page 175
Las Meninas, c.1656
Oil on canvas
318 × 276 cm / 10 ft 5 in × 9 ft
Prado, Madrid, Spain

ANDY WARHOL
Page 177
Peach Marilyn, 1962
Acrylic and silkscreen ink on linen
50.8 × 40.6 cm / 20 × 16 in
Private collection

Page 178
Blue Marilyn, 1962
Acrylic and screen print ink on canvas
50.5 × 40.3 cm / 19 ⅞ x 15 ⅞ in
Princeton University Art Museum, USA

Red Marilyn, 1962
Acrylic and silkscreen ink on linen
50.8 × 40.6 cm / 20 × 16 in
Irving Blum, New York, USA

Lemon Marilyn, 1962
Synthetic polymer, silkscreen inks and acrylic
on canvas
50.8 × 40.6 cm / 20 × 16 in
Private collection

Licorice Marilyn, 1962
Acrylic and silkscreen ink on linen
50.8 × 40.6 cm / 20 × 16 in
Private collection

Page 179
Two Marilyns, 1962
Acrylic and silkscreen ink on linen, laid on canvas
31.8 × 55.9 cm / 12½ × 22 in
Private collection

Shot Sage Blue Marilyn, 1964
Acrylic and silkscreen ink on linen
101.6 × 101.6 cm / 40 × 40 in
Private collection

Marilyn Monroe, c.1953
Gelatin silver print, ink, and graphite
25.9 × 20.2 cm / 10³⁄₁₆ x 7¹⁵⁄₁₆ in
Andy Warhol Museum, Pittsburgh, PA, USA

RACHEL WHITEREAD
Page 181
Untitled (Stairs), 2001
Plaster, fibreglass, and wood
375 × 220 × 580 cm / 147¾ x 86¾ x 228¼ in
Tate, London, UK

Pages 182–83
Chicken Shed, 2017
Concrete
217 × 230 × 280 cm/ 85½ × 90½ × 110¼ in
Tate, London, UK

YIN XIUZHEN
Page 185
Portable City: Tokyo, 2005
Mixed media
82 × 144 × 30 cm / 32¼ × 56¾ × 11¾ in
Mori Art Museum, Tokyo, Japan